WILD CENT

Discovering the natural history of C‌‍ ‍‍‍ ‍ ‍

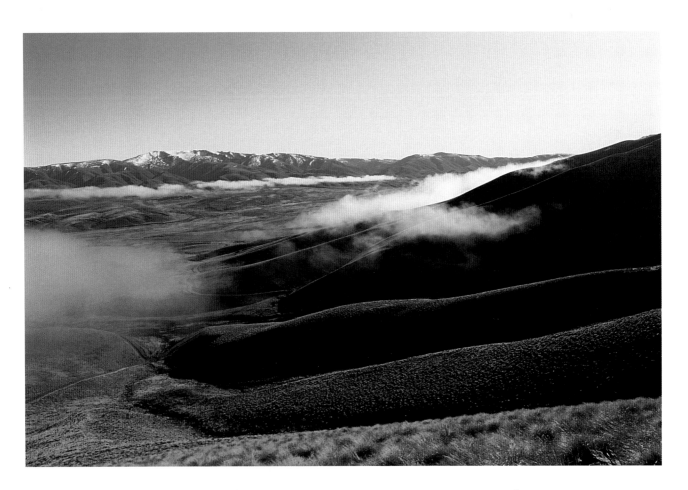

Neville Peat & Brian Patrick

University of Otago Press

Acknowledgements

The authors gratefully acknowledge the financial support provided by the Dr Marjorie Barclay Trust and Dunedin Branch of the Royal Forest and Bird Protection Society. Assistance with funding also came from the Central Otago District Council's Cromwell Community Board.

For scientific information and other advice, the authors are indebted to the following:

John Barkla, Barbara Barratt, John Beattie, Peter Bristow, Dave Craw, Robin Craw, Katherine Dickinson, John Douglas, Eric Edwards, Brent Emerson, Warren Featherston, Blair Fitzharris, Malcolm Foord, Lyn Forster, David Galloway, Tom Gilmore, Dianne Gleeson, Philip Grove, Michael Heads, Bill Hislop, Rod Hitchmough, Neil Hudson, Colleen Jamieson, Paul Johnston, Sam Leask, Ian McLellan, Graeme Mason, Jolyon Manning, Nick Mortimer, Tony Perrett, Brian Rance, Neill Simpson, Mandy Tocher, Royden Thomson, Susan Walker, John Ward, Rob Wardle, Trevor Worthy, John Youngson and many runholders.

For the use of photographs, thanks are extended to Richard Allibone, John Barkla, George Chance, Dave Craw, John Douglas, Ray Forster, Dianne Gleeson, Philip Grove, Kelvin Lloyd, Graeme Loh, Leigh Marshall, Rod Morris, Sue Noble-Adams, Neill Simpson and Ian Southey. Special thanks to Grahame Sydney for the use of one of his latest paintings from Central Otago, to the Department of Conservation for the use of photographs from its collections, and to Chris Gaskin for allowing the reproduction of the painting of extinct birds (page 26), first published in *Moa – the story of a fabulous bird*, by Philip Temple and Chris Gaskin, Hodder & Stoughton, 1985. Te Papa Museum of New Zealand supplied the photograph of a mummified moa head on page 28.

The authors acknowledge the co-operation of the Otago Conservancy of the Department of Conservation and Otago Museum in the course of this project.

Front cover photographs: Otago skinks, *Ian Southey*; Tussock as mist lifts, Hawkdun Range, *Neville Peat*.

Back cover photograph: *Aciphylla simplex*, The Remarkables, *Neill Simpson*.

Title page photograph: Two Mile, Hawkdun Range, *Neville Peat*.

Published by University of Otago Press,
PO Box 56/56 Union Street, Dunedin, New Zealand
Fax: 64 3 479 8385
Email: university.press@stonebow.otago.ac.nz

Copyright © Neville Peat & Brian Patrick 1999
First published 1999, ISBN 1 877133 65 5
Cover design by Wendy Harrex
Map by Jan Kelly, Geography Dept, University of Auckland
Printed by Spectrum Print Ltd, Christchurch

Typical of the grasslands of Central is the skylark *Alauda arvensis*. A bird of open country, it pours forth its distinctive song, a rolling trill and chirrup, from a hovering flight through spring and summer. Superficially similar to the native New Zealand pipit, the skylark was introduced in the 1860s to help the European settlers feel more at home. Pairs are territorial in the breeding season. Two to four chicks are commonly raised. The skylark feeds mainly on seeds and invertebrates such as moths, beetles, bugs, flies and their larvae. *Department of Conservation*

Contents

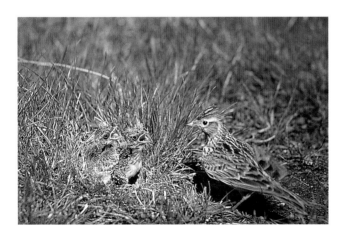

Map of the Central Otago Region

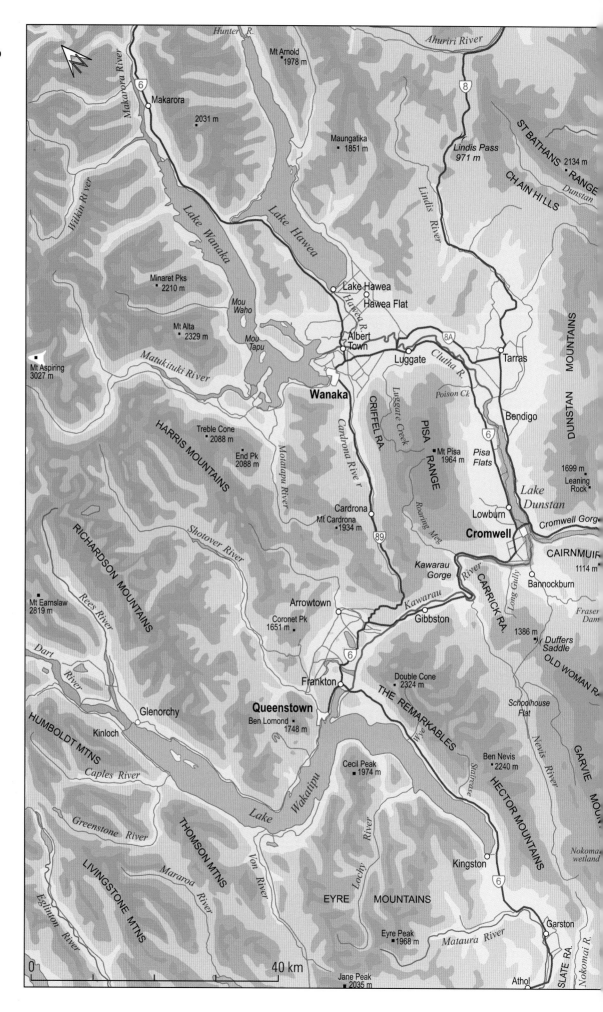

Hunter R.

Ahuriri River

Mt Arnold
■ 1978 m

Makarora River

6

Makarora

2031 m

Wilkin River

Lake Wanaka

Lake Hawea

Maungatika
■ 1851 m

Lindis Pass
971 m

8

ST BATHANS
RANGE

2134 m

CHAIN HILLS

Dunstan

Lindis River

Minaret Pks
■ 2210 m

Mou
Waho

Lake Hawea

Hawea Flat

Mou
Tapu

Mt Alta
■ 2329 m

Albert
Town

8A

Tarras

Matukituki River

Hawea R.

Luggate

Clutha R.

DUNSTAN MOUNTAINS

Mt Aspiring
3027 m

Wanaka

CRIFFEL RA.

Luggate Creek

Poison Ck

PISA

Bendigo

6

HARRIS MOUNTAINS

Treble Cone
■ 2088 m

Cardrona River

Mt Pisa
■ 1964 m

RANGE

Pisa
Flats

1699 m ■

Leaning
Rock ■

End Pk
2088 m

Moitapu River

Lowburn

Lake
Dunstan

Shotover River

Cardrona

Mt Cardrona
■ 1934 m

89

Roaring Meg

Cromwell

Cromwell Gorg

RICHARDSON MOUNTAINS

Rees River

Kawarau
Gorge

River

CARRICK RA.

CAIRNMUIR
1114 m

Mt Earnslaw
2819 m

Arrowtown

Coronet Pk
1651 m ■

Kawarau

Gibbston

Long Gully

Bannockburn

1386 m ■

Duffers
Saddle

Fraser
Dam

Dart River

6

OLD WOMAN R.

Frankton

Double Cone
■ 2324 m

Schoolhouse
Flat

HUMBOLDT MTNS

Glenorchy

Queenstown

Ben Lomond ■
1748 m

THE REMARKABLES

Ben Nevis
■ 2240 m

Nevis River

GARVIE MOUN

Kinloch

Caples River

Lake Wakatipu

Cecil Peak
■ 1974 m

Staircase

HECTOR MOUNTAINS

Wye

Greenstone River

THOMSON MTNS

Von River

Lochy River

Kingston

6

Nokoma
wetland

LIVINGSTONE MTNS

Mararoa River

EYRE MOUNTAINS

Eglinton River

0

40 km

Eyre Peak
■ 1968 m

Mataura River

Garston

SLATE RA.

Nokomai R.

Jane Peak
■ 2035 m

Athol

Names and terms

The text in this book is strewn with scientific names as well as common and, in some cases, Maori names. The widespread use of scientific names is intended to be educational. Every described life form has a species name and a genus name and sometimes a third name that identifies a subspecies or variety. The genus name is expressed first. For closely related species the terms 'var' (meaning variety), 'aff' (affiliated with) and 'cf' (comparable with) may be used.

However difficult some of the names may look, just remember that a little Greek or Latin goes a long way. If you have mastered such names as Hippopotamus, Rhododendron, Rhinoceros and Geranium, why not extend your scientific vocabulary. Here is your chance!

The term 'endemic' means 'found nowhere else – confined to', and 'local endemic' means that the plant or animal is unique to an area or region. Another scientific term used in the text is 'taxa' (singular form, 'taxon'), which covers all entities that have been scientifically described, whether species, subspecies, variety or affiliated kind. 'Type locality' refers to the area from which a taxon was first described, and is significant in fixing a name to a population.

The term 'reservoir' appears frequently in the text to describe a body of water artificially created for hydro-electric generation, storage or irrigation purposes. Lake Dunstan, for example, is mostly referred to as the Dunstan reservoir.

The Quiet Earth

Neville Peat

Central is something else again.

Inland, upland, old land, the quiet earth ... quiet except on the days when the nor'wester whips the tussocks, bends the autumn-gilded poplars and converts clouds into flying-saucers.

Castellated mountains hunch under wide skies, worn down by eons of freeze-thaw and wind-whip. Their rock tors stand dark as gun turrets in the battle against the elements.

Range and basin. A parallel pattern on a broad canvas. A frontier land, out west. Picture greenstone-seeking Maori with cabbage-tree cape and sandals, bearded pioneer and totara post, gold pan and girdle scone, merino and magpie.

Moa once ruled this roost. Their bones, preserved in dry caves and crevices, mingle with the fossil remains of species long gone. Eagle, adzebill, goshawk, goose.

Yet for all the biscuit-dryness, water has danced a sculptor's jig across this land. Persistent stream erosion has left fretted faces on the ranges, and through the desert heat of Central runs an artery called Clutha, deeply entrenched.

How concentrated the weather . . . hot enough to buckle railway lines (in the days of trains), cold enough to shatter the schist and freeze a steam engine's whistle. For relief in the baking heat, merino wethers, hardiest sheep of all, push their heads under rock overhangs, seeking any scrap of shade. Worse for all living things on the valley floor is hoarfrost. Perishingly beautiful. Dry days, weeks even, of cold storage.

Tough going breeds tough characters. Wild Spaniard and wild Irishman are prickly customers, old-timers of the rangelands – speargrass and matagouri, respectively.

Saltpans harbour a select group of plants, and high up in the mountains, perpetually hunkered down, are cushion species in rich array, the tundra of the south.

Tussocks tall and short make Central a grassland gallery. Tallest of all are the showy snow tussocks – tawny hair whose tufted or bunched habit gives them their name, which is derived from 'tusk', Old English for a tuft of hair.

Endemic and eccentric – Central has its share of special flora and fauna, not the least galaxiid fish of Gondwanan ancestry, gold-speckled skinks that give birth to live young and grow to be as large as any in New Zealand, dazzling day-flying moths, lumbering beetles, and tree weta, all knees and knuckles, that no longer live in trees but under flat rocks.

In the world of birds, the presence of seashore birds in Central is a puzzling feature. Oystercatcher, blackbacked gull, banded dotterel, pied stilt, black-fronted tern. In the breeding season, some of them swap wave crests of inshore seas for the summit crests of mountain ranges. How bizzare the image of black-backed gulls incubating eggs in a blizzard 1,500m above sea level.

The call of the wild in Central remains the riveting kek-kek-kek-kek of the New Zealand falcon, a clarion call feared by all native birds but lately challenged by the Outback warble of the magpie, a newcomer to Central like so many of the birds.

Here in Central new mixes with old but timelessness is the enduring impression, no better expressed than in the schist, which started out as sediment on the ocean floor. Transformed deep down, uplifted and weathered, the schist forms the bones, now almost everywhere lichen-covered, of this quiet earth.

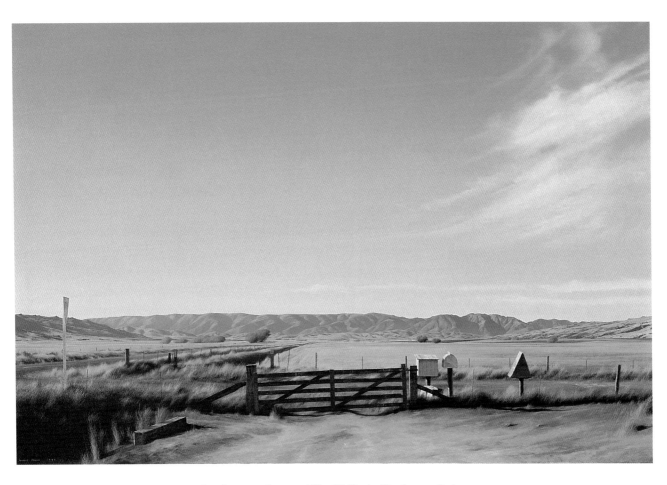

Anderson Lane *(Ida Valley), Grahame Sydney*
oil on linen canvas, 915 mm x 1375 mm, 1999.
Private collection, Dunedin

A Journey Back In Time

Brian Patrick

A journey into the alpine zone of the broad-topped ranges of Central Otago generally means traversing steep, twisting, dusty dirt tracks by four-wheel-drive vehicle. It means opening and closing numerous assorted wooden farm gates as the tops draw nearer. I am always filled with anticipation, anxious about the kind of weather I will encounter and curious about what new records or new species of insect might be awaiting me. Often I have been the first entomologist to explore and sample some of these alpine areas. Each trip to the tops is truly a journey of discovery.

I invariably head for the highest point, where I feel the most interesting communities and species will be found. Here the vegetation is dwarfed, a miniature forest. I sample it like some giant trampling over a spongy canopy. Bare ground and rocky areas are also productive. On a warm, calm day my heart soars. In midsummer it is a relief to escape the intense dry heat of the valley floors and find a more comfortable temperature on the tops. Wind is my main worry. These mountains are notoriously windy. Winds make conditions unpleasant; they also discourage insects from venturing out. But when summer comes conditions are perfect, the high-alpine zone is alive with insects whose colours, forms and strategies are simply amazing. Some flightless species bumble over the cushion plants; others spring from plant to plant or fly over them swiftly and elusively, settling only long enough, with wings constantly vibrating, to lure me closer before they take to the air once again.

With a short growing season at this altitude, insects can at best undergo only one complete lifecycle annually compared to maybe three in the lowlands. That is why I feel that a foray into the mountains is a trip back in time. Life is effectively in a fridge for much of the time and consequently the rate of evolution compared to the lowlands is slower. This high-alpine zone, with its fellfield, snowbanks, seepages and screes, is my favourite place for studying insects and plants. Insect variety is matched by the variety of vascular and non-vascular plants, many of which produce intoxicating scents. An

example of a perfumed plant is the sprawling daphne Pimelea oreophila. Many of the plants and insects are diminutive and best examined on hands and knees. At this close range the variety of colour, form and smell of the flora is astounding. Sticky-leaved daisies, prickly miniature speargrasses and soft convex cushions are all a part of the mix.

Because these mountaintops are like islands separated by inhospitable lowlands, I collect data on the presence of every species for biogeographic studies. Another facet of my work is elucidating the life history of the moth species. I do this by carefully observing larval damage to plants, then I search for the culprit. It is useful to note the plants that the adults appear to be attracted to in case I am able to hatch eggs laid by captured females. I have gradually widened my interests over the years so that my objective is to know the name of every insect and plant I encounter in the mountains.

I first ventured into the mountains of Otago twenty years ago. I was so taken with the landscape, plants and insects in the hills above Danseys Pass that I returned thirty-seven times over three seasons, carefully recording all my observations in a logbook. That was to be the pattern for me for years to come. To adequately sample all the seasons, by day and night, together with the vagaries of the climate, it took many expeditions for me to be able to make valid comparisons. For a while I found new species on nearly every expedition, especially early or late in the season, which were times of the year that had not been well sampled previously. While reward for effort can decrease over time, I have constantly added new goals. Thus every trip is exciting.

It has been a privilege to be able to visit so many of Otago's remote alpine corners. The biota is as old and important as the ancient peneplain surface on which it lives. It has undergone much less disturbance and change than the lowland biota and can tell us a great deal about the region's, not to mention the nation's, geological and biological history. It takes a lot to beat the biodiversity of Otago's mountains.

1 Rock Tors and Rainshadow

In a land as green, temperate and oceanic as New Zealand, Central Otago is an anomaly. It is the region of New Zealand farthest removed from the sea, the most inland. Geographers describe it as subcontinental (almost continental), with climatic extremes to prove it.

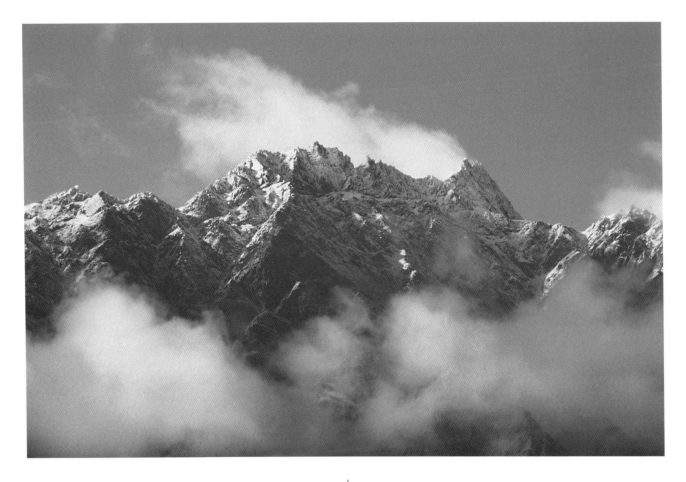

To those people who know and cherish its many special features, this region is simply called 'Central', although you may still hear the term Otago Central, which was applied, for example, to the branch railway line that once traversed the dry core of the region. That heartland is generally considered to be the true Central. But the region encompassed by this book pushes the boundaries west to include the southern lakes of Wakatipu, Wanaka and Hawea and south to take in the mountain wildernesses of the Eyre, Hector, Garvie and Umbrella Mountains and the full extent of the Old Man Range. In essence, the Central described here is based solidly on a rock type called schist. Geology rather than provincial politics has determined the boundary. In the south, the shallow arc of the Livingstone Fault swings through the Eyre, Garvie and Umbrella Mountains, neatly enclosing the schist country. As the goldminers of last century well knew, the schist and its gold-bearing quartz runs into northern Southland in the upper Waikaia catchment.

This expanded Central lies like a diamond on the southern half of the South Island. At the northern tip are the heads of Lakes Wanaka and Hawea. The eastern tip is Danseys Pass. The Blue Mountains mark the southern tip and the head of Lake Wakatipu is away out west. These points enclose an area of about 19,000 square kilometres, seven percent of the total land area of New Zealand. Coincidentally, two features crisscross the diamond. Running east-west through the middle is latitude 45 degrees south, the halfway line between the Equator and South Pole, and on the opposite axis, running more or less north to south, is the main stem of New Zealand's largest river, the Clutha. The 45-degree latitude line and the Clutha intersect at Lowburn, 4km north of the town of Cromwell. Cromwell is not only at the geographical centre of this enlarged Central region; it is also the most inland town in New Zealand.

Rippling through the middle of the region is a set of parallel ranges, the so-called block mountains, separated by basins. From satellite height they appear to be terrestrial waves set in motion by some huge unseen force, and in reality they are just that – ripples emanating from the Alpine Fault and its spectacular uplift, the Southern Alps.

A colourful mosaic of alpine cushion plants just below the summit crest of the Old Man Range. *Brian Patrick*

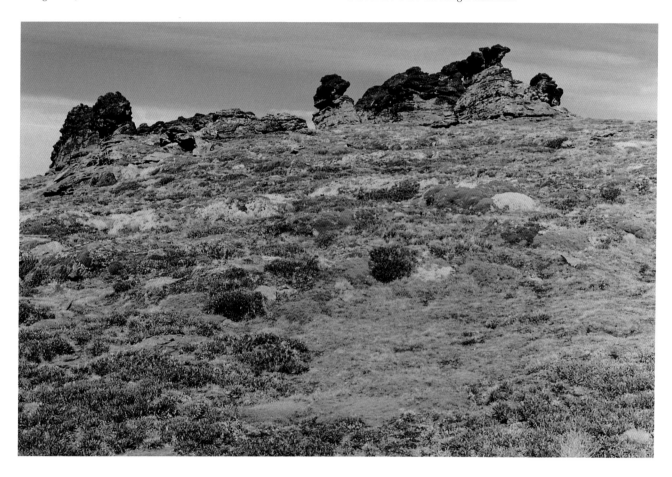

Two main characteristics make Central stand out from other parts of New Zealand – dryness and age. It is dry because of the rainshadow cast by high mountains to the south and west. New Zealand's driest region abuts its wettest, Fiordland. Central's rocks are old, originating as sediments laid down under the sea and transformed over eons. The weathered outcrops of schist known as tors stake out the tops of ranges. Some are stately, some weirdly sculpted. Many stand as tilting tombstones commemorating an unspeakably long past. Age, stability and dryness manifest themselves here in many ways, in the landforms, flora and fauna, all of which contain unique elements that help set Central apart from the rest of New Zealand. Besides harbouring numerous endemic life forms, the dry rocky environment has preserved a remarkable record of extinct fauna and flora. Old bones, pollen and leaf remains open a window to a past that is not only strangely different; they paint a picture going back tens of millions of years that touches on the bizarre.

Some living elements reflect the existence of an old and relatively stable terrain in which the fauna had time to evolve new forms – for example, Central's diverse lizards, fish and invertebrates. In human times, there have been accelerated changes. They include a reduction in forest and shrubland and an increase in grassland, the disappearance into extinction of moa and other ancient birds, and a decline in native fish and the larger lizards. But there have been gains. For example, Australasian harrier and New Zealand falcon, New Zealand's only day-time birds of prey, have widened their range.

Despite 140 years of pastoralism, the valley floors of Central have retained a surprising array of semi-natural communities. Perhaps no other area of New Zealand apart from the Mackenzie Country has such extensive areas of flat, relatively low-altitude land that still retain significant elements of native biodiversity and the natural landscape. This is due to the presence of generally poor and water-deficient soils – the saltpans, sand dunes and rocky sites. Bird life is typical of open country in other parts of the South Island – a mixture of native and introduced species, typified by the juxtaposition of New Zealand pipit and European

Storm over tussock grassland near Mt Teviot.
Neville Peat/Department of Conservation

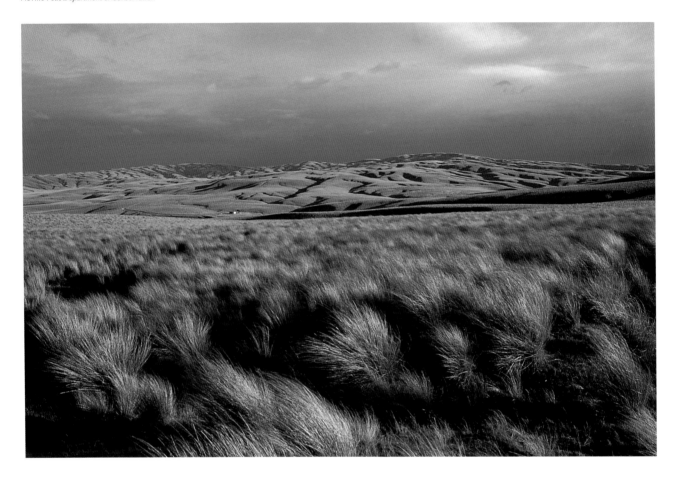

skylark, harrier hawk and Australian magpie, spur-winged plover and chaffinch, Australasian shoveler and mallard. Invertebrate life makes a strong impression in Central. Factors influencing the composition of the insect fauna are the amount of bare ground, occurrence of tors, differential height of vegetation, diversity of native flora and drainage. Not surprisingly, the alpine areas of Central are treasure troves of endemic life. They include species that are found only on a single range or shared between a group of adjacent ranges. The high alpine zone is especially immune to human-induced change but everything stands to win or lose when the climate itself changes.

In a region whose climate is so strongly defined as that of Central – the coldest, driest place in New Zealand and one of the hottest – the prospect of global warming could have far-reaching effects. Some climatologists confidently predict that global warming will be felt early in the twenty-first century. One scenario suggests that by the year 2100, average annual temperatures could be higher by as much as three degrees Celsius and annual rainfall could increase

by more than 14 percent, producing a 40 percent increase in river flows in winter and 13 percent loss in summer flows. The snowline could rise by 300m to 400m above present levels. All of this would create substantial changes in Central, both for natural ecosystems and for primary production. In terms of land uses, for example, there could be an expansion in horticulture, forestry and summer tourism, with consequent impacts on natural values.

For all that, it would take major climate change to knock Central off its subcontinental perch. In the foreseeable future anyway, it is bound to retain a distinctive atmosphere.

Grasses Galore

Much of Central is a prairie. Grasslands may stretch as far as the eye can see. The tussock grassland has prospered from fires – fires that reduced forest and shrubland before and after humans arrived, and from pastoral farming's burning/grazing regimes. The largest of the grasses are the tall tussocks or snow tussocks in the genus *Chionochloa*, meaning snowgrass. Narrow-leaved snow tussock *C. rigida* is the

The rare fern *Pleurosorus rutifolius* typically grows on sunny rock faces. The species has significant populations at Cornish Point near Cromwell and on the rock bluffs east of Alexandra, where this specimen was photographed. *John Douglas*

The flightless alpine stoner *Zelandobius childi*, endemic to Central, is pictured at its type locality, the Old Man Range, at an altitude of 1,460m. The genus has its centre of diversity in Otago, with at least 19 species found here. Its larvae inhabit swift alpine streams. *Brian Patrick*

Large moths in the genus *Aoraia*, including this one, *A. flavida*, are a feature of the uplands of Central. Females are heavy-bodied and flightless, and among the nation's largest moths. No fewer than four species are found in the Umbrella Mountains, a stronghold for the genus. This male has its type locality there. *Brian Patrick*

Bright flowers of *Celmisia sessiliflora* stand out against the background of the cushion *Dracophyllum muscoides* on the Dunstan Mountains. The Dracophyllum has just finished flowering. Both species are common and characteristic of the summits of all Central Otago ranges. *Brian Patrick*

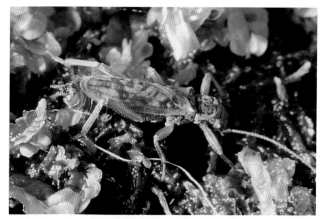

signature species of Central. In places where it is conservatively grazed it is still growing densely and head-high. It grows to well above the treeline and is often mixed with shrubland. At higher elevations, though, it gives way to slim snow tussock *C. macra*, which has become rare in Otago. Copper tussock *C. rubra cuprea*, a subspecies of red tussock restricted to southern South Island, grows at mid-altitude or lower, often on wetter sites. It sometimes hybridises with narrow-leaved snow tussock. Copper tussock's abundance has been drastically reduced by pastoral farming.

Short tussock grasslands are dominated by the common hard tussock *Festuca novaezelandiae*, which has maintained its share of the grassland zone because it is unpalatable to stock. Silver tussock *Poa cita*, intermediate in size between hard tussock and the taller tussocks, impresses with its shiny golden tufts. Recent studies have recognised *Festuca madida*, a new grass from the uplands of Central, including the Umbrella and Garvie Mountains, Danseys Pass and the Old Man Range. A grass of low stature, growing in clumps in wet sites, it has a scattered distribution from the Kaweka Range

in the North Island to subantarctic Campbell Island.

Grasses of small stature retain their share of space, too, with several species such as *Poa maniototo*, *Rytidosperma maculatum* and *R. pumilum* abundant over large areas. Although they have undoubtedly expanded their ranges due to land degradation, these diminutive grasses always had a place adjoining bare ground – places such as saltpans where other tiny species grow, for example *Puccinellia raroflorens* and *P. stricta*.

On roadsides spared the attention of sheep, sharp-eyed observers will find tall native grasses such as *Elymus solandri* and *E. apricus*. These are among the most palatable of native grasses and soon disappear when grazed heavily or burnt.

Somewhat Continental – Central's climate

Central Otago – the core of the region rather than its fringes – is a land of extremes climatically. Whereas much of New Zealand's climate is modified by maritime influences, Central's weather is more like that of a continent. Picture hot, dry summer days and cool nights; clear skies for days

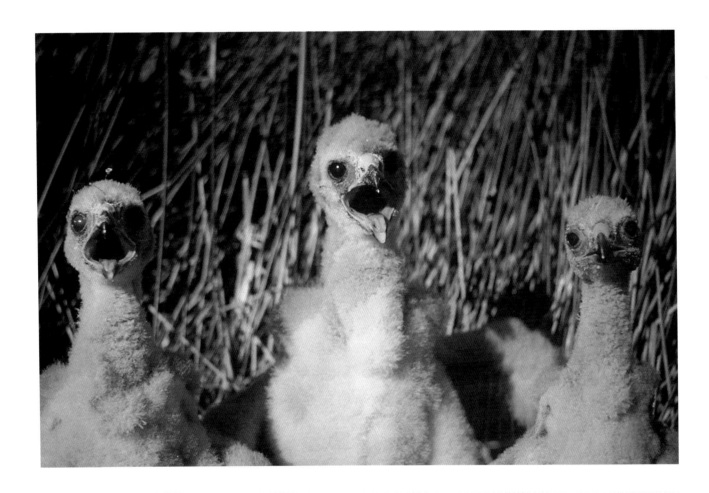

Avian Icon – the 'Hawk'

Bird alone in a lonely landscape – this is the image portrayed by the Australasian harrier *Circus approximans* as it patrols and quarters the rock-and-tussock country of Central Otago, swooping low if something catches its eye but otherwise soaring in leisurely style, with wide-fingered wings forming a shallow V. The harrier, also known as hawk and to the Maori as kahu, typically hunts alone within its home territory, which is about 30ha in extent.

Nervous of humans, the harrier is quickly put to flight. It eats both carrion and live prey. It can catch rabbits but not as effectively as the New Zealand falcon, with which it shares the open rangeland habitat. Courtship occurs in late winter, accompanied by aerial displays and sharp calls that carry a good distance on still days. Nests (June to March) are mostly secreted in wetland vegetation, and the female does all the incubating while the male's job is to bring food. Two chicks usually survive to fledging. The female harrier is larger, reaching a weight of 850g. The male is about a quarter smaller at 650-750g. Plumage is paler in older birds, which can live to about

20 years. The faster-flying falcon, magpie and spur-winged plover are liable to chase harriers that come into their territories.

Rare in New Zealand in the early 1800s, the harrier is now well established across the country because of the clearance of forest and the introduction of prey such as rats, mice, rabbits, hedgehogs and the small passerine birds. The harrier was regarded at one time as a menace to introduced game birds, young lambs and cast sheep and as a result had a price on its head in the 1870s and again in the 1930s and 1940s. Thousands were killed. These days most die on the roads, run over by vehicles while scavenging on the carrion that has helped increase their numbers. Drainage of wetlands has also limited harrier breeding habitats but despite these setbacks the species remains widespread. It is now fully protected.

Above: Australasian harrier chicks at their nest.
Department of Conservation

The Big Dry

Central was hit hard by drought in the summer of 1998-99. New records were set for heat and dryness. At Clyde, the drought topped 1000 (1034) for the first time in New Zealand. Across the region, streams dried up and river levels fell close to all-time low levels. In the dry core of Central, notably the Maniototo, farmers faced their second consecutive dry summer, which forced mass destocking. Some irrigation and rural water supply schemes dried up. The drought also tested the resilience of natural ecosystems and the birds, lizards, insects and aquatic life inhabiting them.

Parched farmland at Ophir in the dry core of Central during the Big Dry of February 1999, looking towards Tiger Hill in the middle distance. *Neville Peat*

Alexandra experienced the hottest summer since records began in 1922. The average daily maximum temperature was 26.5 degrees Celsius for the three months, December to February. This eclipsed the previous record, set in 1955-56, of 26.1 degrees. Thirteen days in January topped 30 degrees. February was also hot. On 8 February the mercury climbed to 37 degrees Celsius, a record for February and just short of the all-time high of 37.2 degrees, recorded in January 1956.

The 1998-99 summer was exceptionally dry as well as hot. For the three summer months, rainfall at Alexandra totalled just 55.7mm, which was close to the low of 50mm in 1975-76. When rain finally came in quantity, on 8 March, 50.4mm was recorded in just twenty-four hours.

At Waipiata in the Maniototo, the Taieri River's flow was measured at nine-tenths of a cubic metre per second, the lowest flow since the introduction of the Maniototo Irrigation and hydro-electric power scheme in 1984.

The fire risk was extreme for much of the summer. On 28 February, grass and shrubland fires of Australian severity burnt 9,500ha of farmland at two locations – to the north of Alexandra and in the Lake Roxburgh-Knobby Range area.

on end that in winter turn the nights frosty; and low rainfall with droughts not uncommon.

The parched nature of the most inland valleys is what is immediately striking. This is caused by the rainshadow effect of the mountains to the west, which intercept moist weather systems approaching from the west and south-west and which wring the bulk of the rain out of them. As the rain pours down in Fiordland and the alpine zone of Mount Aspiring National Park, the land to the east of the mountains is often swept by warm, dry north-west winds – the foehn pheno-menon, called Chinook in North America. Within Central Otago the parallel block mountains heighten the rainshadow effect. In the Maniototo and Manuherikia Valleys, rainfall decreases towards the south. The Manuherikia's annual rainfall gradient is expressed thus: St Bathans 646mm, Lauder 498mm, Alexandra 344mm. In the Maniototo, Naseby receives about 610mm a year, Ranfurly 439mm and Patearoa 385mm. Ranfurly has about 60 rain days a year – half the number Dunedin can expect. Alexandra was exceptionally dry in 1964. For the 12 months to October

Hoarfrost at Butchers Dam near Alexandra. Ice partly covers the lake, interrupting the reflections in this view. It takes several days of freezing foggy conditions to build up frost crystals to the point where they drape vegetation to this extent. *Sue Noble-Adams*

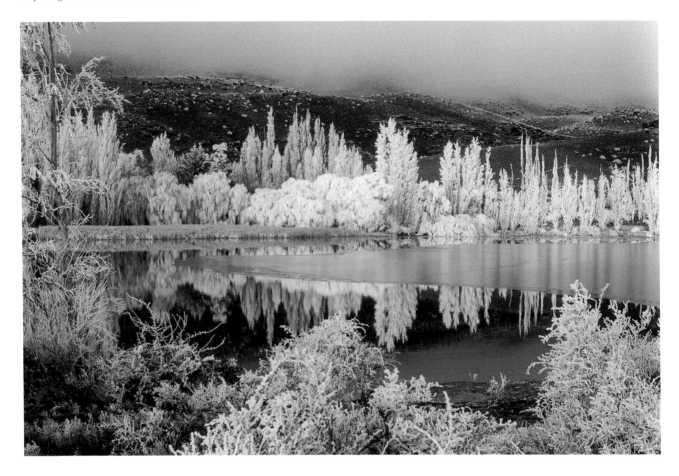

that year, it received only 165mm. A measure of the dryness of an area is obtained by comparing the evaporation rate to rainfall, and at Alexandra evaporation can be more than twice the rainfall. The water deficit can be acute. Some areas have recorded 60 days without rain. To survive in such a dry zone, humans resort to irrigation systems and reservoirs big and small.

Summer sometimes brings sudden downpours, known as 'thunderplumps', following the build-up of clouds through thermal convection. Rainfall can vary considerably between years. Although the western edges of Central Otago are wetter than the interior, the rainfall at, say, Glenorchy (1,130mm annual mean) is still much less than that falling next door in Fiordland (Milford Sound 6,267mm). The wettest months in the semi-arid areas are in late spring and early summer; the driest months are June to August. Snow collects on the ranges in winter and spring, contributing 10 to 30 percent of the flow into rivers. But snow does not usually lie for long on the valley floors. In autumn and winter valley-floor fogs are common, and they may persist all day.

A foggy day after a hoar frost can be punishingly cold.

The township of Ophir, near Omakau in the Manuherikia Valley, is officially New Zealand's coldest place and third driest place in the country. On 3 July 1995 the thermometer dropped to minus 21.6 degrees Celsius following freezing conditions over several days. The Big Chill was widespread that winter, with temperatures remaining below zero for about three weeks and the landscape an iced-up wonderland. Ophir held the previous official low temperature record as well – minus 19.7 degrees, set 52 years earlier on 2 July 1943. Temperature-takers at Moa Creek in the Ida Valley produced a minus 21.6 degrees in July 1991, but the record was unofficial. That July was chronically cold. The Shotover River froze over on 1 July for the first time in the twentieth century, and the mean daily maximum for Alexandra that month was a mere 3.1 degrees. Fog suppressed temperatures for weeks on end.

Consistent with the cold/hot continental pattern, Ophir also happens to be one of the hottest places in New Zealand, having recorded air temperatures over 30 degrees Celsius

Novel native fish: This new species of non-migratory galaxiid has been recorded in Totara Creek, which flows off South Rough Ridge into the Maniototo Valley. It complements an already rich array of freshwater native fish found in Central Otago. *Richard Allibone*

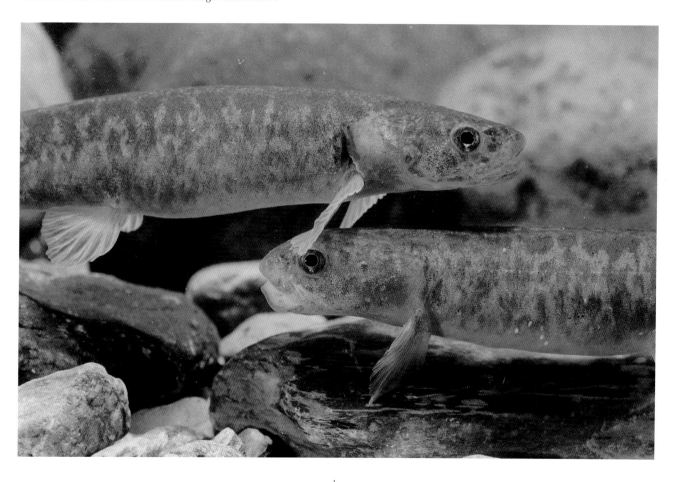

many times at the height of summer. A maximum of 35.2 degrees was recorded in January 1959. Although higher temperatures have been recorded elsewhere, Ophir is still renowned for having the greatest summer-winter temperature range in New Zealand. Alexandra also has a wide daily and seasonal range. Its daily mean temperature in summer is 23.7 degrees but its winter mean is only about four degrees. Central Otago's sunshine hours, in New Zealand terms, are exceeded only by Blenheim's, with Alexandra being the sunniest place in Central (2,081 hours) and Ranfurly not far behind at 2,011 hours.

A Window on the Heavens

Central Otago's low humidity and exceptionally clear skies make it an ideal platform for observing and measuring invisible stirrings in the atmosphere, some of which have a major influence on climate. At Lauder in the Manuherikia Valley, 40km north of Alexandra, atmospheric research is carried out round the clock at a station operated by the National Institute of Water and Atmospheric Research. The

station was established in 1960 to study the Aurora Australis, the Southern Lights, but its role these days is focused mainly on monitoring trace gases, particularly ozone in the stratosphere 10 to 50km above the surface of the earth.

Depletion of the ozone layer is of world significance, and Lauder's work feeds into an international network that reports on ozone levels. To measure ozone and other gases, powerful laser beams are projected skywards from the station and sensed by a large telescope. Other measurements are obtained by the release into the atmosphere of gas-filled balloons mounted with sensing equipment. The ozone layer helps protect the earth from ultra-violet (UVB) radiation, which is harmful to human health and the wellbeing of ecosystems generally. Too much UV will have a major adverse impact on the primary sector – agriculture, forestry and fisheries. Ozone is destroyed by chlorine monoxide, which is released by products containing CFCs, now banned in most countries. Lauder's research is also important for tracking trends in global warming.

2 Schist Showcase

Central Otago was a wild place 200 million years ago. It was centre-stage in the collision of two large geological blocks known as terranes, comprising mainly mudstone and sandstone with a few volcanic patches interspersed.

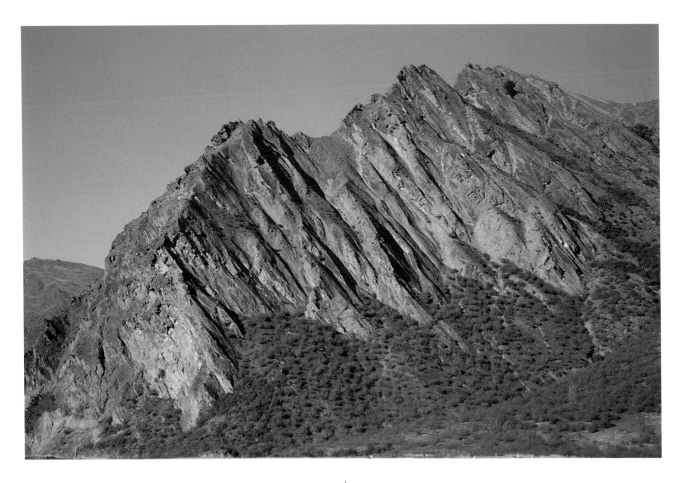

Thrust together by tectonic forces (movement of the vast plates that make up the earth's crust), the rocks in the collision zone were transformed under colossal heat and pressure that reached depths of 15km. Temperatures climbed to 400 degrees Celsius. The upshot of this process, which spanned about 80 million years, was a metamorphic rock called schist. Layered and prone to splitting, it derives its name from a Greek word meaning to split. It is the rock type that underlies most of Otago. Central Otago is a showcase of schist, which is graphically displayed in the exhumed and weathered outcrops called tors.

By 130 million years ago the great clash of the terranes was over. Things were cooling down. As the schist cooled, it was uplifted and during a mountain-building era it was subjected to tilting and folding. In the next phase, which took about 50 million years, the landscape was slowly smoothed down by the forces of erosion. The mountains were whittled away and a gently undulating, low-relief region (peneplain) was created, sloping towards the north-east. Rivers meandered through it, and there were numerous swampy areas. Then came the sea. From about 80 to 20 million years ago, tentative tongues of sea flooded the eastern side of Otago. At times of high sea levels, they reached at least as far inland as Ranfurly and Naseby – an unthinkable proposition today. There were more than 20 advances by the sea (marine transgressions), with the maximum advance occurring between 37 and 24 million years ago. For the most part the seas were shallow over the peneplain. Evidence of the sea's invasion shows up in the form of low-grade limestone deposits in the White Sow Valley and the Swin Burn in the Maniototo and greensand deposits at Naseby. In the west, the sea also made inroads, leaving its mark at Bob's Cove on Lake Wakatipu, where marine fossils appear in limestone.

When the sea was at its maximum advance, very little of the present New Zealand landscape was dry. Central Otago was one of the larger islands in an extensive archipelago. Before these invasions by the sea and between them, rivers left gravel deposits. Swamps also made their mark. As the sea gradually receded, a huge freshwater wetland complex

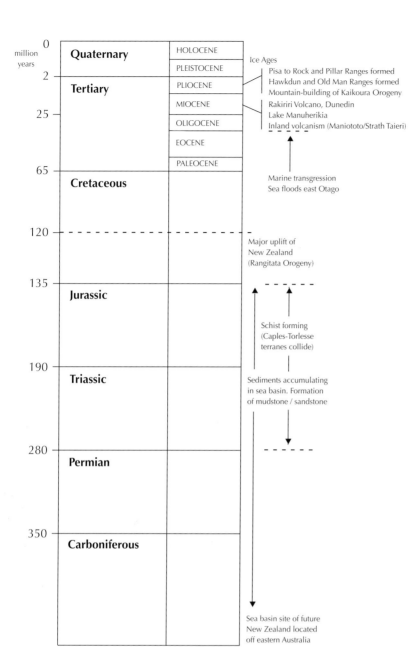

million years				Ice Ages
0	Quaternary	HOLOCENE		
		PLEISTOCENE		
2	Tertiary	PLIOCENE		Pisa to Rock and Pillar Ranges formed
				Hawkdun and Old Man Ranges formed
				Mountain-building of Kaikoura Orogeny
		MIOCENE		Rakiriri Volcano, Dunedin
25		OLIGOCENE		Lake Manuherikia
				Inland volcanism (Maniototo/Strath Taieri)
		EOCENE		
		PALEOCENE		
65	Cretaceous			Marine transgression Sea floods east Otago
120				Major uplift of New Zealand (Rangitata Orogeny)
135	Jurassic			Schist forming (Caples-Torlesse terranes collide)
190	Triassic			Sediments accumulating in sea basin. Formation of mudstone / sandstone
280	Permian			
350	Carboniferous			Sea basin site of future New Zealand located off eastern Australia

Previous page: Slanting schist – a bluff in the Kawarau Gorge, showing the dipping grain of the schist in this area. Bushes of a garden escape, briar (rosehip), dominate the shrubland at the foot of the bluff.

Neville Peat

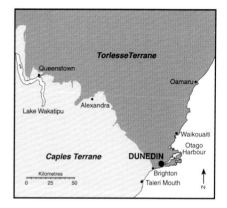

A simplified geological map of Otago schist (after Mortimer 1993) showing the Torlesse terrane in the north and the Caples terrane to the south. Through modern chemical testing, the boundary can be traced with considerable precision. Relatively high levels of iron and magnesium are found on the Caples terrane, whereas the Torlesse terrane is richer in silicon and potassium. The zone bisects Central Otago. Starting near the head of Lake Wakatipu, it swings past Queenstown, shaves Cromwell and Alexandra and continues past the Poolburn and Loganburn Reservoirs to reach the coast near Brighton.

evolved on the peneplain. It has been named Lake Manuherikia (see also page 30).

A prominent feature between 15 and eight million years ago, Lake Manuherikia stretched from Ranfurly in the east to The Remarkables in the west, and from St Bathans (possibly Tarras) in the north to Roxburgh in the south – an area of about 5,600 sq km or a quarter of the region described in this book. At its margins there were peat-rich swamps where coal and shale deposits formed. The coal seams of Roxburgh have long been worked. There is also coal at Home Hills at the foot of the Hawkdun Range, shale at Bannockburn and an oily black ooze on the shores of Blue Lake at St Bathans. Beaches, mud flats and stagnant bays would have occurred along the lake edges, and organically rich sediments poured into the stagnant bays to form the Nevis oil shale. Later, as mountain-building occurred, Lake Manuherikia and its swamps were infilled with gravels and finer sediments carried off the surrounding land by rivers and streams, especially rivers flowing off the greywacke mountains to the north. This infilling, combined with the gradual uplift of the land, eventually eliminated the lake complex from the landscape.

From 13 to 10 million years ago, Dunedin's spectacular hills were created by the Rakiriri volcano, a shield volcano that grew steadily to a height of about 1,000 metres – a great black knuckle on the Otago coastline. Then came another general mountain-building era, the Kaikoura Orogeny. Acting on a series of fault lines, it transformed the old peneplain into a network of ranges. The Hawkdun and Ida Ranges in the north and the Old Man Range in the south are about five million years old. The system of parallel ranges through the centre of the region, from Pisa in the west to Rock and Pillar in the east, are younger, around three million years old. Essentially, they are fault-controlled ripples of the mountain-building going on along the Alpine Fault, which has created the Southern Alps over the past five million years.

The range-and-basin system is a unique feature of the topography of Central Otago. Most of the ranges have eastern faces that rise steepishly from fault lines, whereas

A long way from salt water these days, the Bob's Cove area on Lake Wakatipu exposes a variety of marine fossils, including shellfish. The fossil-rich rocks here were deposited in shallow seas about 25 million years ago, when a narrow inlet of ocean pushed into the region.
Neville Peat

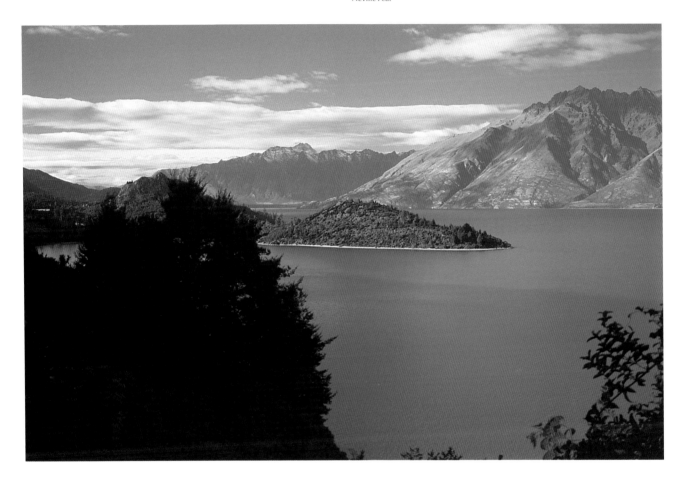

on their western sides the land slopes gradually down to the next basin, often 'fretted' by stream erosion. In some eastern upland areas, however, the surface of the ancient peneplain is still recognisable.

Everywhere, schist shows out. Greyschist – metamorphosed mudstone and sandstone – predominates. It has a high quartz content. Greenschist, which is derived from metamorphosed volcanic rocks (old sea-floor lava flows), occurs mainly in thin bands. It contains the green mineral chlorite.

In the south the schist boundary is well defined by the Livingstone Fault and a belt of volcanic and igneous (ultramafic) rocks. In the north, the schist grades unevenly into greywacke, a hardened sedimentary rock related to schist but more resistant (greywacke, derived from mudstone and sandstone, has been formed under pressure but without the heat that made schist). In the west, the schist country spreads through much of Mount Aspiring National Park and a thin band extends north along the Southern Alps. Dividing the folded range-and-basin topography at the region's core

from the dissected, steep and spiky country to the west is the Nevis-Cardrona fault system.

What is happening in the Central Otago landscape today? The core ranges are still rising but only very slowly – at a rate of about 1mm a year. The valleys are also going up, at about 0.5mm a year. Meanwhile, the streams and rivers continue to cut down through this rising landscape.

Tors – Monuments to a buried past

Conspicuous across much of the Central Otago landscape are the schist rock outcrops known as tors. The term – derived from the Gaelic 'torr', meaning a bulging hill – is normally reserved for tall and monumental outcrops, the most spectacular of which are found on the summit crests of the block mountain. The best examples decorate the Dunstan Mountains and the Old Man, Pisa and Rock and Pillar Ranges. Tors can also occur at relatively low altitudes, though. Extensive tor fields are encountered around Alexandra, in the southern Maniototo Valley and at Sutton in the Strath Taieri.

Bones of the Earth: schist tors and boulderfields on the summit crest of
the North Dunstan Mountains. *Neville Peat*

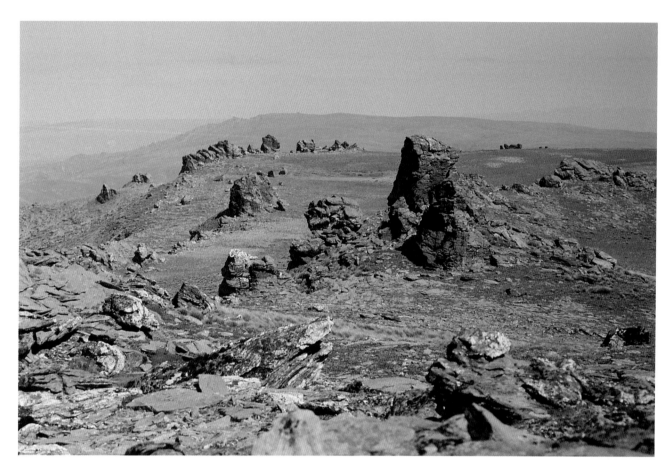

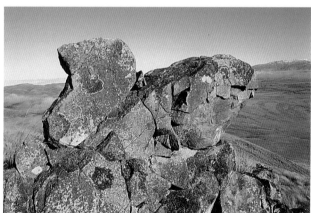

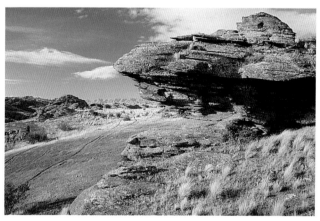

A curiously shaped lichen-encrusted rock outcrop on the lower slopes
of the Hawkdun Range. Schist outcrops often display smooth vertical
faces. *Neville Peat*

Overhanging schist in the Upper Maniototo. Outcrops are often
eroded around the base. *Neville Peat*

Tor-studded landscape in the Ida Valley: stream-carved western slopes of North Rough Ridge. *Neville Peat*

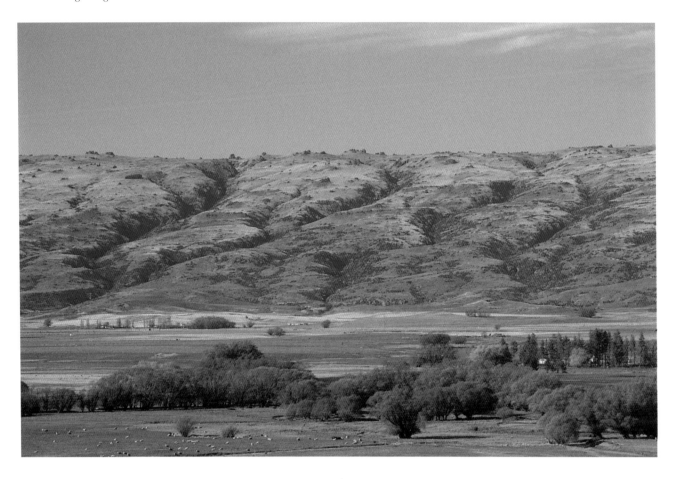

Tors come in different forms – as pillars or rectangular blocks with steep smooth faces, as angular or cavernous rocks that project animal and other images, and as pancake-layered formations. They give the landscape an aged appearance, and because of their aesthetic qualities they will forever inspire poetic writing and painting.

But how did they develop? Geologists and geomorphologists have long pondered this question. Theories tend to focus on their creation from parent schist underground through chemical weathering that acted on the softest parts of the rock over millions of years. Schist containing quartz bands would have been largely resistant to the erosive impact of the salts and other chemicals. Vertical jointing in the rock helped separate out the tors, which were eventually exhumed by erosion processes. Exposed to the air, the tors have been further attacked by climatic factors (freeze-thaw cycles and strong winds) but these factors were not as significant in the formation of the tors as the erosive impact of salts and other chemicals underground. In some areas, there are tors still buried that await their turn in the sun, whereas in the Styx Basin (southern Maniototo) river sediments are reburying some outcrops.

Undercutting near ground level is a distinctive feature of many outcrops, to the advantage of sheep seeking shade or shelter, and the gold-diggers of yesteryear who sometimes made rock shelters from the overhangs. This undercutting may be caused by several factors, including wind-scour and frost action arising from extra moisture near ground level.

Gold!

The collision of the terranes that created the schist also created the gold veins for which Central Otago is renowned. In temperatures over 200 degrees Celsius, gold becomes soluble and readily moves around through fractures in the rock. It settles into veins of quartz (silicon dioxide), from which it may be released by weathering or erosion.

Thus gold occurs in two settings, either as grains or nuggets in river gravels (alluvial gold) or encased in quartz seams in the schist (reef or hard-rock gold). By far the bulk

Quartz veins folded into schist, Roaring Meg Valley (Pisa Range). *Neville Peat*

Motherlode: a 3mm-long piece of gold embedded in quartz. *Dave Craw/Otago University Geology Department*

Schist patterns, Dunstan Mountains. *Neville Peat*

A curious feature of schist outcrops is the appearance of round or elliptical holes, called pit holes, up to about 1m in diameter, on flat surfaces. The holes are chemically created, and sometimes they are filled with wind-blown pebbles. *Neville Peat*

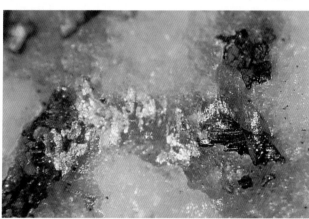

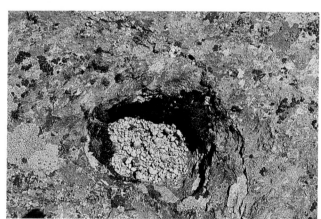

of the gold won in Otago has come from alluvial sources thanks to 100 million years of wear and tear on the landscape. Being 19 times denser than water, the gold grains (at least those over 1mm diameter) tend to sink after their release during the process of erosion and they accumulate at the bottom of streams and rivers. Some gold-bearing gravels have been found high up in the mountains as a result of the uplift of the ranges over the past few million years. The Mt Buster diggings at about 1,200m in the Ida Range are an example (see page 115).

The quartz gold is contained in sulphide minerals. When the sulphides are exposed to air they oxidise (rust), providing miners with a colourful clue to the presence of quartz reefs. Also found in quartz is fool's gold or pyrite, a sulphide mineral pale yellow in colour. Harder than steel, it is formed of cube-like crystals with shiny flat faces. Gold, on the other hand, is yellow-orange, generally irregular in shape and so soft it can be cut with a knife. Mica, incorporating aluminium silicate, adds glitter to the quartz-rich schist with its small shiny scales.

In addition to being a source of gold, quartz also contains scheelite, which was extracted as a source of tungsten. The Glenorchy scheelite mining industry, centred on the Buckler Burn, started in the 1890s and fluctuated (as the world price for tungsten rose and fell) till the 1970s. Tungsten, used in the steel industry, was especially important at times of war. Scheelite ore was mined underground and crushed in stamper batteries similar to those used in hard-rock gold mining.

Soil Patterns

Central Otago's orchards are found mainly on semi-arid soils (formerly known as brown-grey earths). This soil type has developed in the drier areas (annual rainfall below 450mm) and is commonly a fertile sandy loam suitable for stonefuit crops. Semi-arid soils occur in the Upper Clutha Valley, lower Manuherikia, Roxburgh-Coal Creek area, southern Ida Valley and Maniototo.

Soil types are strongly influenced by rainfall and altitude. Pallic soils (yellow-grey earths) are found in areas where

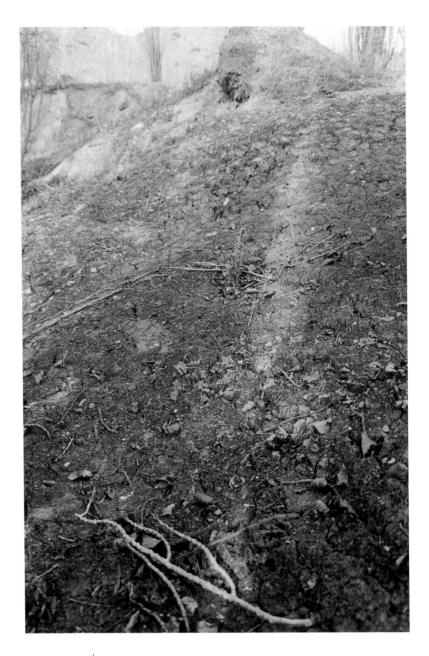

The multi-coloured soils (red, orange, yellow and dazzling white) on the shores of Butchers Dam near Alexandra are ancient paleosols, formed 20 to 25 million years ago when the climate was subtropical. They remained buried under sedimentary layers until gold miners arrived and exposed the soils through sluicing operations. The colour of the soils is caused by chemical weathering and the extent to which they have developed below the surface. Red soils, reflecting the presence of iron-rich haematite, were formed at the top of the sequence, with orange and yellow next. The white soils were buried the deepest. The paleosols are now protected within the Flat Top Hill Conservation Area. *John Douglas*

annual rainfall is between 450 and 900mm – for example, the northern parts of the Maniototo, Manuherikia and Ida Valleys. Pallic soils, generally derived from loess (wind-blown silt, deposited over eons), are more weathered and leached than semi-arid soils.

Brown soils (yellow-brown earths), which are low in fertility, form steepland soils – the mainstay of Otago's fine-wool industry. Recent soils, formed from alluvium deposited by floods (silt, sand and gravels), occur on floodplains and the lowest river terraces.

Salty soils are a hallmark of Central Otago. Once a dominant landscape feature of valley floors and low terraces, salty soils have either been reduced to vestigial patches by land development or eliminated altogether (see page 52). Only a few plants are specialised to grow in a salty situation. Saltpans sometimes develop from salt-rich water tables or areas of poor drainage where salts have accumulated through run-off from the surrounding landscape. Salts may also percolate up from deeply weathered schist. As a rule, soil acidity increases with altitude.

Ice Ages

Glacial ice had a major impact on the landforms in western areas of the region. Glaciers hundreds of metres thick carved the trenches in which the big lakes lie. At their peak, these great rivers of ice extended beyond the present lakebeds. The Wanaka Glacier, originating high up in the Makarora area and fed by ice from the Matukituki Valley and Hawea, pushed almost as far as Cromwell. The Wakatipu Glacier was 130km long at its peak. Queenstown once had 900m of ice riding over the top of it. The gouging impact of both these glaciers is evident in the depth of the lakes they left behind. Both lakes reach depths below present-day sea level.

The ice ages began about two million years ago when the earth entered a colder period. Ice advances or glaciations alternated with warm periods, and each glaciation left its own marks on the land in the form of deepened lake beds, mountain cirques, hanging valleys, ice-smoothed valley walls and low hills, and heaped-up rock debris (moraines). The most recent glaciation peaked 18 to 20,000 years ago, when temperatures in southern New Zealand were on average

Sarsen Stones

Sarsen stones lie scattered about upland pasture in the Roxburgh District. Widely and sporadically distributed through core areas of Central Otago, these boulders are strikingly different from the schist outcrops that often surround them. Made of silica-bonded quartzitic sandstone, they are considerably harder than the schist, and on paddocks that can be ploughed are usually removed or gathered into piles. Sarsen stones were formed underground from silica-cemented quartz gravels during the formation of the schist. They were nicknamed 'chinamen' last century, presumably for their pale colours. The largest boulders are 3m high and about as wide. They are especially large and distinctive near Shepherds Creeks on the western side of North Rough Ridge. The world's most famous sarsen stones are the sandstone blocks of Stonehenge in England. *Brian Patrick*

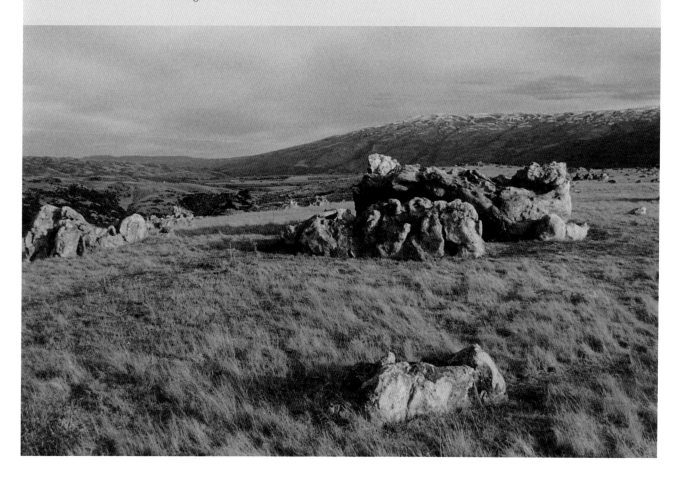

about 6 degrees Celsius cooler than at present. By 12,000 years ago, rapid warming had begun.

Few people would associate ice sheets and glaciers with the rounded block mountains of Central Otago, but recent studies suggest that an ice sheet about 30km by 20km developed on the summit of the Old Man and Old Woman Ranges during ice advances in the last few hundred thousand years. Valley glaciers spilled off the ice sheet. The most recent glaciation produced only small valley glaciers. One such glacier in the Fraser Valley left recognisable moraine deposits.

Numerous periglacial features remain on the Old Man and other ranges that experience long periods of freezing temperatures – features such as soil stripes (lines of crests and hollows created by differential freezing), hummock-fields and solifluction lobes where the soil has become viscous and developed bulges – features that are still active. Freeze-thaw cycles have produced some strange effects. Small slabs and fragments of schist on some range summits have been sorted into 'stone drains' and 'stone polygons' by the freeze-thaw phenomenon.

Pre-Human Plant Life

However permanent the tussock-mantled landscape of Central Otago may seem, the fact is there have been radical changes in the plant and animal life of the region in the past. Central was much greener 2,000 years ago. Extensive tracts of forest, dominated by matai, totara and other large podocarp trees and in the wetter western areas by silver beech, surrounded open valley floors, where cold air drainage precluded the establishment of forest. There were wet and dry areas on the valley floors. Dry systems contained abundant grasses, sedges and small-leaved shrubs of *Pimelea* and *Olearia*, with almost-bare salty areas supporting salt-tolerant ground-hugging herbs and grasses. The vegetation increased in height as the soil grew less salty away from the saltpans. In wetter areas, peat bogs featured flax, *Sphagnum* moss, *Gleichenia* fern and rushes.

Studies based on fossil pollen analysis show that forest and shrubland occupied many mid-altitude areas now dominated by tall tussock. Matai, totara, rimu and, surprisingly, kahikatea were widely distributed through the tall montane forest. Hall's

Before it was created in the 1980s the Loganburn Reservoir was a vast wetland known as the Great Moss Swamp. Tussock grassland has been dominant in the area for centuries, although before fire and climate change induced the tussock the area could well have supported shrubland communities and even patches of forest in the wetter gullies. *Neville Peat*

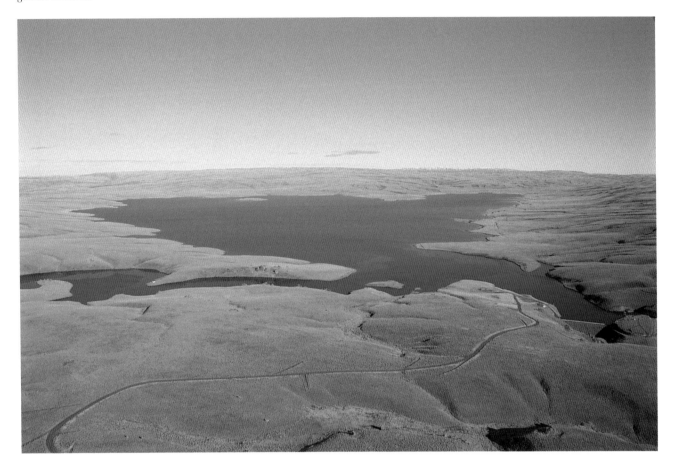

totara *Podocarpus hallii* grew as high up the mountains as any of the podocarps, reaching 1,000m above sea level in places. At these higher altitudes it was often associated with mountain toatoa (celery pine) *Phyllocladus alpinus* and bog pine *Halocarpus bidwillii*. 'Bog pine' is an unfortunate name for this hardy small podocarp tree as it will grow in relatively dry sites as well as in damp places.

The toatoa-totara-bog pine association was common in the mountains of Central Otago between 600m and 1,000m. Shrublands were dominated by prickly matagouri *Discaria toumatou* and small-leaved shrubs of *Coprosma* and *Olearia*, with much of the vegetation draped by *Muehlenbeckia*. Kanuka, kowhai and mapou *Myrsine australis* were also common in shrubland. On mountain slopes in the region today you may stumble upon a preserved totara log – a relict of old forest.

Pre-human vegetation patterns on the Old Man Range give an idea of how things looked generally across Central. At about 500m on the northern (dry) side of the range, patches of podocarp forest, dominated by matai and totara,

survived in the gullies, with shrublands of toatoa, kowhai, Coprosma and Muehlenbeckia occupying the ridges and drier sites. It was a good environment for moa (see Earnscleugh Cave, page 29). On the other side of the Old Man Range, in the Pomahaka headwaters at 875m, toatoa and bog pine were dominant, mixed with *Coprosma*, *Muehlenbeckia* and *Myrsine*. At Potters, a little further north but higher on the range at 1,200m, silver and mountain beech grew patchily, interspersed with subalpine species such as grass tree *Dracophyllum longifolium* and low round shrubs of *Leonohebe odora*.

But by 2,000 years ago things were beginning to change. A warming climate spawned summer droughts. Periodically there were fires from natural causes, fanned by dry north-west foehn winds. There were appreciably more fires below an altitude of about 600m than above it. Some of the forest was lost, and tussock grasses rushed to fill the gaps. The first Polynesians to occupy this region – the moa-hunters – also brought fire with them. Although some of the fires were probably accidental – camp fires escaping in high winds,

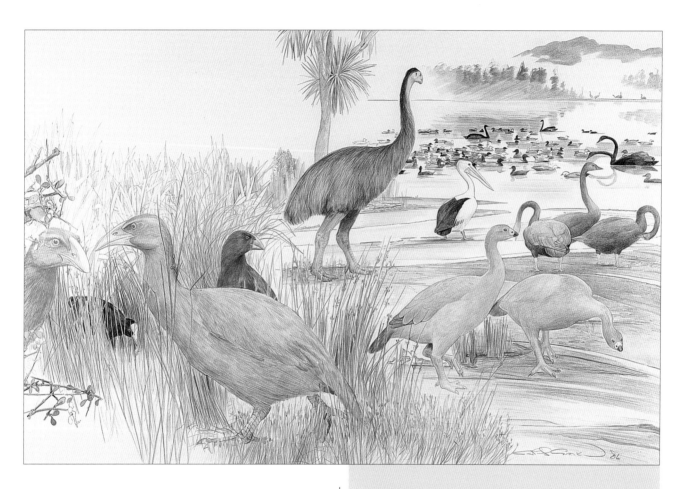

for example – the moa-hunters no doubt used fire as a tool with which to clear routes through tangly shrubland and to flush game birds such as moa from the bush. The analysis of charcoal samples across the region suggest there was a spate of burning 700 to 750 years ago. By the time Europeans arrived, more than half the pre-Polynesian forest had gone.

The Lost Fauna

Tuatara, mini-dinosaurs, once scratched out a living in the hills around Alexandra. Kiwis and bats lived here, too, when forest covered the lower slopes of the Old Man Range. Their bones, preserved by a dry climate in caves and crevices, tell a story of animal life in Central Otago that is almost beyond imagining.

Before humans arrived there were moa everywhere, several different kinds – moa of the deep forest and forest margins, shrubland moa and grassland or open country moa. Wingless, they browsed the vegetation like deer and goats, consuming seeds, leaves, twigs and fruit. Seven species inhabited the Manuherikia Valley. Most avoided competition

Flashback

A lake shore scene from some 3,000 years ago, teeming with land birds and waterfowl, most of them now extinct. In the centre, surveying the lake life, is the largest moa of all, *Dinoris giganteus*, which weighed up to 250kg and stood almost 3m tall. At left are a pair of South Island adzebills *Aptornis defossor*, rail-like flightless birds weighing about 12kg and standing 80cm tall. Between them is a flightless New Zealand coot *Fulica prisca*, which has also become extinct, and nearby the orange-beaked takahe, subfossil remains of which have been found in Central. On the shore are three extinct species – the heavily-built flightless South Island goose *Cnemiornis calcitrans*, which weighed as much as 15kg, giant swan *Cygnus sumnerensis* and New Zealand pelican *Pelecanus novaezelandiae*. The New Zealand swan was probably a more robust version of the black swan from Australia found in New Zealand today. The New Zealand pelican was larger than the Australian pelican. On the water are various members of the duck family, including the familiar paradise shelduck.

Chris Gaskin

Moa-hunters prepare to cook newly caught moa at their summer camp in the Cairnmuir Mountains behind the Cromwell Gorge 500-600 years ago. The site is on the banks of the Hawks Burn, 660 metres above sea level. More than 400 moa were butchered and cooked here, according to the archaeological evidence. The species most often caught were the stoutly-built *Euryapteryx geranoides* and *Pachyornis elephantopus*, and the smaller eastern moa *Emeus crassus*.

They were probably hunted with dogs and killed with clubs or spears. By the end of the sixteenth century moa hunting on a regular basis had ceased. Beech forest grew in these mountains 500 years ago (the bones of forest birds show up in the middens) but fires started by Maori or naturally have eradicated the forest.

Chris Gaskin/Department of Conservation

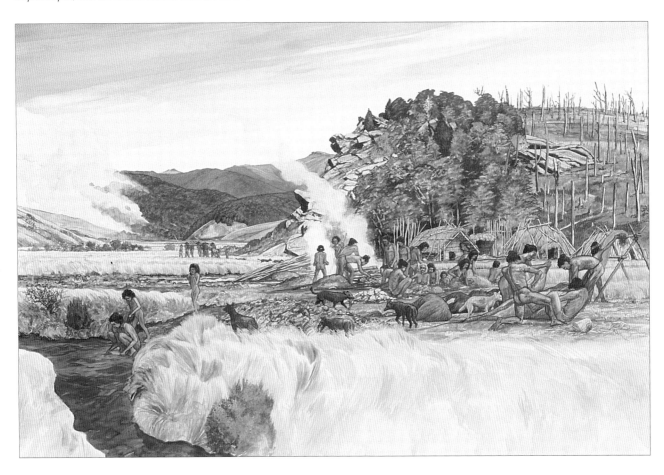

for food by exploiting different environments. The stout-legged moa *Euryapteryx geranoides* was one of the most common species, inhabiting high country shrubland and open forest. It was hunted extensively by early Maori. Weighing up to about 140kg, it was about 1m tall measured at the top of its back.

Another moa species common in Central Otago was the small upland moa *Megalapteryx didinus* (15 to 35kg, and up to about 1.3m tall with head erect). It preferred fairly open montane forest and subalpine habitats – herbfields and tussock grasslands. The upland moa had unusually long toes, possibly an adaptation for walking in snow. Another fairly common species – and a southern one, like *M. didinus* – was the eastern moa *Emeus crassus*. It inhabited drier dry shrubland and low forest.

The largest species of all was found in Central Otago – the giant moa *Dinornis giganteus*, the world's tallest known bird. Upright, it probably touched 3m. It weighed up to 250kg. Its eggs, almost 4kg each, had a capacity equivalent to about 60 hen's eggs. Bones of the giant moa have been

found in the Alexandra-Roxburgh area, the Maniototo, Upper Clutha and Wanaka. In 1864, a *Dinornis* skeleton was found at Tiger Hill near Alexandra with some skin still adhering to pelvis and toes (it is on display at the Otago Museum).

Many moa were trapped in swamps. At Paerau and Hamilton in the Maniototo, moa bones were recovered by the tonne in the nineteenth century. The bones of some moa have been preserved in caves or dry crevices into which they fell (pitfalls) and were trapped. Huge numbers were killed by Maori for food, and this hunting pressure, together with the burning of habitat, hastened the extinction of these incredible birds.

Several other bird species now extinct were characteristic of Central Otago for thousands of years, among them the South Island goose *Cnemiornis calcitrans*, heavy (up to 15kg) and flightless, and a heavily-built and weakly-flighted duck, Finsch's duck *Euryanas finschi*, whose bones show up in Maori middens. New Zealand quail *Coturnix novaezelandiae*, smaller than the introduced California quail, was common in open

This head of the upland moa *Megalapteryx didinus* was found with an almost complete skeleton in a cave near Cromwell over 100 years ago. The mummified head and upper neck are covered by skin and dried flesh. No feathers have survived, however. The remains could be hundreds of years old if not thousands.
Museum of New Zealand Te Papa Tongarewa (neg. B.7104)

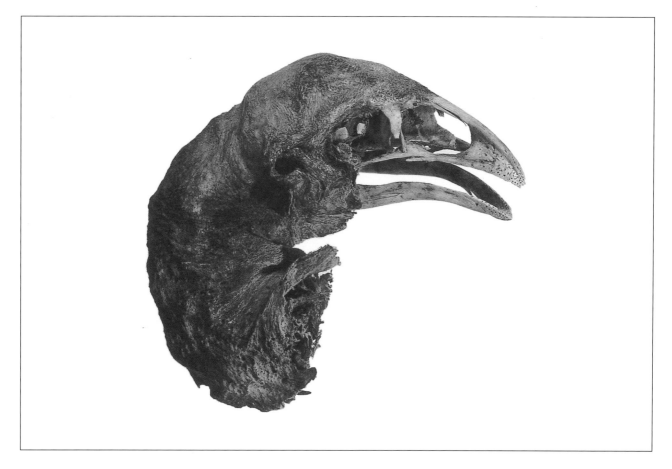

country. Kiwi – a large species and the little spotted kiwi – were widely distributed in the forests of Central. Other fairly common forest species were New Zealand pigeon, South Island robin, South Island saddleback, South Island kokako and laughing owl. New Zealand pipit was abundant in open rangeland areas. Of all these species, only the pipit has survived in the dry interior of Central.

One of the most spectacular birds of all, Haast's eagle *Harpagornis moorei*, turned up in fossil remains at Alexandra and Wanaka. It was the world's largest bird of prey. The female had a wingspan of almost 3m and weighed 10 to 13 kg. Males were smaller (up to 10kg). These eagles probably hunted moa, although their weight would have been a disadvantage. It is suggested they attacked prey by swooping down on them from perches. The eagle may have survived till 500 years ago.

Non-bird fauna showing up in the fossil record are tuatara, several lizard species including a large skink that is probably the Otago skink, and two bats – the greater and lesser short-tailed bats.

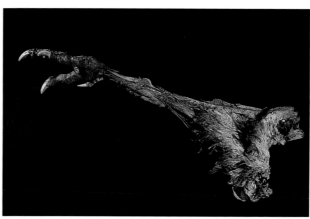

A leg of the upland moa *M. didinus*, complete with feathers on the upper parts and parched skin. Found at the head of the Waikaia Valley in 1895, it is on display at the Otago Museum, where it is described as the most complete moa leg ever collected. *Rod Morris/Otago Museum*

The return of large ratites: A female ostrich stoops to feed on a farm at Cardrona. Ostrich farming is becoming more conspicuous in Central, the New Zealand region that most closely resembles the bird's African haunts. Long-necked moa are thought to have had a stooped rather than erect posture. *Neville Peat*

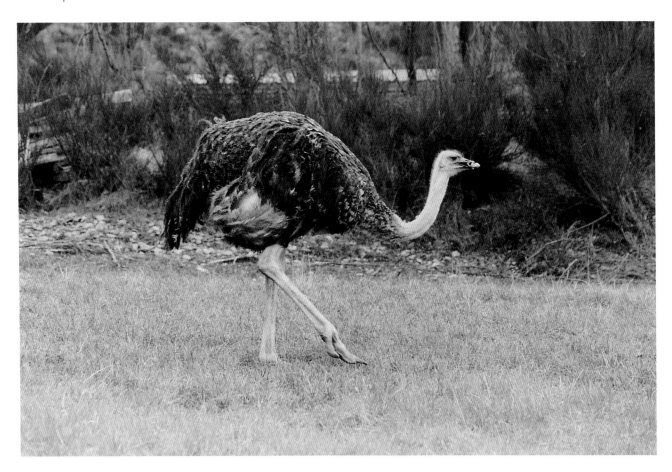

Earnscleugh Cave

On the lower slopes of the Old Man Range overlooking Alexandra is a small multi-level cave system known as the Earnscleugh Cave. Despite its narrow entrance and confined passageways (it is formed between two large blocks of schist), the cave has collected over time, mainly through pitfall entrapment, an extraordinary range of Central Otago's ancient animal life. Fossil pollen collected from the site, 540m above sea level, indicates the cave was once surrounded by podocarp forest dominated by matai. Today the countryside around the cave is grassland, with shrubs occurring in patches.

Eighteen species of fauna have been identified in the fossil remains collected or excavated from the cave, including New Zealand goose, Finsch's duck, three moa species, New Zealand quail, tuatara and the greater short-tailed bat. Of tantalising interest was the discovery in the 1870s of the lower jawbone and rib or cloacal bones of what was thought to be an astonishingly large lizard. Links have been made between these bones and a 'New Zealand gecko' (*Hoplodactylus delcourti*) held by the Marseilles Natural History Museum in France. At 62cm long, this unique gecko is the largest the world has seen but doubt remains as to its New Zealand origin because the Earnscleugh Cave jawbone has disappeared and no certain comparisons can be made between the rib bone and the Marseilles specimen.

Extant bird species recorded at Earnscleugh Cave but no longer surviving here include kea, robin, kiwi (large and little spotted) and New Zealand's smallest bird, the rifleman. An insect specimen collected at Earnscleugh Cave, however, has greatly excited entomologists. It is a portion of a speargrass weevil *Lyperobius cupiendus*, which is today still found on the Old Man Range but at altitudes 700m higher on the range.

Blue Lake, St Bathans, close to the northwest limit of Lake Manuherikia. *Neville Peat*

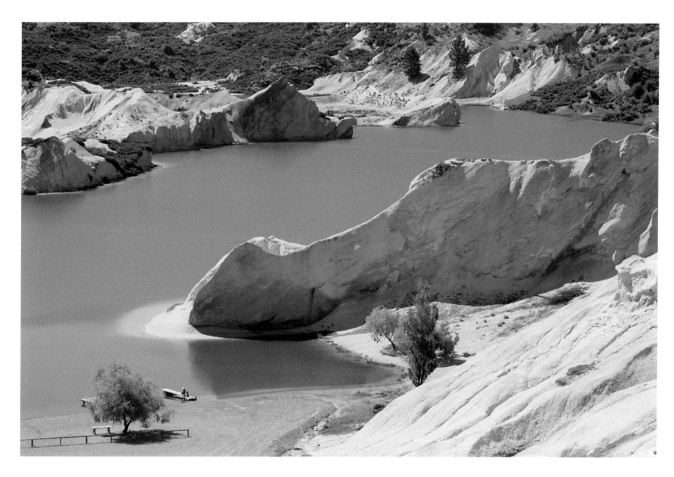

Lake Manuherikia – Crocodile Country

A wetland complex bigger than anything that exists now, Lake Manuherikia was a conspicuous feature in the Central Otago region 15 million years ago, when Otago was a relatively flat place and the climate was warmer than it is today, more like that of Queensland.

Research suggests that the 5,600 sq km complex was not so much one huge expanse of water but rather a series of freshwater lakes of varying size, some of them deep, with swamps and backwaters connecting them – a sort of everglades environment. Low hills protruded in places. There were significant salty areas, the precursors of Central's saltpans. Levees and lake margins were well vegetated with *Casuarina* species, trees and shrubs with long, drooping leaves, from the Palmae, Liliaceae and Myrtaceae families. At the shorelines were chenopods (herbs related to the introduced fat-hen that often grow in saline conditions), sedges and the rush-like restiads.

Fossil deposits around the lake edges have left sketchy evidence of life in this Miocene wetland. At Bannockburn, fossil Eucalyptus leaves conjure up an image of subtropical Australia, an image reinforced by the discovery in 1989 of a bone from a freshwater crocodile. The fragment of jawbone was found protruding from a low cliff near St Bathans, which is close to the northwest limit of Lake Manuherikia. The bone fragment, just 70mm long and 23mm deep, came from sediments estimated to be 15 million years old – the first undisputed record of crocodiles occurring in New Zealand.

3 Clutha Connections

Of all the contrasts and incongruities in the New Zealand landscape, perhaps the most graphic is to be found in Central Otago, where the country's largest river flows deeply and powerfully through the driest landscape, a river older than the hills – the Clutha.

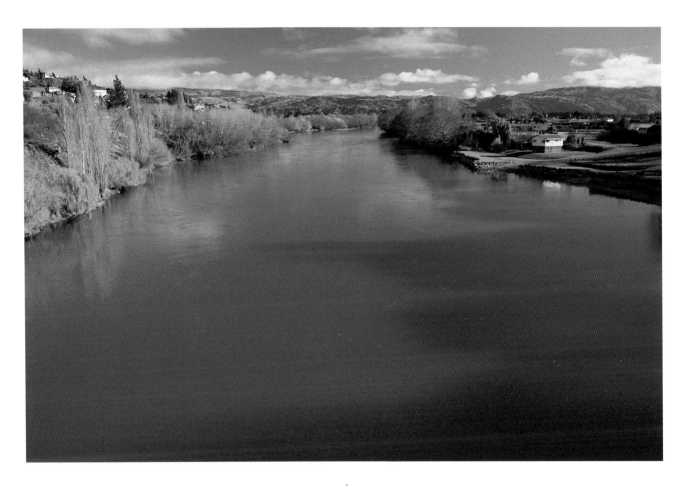

Like something out of Colorado, the Clutha glides nonchalantly past Alexandra and on into the arid Roxburgh Gorge. Clearly, a river this size is not nourished by these hills. The source of its power lies away to the west, in the drenched catchments of the Southern Alps and the ranges immediately east of them.

The Clutha's catchment area, 20,582 sq km (20.5 million ha), is by far the largest in New Zealand. The Southern Alps form its western boundary, which stretches from just north of Mt Brewster near the Haast Pass all the way down to Lake McKellar at the head of the Greenstone Valley on the edge of Fiordland, a distance of about 150km. Four western subcatchments – Wakatipu, Shotover, Wanaka and Hawea – contribute 75 percent of the Clutha's average flow (measured at Balclutha). The elevation of these four catchments is the critical factor. Rainfall increases with height above sea level, reaching a maximum west of the main divide at about the 1,400m contour line (three-quarters of the land in the four main Clutha subcatchments lies above an altitude of 750m). Although the rainfall is heavier in the

west, many alpine areas east of the main divide probably receive annual rainfall in excess of 5,000mm – five metres a year. Compare that figure with the 330mm average for the Alexandra area.

Snowmelt adds substantially to the flows. In the lake catchments the maximum flows from snowmelt usually occur in November-December, whereas the thaw occurs earlier in tributary catchments such as the Lindis, Manuherikia and Fraser, usually in September-October. The permanent snowline in the Clutha's alpine catchments is at an altitude of about 2,400m. Rainfall reaches a maximum in summer.

Most people would say the Clutha River crosses the province from west to east. In fact, the main stem flows more or less north to south due to the north-east/south-west axis of the South Island. Lake Wanaka is the source of the Clutha River, a full-throated river from the outset. Flows measured at the lake outlet (4km north of the town centre of Wanaka) contribute about 37 percent of the mean flows at Balclutha. The Wakatipu subcatchment is the next largest at 30 percent and Hawea (before the control structure was built) accounts

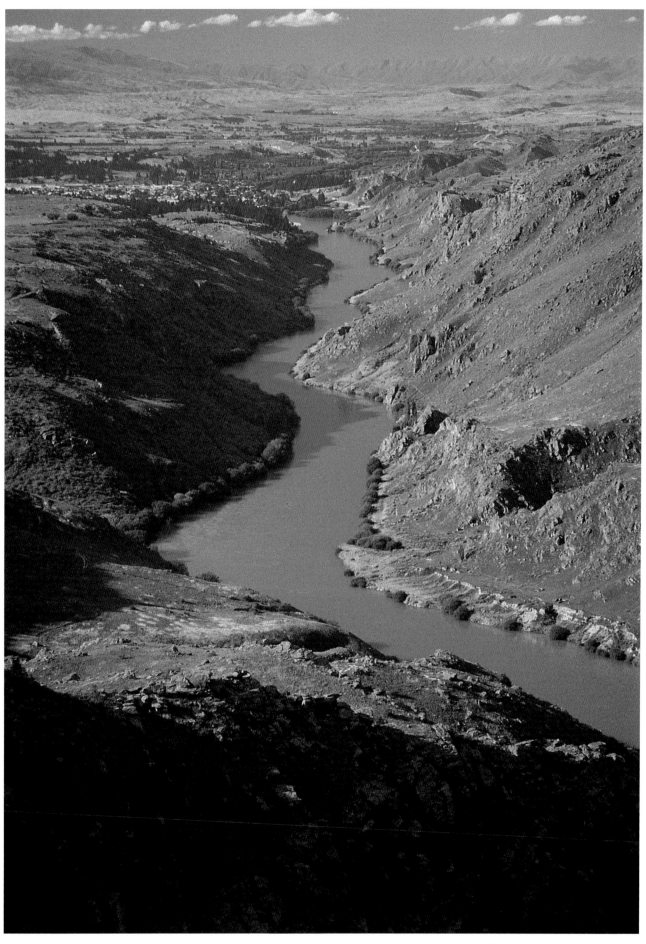

Previous page: A broad reflective reach of the Clutha River at Alexandra. *Neville Peat*

Above: Clutha River from Flat Top Hill, with Alexandra centre left and the Hawkdun Range in the distance. *Neville Peat*

The Floods

On 14 December 1995, the Clutha River flooded low-lying edges of Alexandra. It was the biggest flood ever recorded at the town (measured at the bridge over the river). Levels reached 141.91m above sea level or 7m above normal. This compares with the legendary Big Flood of 1878, which peaked at 140.28m. The riverbank by the bridge is 135m above sea level. At the time of the record flood, flows into Lake Roxburgh were measured at 3,350 cubic metres per second.

Islands dot the upper reaches of Lake Dunstan, a paradise for aquatic birds. *Neville Peat*

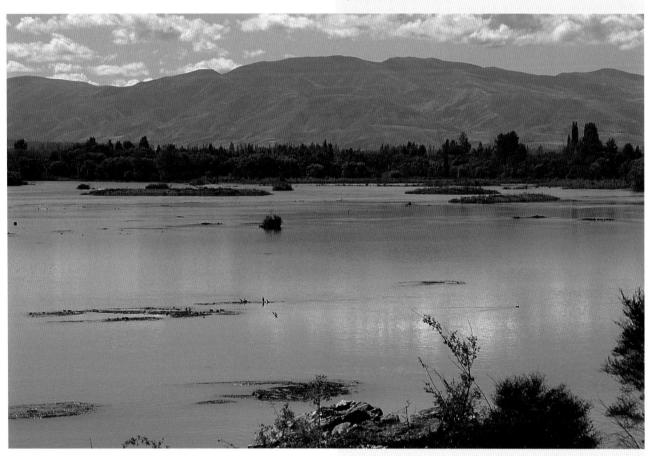

for 12 percent, making a total of 79 percent from the alpine areas serving the three lake catchments. Wanaka's main tributaries are the Makarora and Matukituki Rivers. Wakatipu has the Dart, Rees, Greenstone/Caples and Von Rivers feeding the bulk of its water, which is carried on by the Kawarau River to meet the Clutha at Cromwell. Five kilometres from the lake outlet, the Kawarau collects water from the Shotover catchment. Strangely, in flood events, sediment-rich Shotover water can end up in the lake by turning back the Kawarau's flow. Hawea's main tributary is the Hunter River. On the main stem of the Clutha the most significant tributaries, listed north to south, are the Hawea, Lindis, Kawarau, Manuherikia, Teviot and Pomahaka Rivers. The shortest main-stem tributary is the Hawea at 14km and the longest, at 169km, is the Pomahaka, which starts on the southern side of the Old Man Range, cuts through the Umbrella Mountains and swings south of the Blue Mountains to meet the Clutha below Clydevale.

All these rivers have cut down through a rising landscape, creating deep gorges in some cases. The incising impact of

The Dams

In its middle reaches the Clutha River has been radically modified by the construction of two hydro-electric schemes. The Roxburgh power station was commissioned in 1956. Its dam created the Roxburgh Reservoir, which lies largely unseen from the main highway in the Roxburgh Gorge. The dam backs up water almost as far as Alexandra. A second and larger scheme, the Clyde power station, involved damming the river at the lower end of the Cromwell (Dunstan) Gorge. Work started on the 432mw scheme in 1977. It was completed in 1989 but not commissioned until the hillsides in the gorge had been stabilised through a network of drainage tunnels. Lake Dunstan is the Clyde power station's reservoir. It flooded much of the productive land in the Cromwell Gorge, extending to Bendigo on the main stem and Bannockburn on the Kawarau River.

Desert broom *Carmichaelia petriei* is an archetypical Central plant, a survivor of not just the climatic extremes but also of centuries of landscape modification. Although leafless, it supports weevils on its seedpods and at least five moth species. *Neville Peat*

Scottish Name

In honour of Otago's Scottish heritage, the Clutha was named after one of Scotland's mightiest rivers, the Clyde, whose Gaelic name is Clutha. The Maori name for the Clutha is Matau-au, which refers to the current, formidable in places for anyone attempting a crossing.

Although it is New Zealand's largest river, the Clutha is second to the Waikato River for length. New Zealand's third-longest river, the Taieri at 318km, drains the north-eastern corner of Central Otago. Although relatively long, it carries much less water than the Clutha because its headwaters and inland tributaries are located in the dry interior.

The Clutha's Vital Statistics

Length of river, 338km
Average volume (at Balclutha), 563 cubic metres per second
Catchment size, 20,582 sq km

the Clutha River is best demonstrated at Alexandra, so far from the sea and yet only 135m above sea level (Dunedin's Northern Motorway at the Leith Saddle is more than twice this altitude). The towns of Alexandra, Cromwell and Roxburgh are built on terraces created by the river over thousands of years. Higher terraces mark old river levels.

This chapter is an exploratory journey through the natural features of the Clutha River, starting in the Upper Clutha Valley and working downstream to the Rongahere Gorge, where Central Otago meets the intensely green Lower Clutha Valley.

Quail Country

There have always been quails in Central Otago. Till the 1860s, the native quail or koreke *Coturnix novaezelandiae* was found across much of the region. Hunted extensively by Maori and early Europeans settlers and miners, the species abruptly declined after 1865. It was a bird of open shrubland and grassland, closely related to Australia's stubble quail, which is still common in Australian grasslands.

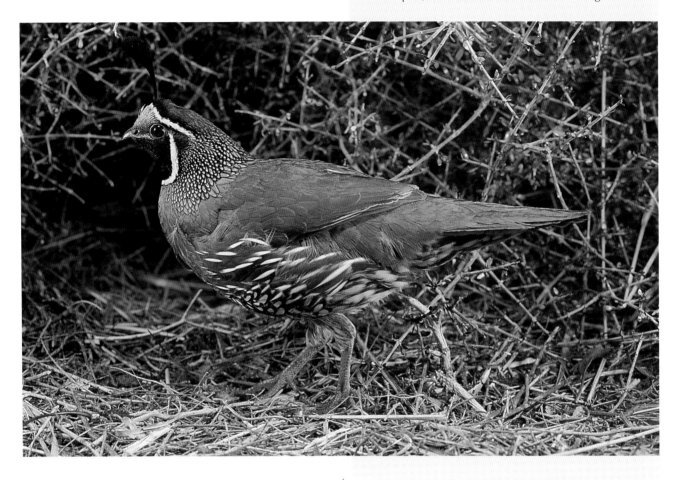

Upper Clutha – A surprise package

Surprising as it may seem, the Upper Clutha area, stretching from Lakes Wanaka and Hawea down a wide and generous valley to Cromwell, was once mostly filled with ice hundreds of metres deep. For this area, thousands of years ago, was the ultimate destination of the Wanaka Glacier. The ice may be long gone but surprises remain in the form of unusual plants and invertebrate animals. They make the Upper Clutha different from anywhere else. Significantly, the valley floor, no less than the mountain tops, harbours special elements such as local endemics and uncommon species, including stars such as the Cromwell chafer beetle, pillow native daphne (a pimelea) and a minute daisy.

The natural and semi-natural parts of the Upper Clutha Valley are flat, rocky and covered with open sparse vegetation. The most northern areas are composed of glacial outwash gravels, a feature that has aided the retention of natural values. Key sites are Pisa, Poison, south Hawea and Long Gully Flats, along with the sand dunes at the mouth of the Lindis River. The Lindis River mouth is best known for

Burning off for pastoral purposes probably hastened the extermination of the New Zealand quail.

In the 1860s and 1870s a slightly larger quail (25cm, 180g) was introduced from North America as a game bird – the California quail *Callipepa californica*. It has become well established in shrubland and along riverbed margins, and benefits from the spread of briar, broom and gorse. California quail nest in long grass under bushes and bracken fern. They are highly productive birds. They can breed after a year, and clutches average 14 (up to 20). During autumn and winter they are found in family groups. Early morning and dusk are favoured feeding times. They eat insects, grasses leaves and seeds.

The cock bird is grey-blue with a crest that points forward. The hen is browner and has a smaller crest. Although commonly seen at mid-altitude, these quail have filled niches as high as 1,800m on the ranges.

Pictured above is a California quail. *Rod Morris*

Neat round grey shrubs of *Pimelea aridula* are dotted over hillsides in Central, with white, fragrant flowers coating them in October. Insects flock to feed on these flowers, repaying the host by assisting with pollination. The foliage is consumed by the larvae of the magnificent pink hind-winged moth *Meterana meyricci*. These plants are on Chard Road, Kawarau Gorge. *Brian Patrick*

its population of desert broom *Carmichaelia petriei*, with another specialist dryland shrub *Coprosma intertexta* locally common south of Hawea. Open vegetation is dominated by degraded fescue grassland, mat or cushion *Raoulia* species and heath plants such as *Leucopogon muscosus*, the woodrush *Luzula ulophylla*, dwarf shrub *Pimelea oreophila* and sedge *Carex breviculmis*.

Flanking the valley floor are rocky areas that have provided refuges from fires. Here, native shrublands containing the yellow-flowered *Corokia cotoneaster*, sweet-smelling tree daisy *Olearia odorata* and small-leaved coprosmas persist. Woody climbing plants (lianes) such as *Rubus schmidelioides*, *Muehlenbeckia complexa* and *Clematis marata* clothe these shrubs, providing food and habitat for fauna. A rare liane *Carmichaelia kirkii* has its type locality in the Cardrona Valley and probably still occurs there. Near Wanaka, Mt Iron has a surprisingly diverse shrubland and understorey of native herbs and ferns. The tree daisy *Olearia avicenniifolia* is found here, and another good-sized shrub *Coprosma crassifolia*. In places, such as around the old mining

area of Bendigo, kanuka flourishes and in turn provides a refuge for a wide range of native herbs and grasses. A rare sedge, *Carex inopinata*, was found at Bendigo in 1974 but has not been seen since. Its only other occurrence is at Castle Hill, inland Canterbury. The lower flanks of the Pisa Range have important remnants of Hall's totara *Podocarpus hallii* and celery pine *Phyllocladus alpinus*, species once widespread in Central but now much less comon because of fires in the distant past. On both the northern and southern ends of the Pisa Range are remnants of silver beech *Nothofagus menziesii*, which is associated with a long list of riparian shrubland and sedge species. The Luggate Creek population is significant as it grows on a site that is exceptionally dry for silver beech. Less common shrub species here are *Melicope simplex*, *Aristotelia fruticosa* and the handsome kotukutuku *Fuchsia excorticata*, with the rare liane *Scandia geniculata*. The podocarp and beech forests might be all but gone but they have retained their distinctive insect fauna, which includes leaf-mining and leaf-binding moths, and a collection of native birds of the forest – South Island fantail, tomtit, grey

Star plants of the Pisa Flats – *Myosotis uniflora* and *Craspedia* new species. *Neville Peat*

Soft green cushions of pillow pimelea, *Pimelea pulvinaris*, are found on both sides of the Clutha River south of Luggate. Although restricted to a small area, they dominate the grazed river terraces, forming prominent mounds. By November they are covered in sweet-smelling flowers that attract a variety of tiny beetles, flies and moths. Elsewhere the plant is found only in the Mackenzie Country south of Tekapo, where it is similarly uncommon. *Brian Patrick*

This day-flying moth in the genus *Loxostege*, an inhabitant of saltpans, has yet to be formally described. Adults sunbathe on the barest areas and the wriggly larvae feed on the mats of *Atriplex buchananii*. *Brian Patrick*

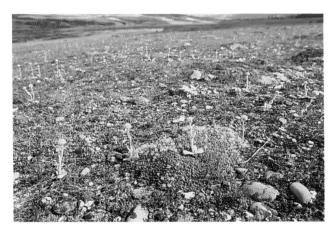

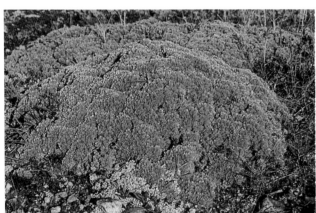

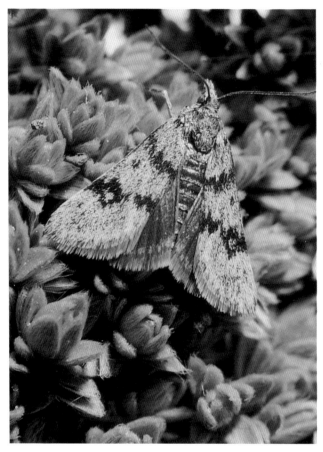

warbler and silvereye. Other native birds inhabiting the area are Australasian harrier, New Zealand falcon, black shag and grey duck.

Among the many native insects in the Upper Clutha, beetles are prominent. At least two are found only in the valley – an undescribed chrysomelid beetle in the genus *Allocharis*, and the well-known Cromwell chafer beetle. Both the shrubland and open habitats have distinctive communities of insects. These open sites are prolific with small, day-active and ground-hugging species, easily seen from hands and knees. Care should be taken, however, with a recent arrival. The poisonous Australian redback spider *Latrodectus hasselti*, a close relative of the native katipo, is well established in Central, especially the Wanaka area. Unlike the katipo, which shuns people, the newcomer enjoys the presence of humans and is quick to set up home close to settlements and often within them.

The Upper Clutha, although still a special area, continues to lose natural habitats to changing land uses, notably the spread of subdivisions. The Dunstan Reservoir invaded

natural habitats at the lower end of the valley, but at the same time it has extended aquatic areas for birds like black swan, Paradise shelduck and New Zealand shoveler. Artificial islands have become breeding grounds for black-fronted terns.

Pisa Flats – Dryland biodiversity

In the Upper Clutha Valley north of Cromwell is a superb area of river terrace that has escaped both the wholesale modification that comes with irrigation and the later flooding from the Dunstan Reservoir. Pisa Flats is acclaimed nationwide for its biodiversity. Although not immediately obvious to the eye, it is one of Otago's biological gems. Over an area of just 20 hectares are found 41 native plant species, 13 of which are uncommon or rare. Three have yet to be formally described.

A visit in October will reveal the bright yellow splashes of the rare cushion forget-me-not *Myosotis uniflora* in flower and carpets of the undescribed woollyhead in the genus *Craspedia* also flowering. The latter, with its grey foliage and yellow flowers, may be endemic to this site alone. Diminutive

Desert Specialist

A caterpillar of the day-flying heliothine moth *Australothis volatilis* (below) feeds on the flowers and foliage of an exotic *Vittadinia* daisy on the Pisa Flats. The day-flying adult, a Central Otago endemic, epitomises insect life in the most continental part of New Zealand. A desert specialist, it was only recently named following its discovery in 1987. Its closest relatives live in the most arid zone of central Australia. The pupa stage in its life cycle depends on rainfall and can last anywhere from one week to two years. Ironically, though, its discovery may have come too late as it is known only from four sites and is threatened with extinction. Although the foodplant is widespread (the larvae feed on both native and introduced *Vittadinia*), suitable habitat for the moth is not. The swift adults require sun-drenched hillsides with plenty of bare ground for courtship and sunbathing. *Brian Patrick*

Rare Plants at Pisa Flats

Craspedia new species
Galium new species
Leptinella new species
Lepidium sisymbrioides
Ophioglossum coriaceum
Myosotis uniflora
Carmichaelia vexillata

Convolvulus verecundus
Carex decurtata
Ceratocephalus pungens
Muehlenbeckia ephedroides
Mazus novaezeelandiae impolitus
Puccinellia raroflorens

Below: Dark-green tufts of a new and unnamed species of *Galium* sprout through a cushion of the common *Raoulia australis* on the Pisa Flats. Known from only three areas – Pisa, Nevis Valley and Kaitorete Spit in Canterbury – its flowers are sweet-smelling. *Brian Patrick*

grasses such as *Rytidosperma maculatum* and *Poa maniototo* grow here, too, and are characteristic of Central Otago drylands but they are giants compared to a tiny undescribed daisy in the genus *Leptinella* that grows among lichen-covered rocks on the terrace edge (where many of the significant plants of the Pisa Flats are found). Elsewhere, the daisy has been sighted only once, in the Nevis Valley. Similarly, the undescribed new species in the genus *Galium* has been found in Otago only at Pisa Flats and in the Nevis Valley, although it also occurs at Kaitorete Spit in Canterbury. Its bright green foliage and sweet-smelling small white flowers are distinctive, and obvious when growing out of the grey cushions of *Raoulia australis*, their normal home. The rare *Galium* has two growth forms; it can either be a cushion or a trailing herb.

Actually the cushion growth form is a feature of Pisa Flats. There are eight native cushion species, including the grass *Agrostis muscosa* and the orange *Scleranthus uniflorus* of the chickweed family. Salty soils, although a minor component of Pisa Flats, constitute the best saline site left in the Upper Clutha, with the cryptic halophyte *Atriplex buchananii* common on the barest, most salty sites. Rounding off this catalogue of dryland biodiversity are a suite of uncommon, rare or poorly known plant species; including the sedge *Carex decurtata*, a cress *Lepidium sisymbrioides*, a herb *Convolvulus verecundus* and the tiny fern relative *Ophioglossum coriaceum*.

Pisa Flats' dwarf dryland vegetation is home to a range of insects that are active by day and thrive here because of the excellent diversity of native plants, mixed with exotic species and interspersed by bare ground. These open sites are important to diurnal insects for sunbathing, courtship and for other behavioural reasons. Tiny beetles of several families are numerous in spring, feeding within the many flowers that appear. Meanwhile, small bugs such as *Nysius huttoni* run rapidly over bare ground. This species dines on plant juices. Diurnal moths such as the newly described heliothiine *Australothis volatilis* and a tiny larentiine *Arctesthes catapyrrha* are present but elusive. An elegant scopariine moth *Eudonia gyrotoma* and an oenochromiine moth, undescribed in the genus *Dichromodes*, are a feature of these

The Kawarau Gorge upstream of Roaring Meg. *Neville Peat*

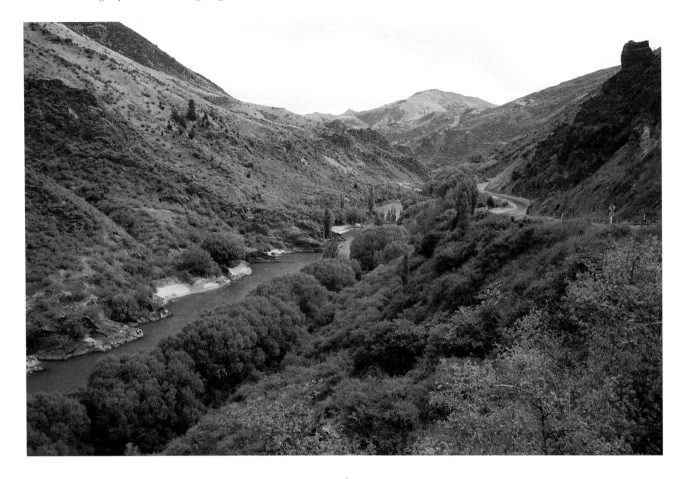

dry flats. Associated with saltpan plants are a larentiine moth *Paranotoreas fulva* and *Loxostege* new species, both with larvae that feed on the chenopod *A. buchananii*. Two grasshoppers, the small *Phaulacridium marginale* and larger sleek *Sigaus australis*, are common and major defoliators.

Although seasonally grazed by sheep, Pisa Flats can boast two native bird species that breed here. Banded dotterels and South Island pied oystercatchers both utilise natural depressions between the hummocks of vegetation as nest sites.

The issue of long-term protection of Pisa Flats is being addressed by the Department of Conservation.

The Kawarau Connection

Snaking its way through the south end of the Pisa Range is the Kawarau River set in the deeply-incised 25km-long Kawarau Gorge. Steep and mostly dry slopes support a fascinating array of plant communities. Numerous bluffs are inhabited by such botanical novelties as the forget-me-not *Myosotis goyenii*, the carrot relative *Anisotome cauticola*, rare broom *Carmichaelia vexillata* and a rare grass *Stipa petriei*. All of these plants are local, as are two nationally rare and threatened cresses that grow in the gorge – *Lepidium kawarau* and *Ischnocarpus novaezelandiae*. The former has several populations here. The Kawarau Gorge is the stronghold for the species, which is elsewhere only found near Falls Dam in the upper Manuherikia Valley. Another Central Otago endemic in the gorge is the attractive broom *Carmichaelia compacta*. Distributed between here and Flat Top Hill to the east, it favours sunny north-facing slopes. Its largest population is in the Kawarau Gorge.

Shady slopes are a haven for mixed native shrublands, which coexist with exotic briar. The lower slopes of Mt

Native broom *Carmichaelia compacta* in flower. The species is a Central Otago endemic and the Kawarau Gorge supports a large population of it. *John Douglas*

The nationally threatened cress *Lepidium kawarau* is found in the Kawarau Gorge and the Falls Dam area. Although this plant has bronze foliage, which tones with its rocky terrain, others may have green leaves. *John Barkla*

Anisotome cauticola in flower in November in the lower Nevis Valley. *John Douglas*

Difficulty and slopes near the Kawarau Bridge, made famous by bungy jumping, support good and apparently expanding examples of these rich shrublands. Natives include *Olearia odorata, Coprosma propinqua* and *Pimelea aridula.* In the lower Roaring Meg a small population of silver beech is found.

Significant amongst the fauna of the Kawarau Gorge is an undescribed species of gecko and an uncommon clapping cicada *Amphipsalta strepitans.* A local endemic amongst the insects is a flightless red-brown chafer *Prodontria jenniferae*, recently named and found only in the lower Roaring Meg area. Underlining the richness of the fauna of the gorge is the fact that 279 species of moth have been documented, including, among the geometrids, the uncommon and related *Samana acutata* and *Adeixis griseata.* New Zealand's only native praying mantis *Orthodera novaezelandiae* finds its natural southern limit in Central and is a conspicuous resident of the gorge where it stalks its prey on shrubs such as thyme *Thymus vulgaris.* Hot rock surfaces are the race track for an Australian spider *Supunna picta*, now common in Central. Fast-running,orange-legged adults

run down their prey with extraordinary swiftness. Similarly, the Cromwell (Dunstan) Gorge exemplifies the value of rocky slopes in retaining elements of the natural flora and fauna. Here, groves of kowhai shine out in spring with splashes of yellow, standing tall over seemingly never-ending tracts of exotic thyme rolled out over the hills.

Nevis Valley

At about the mid-point of the Kawarau Gorge, the Nevis River empties into it from an impressive valley that sits much higher than either the Upper Clutha or Kawarau. About 30km long, the Nevis Valley separates the Garvie and Hector Mountains. With higher altitude comes a lesser degree of modification of the native vegetation, particularly further up the valley. An example is the Schoolhouse Flat fan, which boasts a rare community – a mix of short tussock grassland *Festuca novaezelandiae* and a now uncommon dryland sedge *Carex muellerii.* Among the many understorey natives of this semi-natural area are the low woody species *Muehlenbeckia axillaris, Leucopogon fraserii* and *Pimelea oreophila.* Traversing

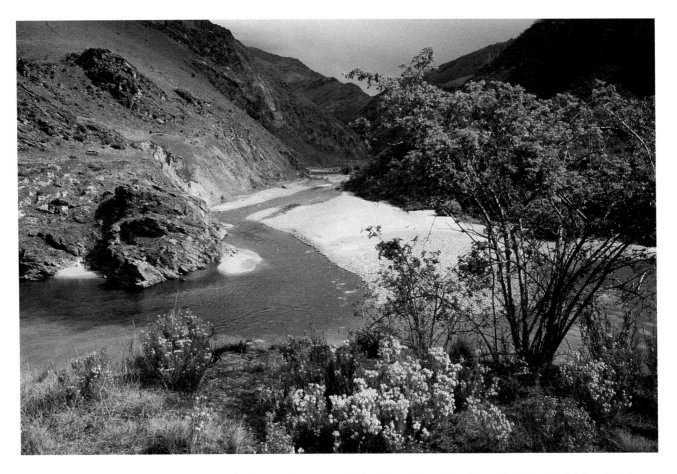

Above: Meeting of waters: The Nevis River joins the Kawarau from a tight gorge. Thyme is flowering in the foreground. *Neville Peat*

Below: Vegetation at Schoolhouse Flat in the Nevis Valley, featuring the sedge *Carex muellerii. Brian Patrick*

Checking chafer beetle pitfall traps at Cromwell Chafer Reserve, a centre for chafer research. *Neville Peat/DOC*

the fan is an array of rivulets supporting rich riparian vegetation. Nearby, on old mine tailings, the rare forget-me-not *Myosotis glauca* and a new species of *Galium* occur. The latter may be found growing on grey cushions of *Raoulia australis*. Underlining the high natural values of the Nevis are wetlands containing impressive stands of copper tussock *Chionochloa rubra cuprea* and a diverse assortment of native herbs. These can be found close to the river or up on terraces. In the gorges of the Nevis are remnant shrublands, some of which harbour bluff-dwelling herbs such as *Anisotome cauticola*, and cushionfields that, surprisingly, contain species such as *Dracophyllum muscoides*.

The Nevis is notable for the richness of its water bodies, including ponds, seepages, streams and small rivers. In addition to over 16 stoner and 27 caddis species, tributaries of the Nevis River contain a non-migratory galaxiid fish that, for the time being anyway, has been placed in the species *Galaxius anomalus*.

The Chafer Story

At various points near the middle reaches of the Clutha system live some of New Zealand's rarest insects, notably the chafer beetles that occupy small and scattered sites around Cromwell and Alexandra. The chafers are chunky beetles, flightless and nocturnal. Seventeen species in the genus *Prodontria* have been described. All are from south of the Mackenzie Country. At least five species are isolated within the valley floors of Central Otago. While the Kawarau, Nevis and Cromwell areas are each home to a single species, the Alexandra environs have two species.

The best-known is the Cromwell chafer *Prodontria lewisii*, discovered on Christmas Day 1903 by J.H.Lewis. At that time it lived in the sand dunes in and around Cromwell but is now increasingly confined to an 81ha reserve off the Cromwell-Bannockburn Road. It was the first New Zealand insect to get its own protected area (Cromwell Chafer Beetle Nature Reserve, gazetted 1984). In spring and summer, adults emerge from burrows to feed on plants such as the native cushion *Raoulia australis*, introduced sheep's sorrel

The Cromwell Chafer Beetle Nature Reserve is located on an old terrace of the Clutha River. The Cairnmuir Mountains are in the distance. *Neville Peat*

Central Otago insect icon: the Cromwell chafer beetle *Prodontria lewisii* is thought to have the smallest natural distribution of any insect in the world. It is a nocturnal species, shiny, dark brown and, at about 15mm long, the size of a thumbnail. *Brian Patrick*

The Alexandra chafers: *P. bicolorata*, two-tone as its names suggests, and the black *P. modesta*. They are found in different areas around Alexandra and overlap only at Conroys Dam. *Brian Patrick*

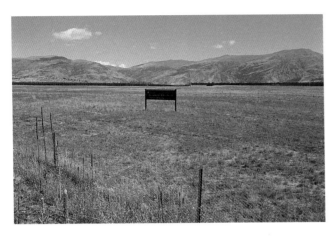

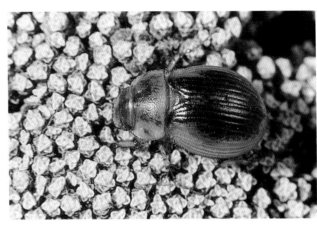

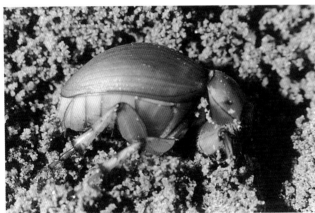

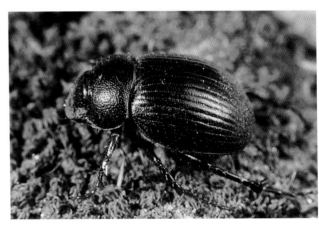

Rumex acetosella and lichen species. Little is know about the underground larval and pupa stages of their lifecycle. Larvae may feed on the roots of silver tussock *Poa cita*. The semi-natural vegetation of the reserve is dominated by exotic grasses and five mat or cushion plants of the genus *Raoulia*. One rare species of native plant, the diminutive woodrush *Luzula celata*, has its only inland Otago populations around Cromwell, both inside the reserve and in *Raoulia* cushion field on the north side of the town. Its tiny flowers appear from the bases of the hairy leaves at ground level in spring.

Considerable conservation effort has been invested in the welfare of this beetle – weed control, rabbit control and fencing, population and predator monitoring, and habitat restoration through the planting of silver tussock *Poa cita*. The reserve is signposted and interpreted on site, and enjoys much local support. Predation of the chafers by little owls living in the adjacent pine plantations may be limiting their numbers. Sharing this special inland sand dune habitat is another scarab beetle *Pericoptus frontalis*, which also has its type locality in the 'Cromwell sands'. A clumsy flier, it is

chunky and black-coloured. A small neat unnamed ground weta can be locally common in the reserve. Both these species also occur around Alexandra.

Of Alexandra's two chafer species, the larger black *P. modesta* is found both east and south of the town in a wide distribution, but the smaller *P. bicolorata* has a much tighter distribution around the town in the north. It is found together with *P. modesta* south of Alexandra on the other side of the Clutha River near Conroys Dam. Both species can be locally common during spring in semi-natural grasslands, but their populations, like other species in the genus, are susceptible to significant land use changes.

Valley Floor Insects

In a New Zealand context, the insect fauna of Central's valley floors is amazingly varied. Many species in several orders are endemic to this part of Central, including chafer and carabid beetles, a tiny wasp, a stoner (stonefly), 11 moths and several bugs. The moth fauna is extensive. A survey identified 387 moths, 97 percent of which are native. Open

The stoner *Zelandobius auratus* is found only in the Alexandra area, where it inhabits wetlands. Adults emerge in August and September and crawl on *Juncus* species. *Brian Patrick*

Vittadinia australis in flower in October on the valley floor near Alexandra. *Brian Patrick*

The female of the geometrid moth *Pseudocoremia cineracia*, whose larvae feed on the foliage of *Olearia odorata*. *Brian Patrick*

Strongly resembling the red-brown stems of its host *O. odorata*, the looper larva of a new species of *Pseudocoremia* that has been found only once, on the Knobby Range. The adult female moth is noteworthy in that it is flightless, with 1mm long wings. *Brian Patrick*

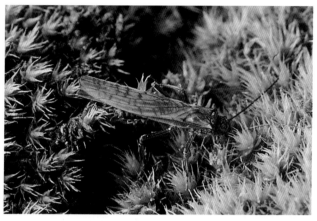

dry grasslands buzz with insect activity during the warmer months with the tiny black wasp *Monomorium antarcticum*, native bee *Leioptroctus fulvescens*, spider hunting wasp *Priocnemus crawi* and myriad native flies all common. Mat or cushion *Raoulia* species are a haven for bugs such as *Rhypodes chinai* and the tiny moth *Eurythecta zelaea*, described from the Ida Valley and possessing a short-winged flightless female. Conspicuous predators of these species are fast-moving cryptic wolf spiders and hidden-from-view trap-door spiders of the genera *Cantuaria* and *Migas*. Some spiders do not equip their retreats with lids. They include the 12mm-long *Hexathele petriei*, a yellow-brown species named from the Alexandra area.

High-Value Olearia

Standing out as the most important group of plants for insects in New Zealand are the small-leaved deciduous tree daisies in the genus *Olearia*, of which *O. odorata* is typical. Central Otago is the stronghold for *O. odorata* and it is widely dispersed across the region. Its species name reflects its

Lichen Communities

Lichens are a complex ecosystem in which an algae and fungus live together in a symbiotic relationship. A fascinating variety of lichens has colonised the exposed schist rock surfaces of Central, displaying an array of colours and shapes. Some Central Otago lichens are related to lichens in southern Australia and South America.

Capable of utilising bare rock, lichens are at the frontline of plant colonisation. A Dunedin-based research project set up in the late 1990s is examining the nitrogen-fixing properties of lichens.

Many different insect groups have utilised lichens for food or shelter. Noteworthy among them are three families of moth whose larvae graze the many species of lichen colouring rock faces in Central. No fewer than five moth species in the genus *Dichromodes* utilise lichens. Whereas the larvae are splendidly camouflaged amongst the lichens, the adults are often gaily-coloured day-flying moths.

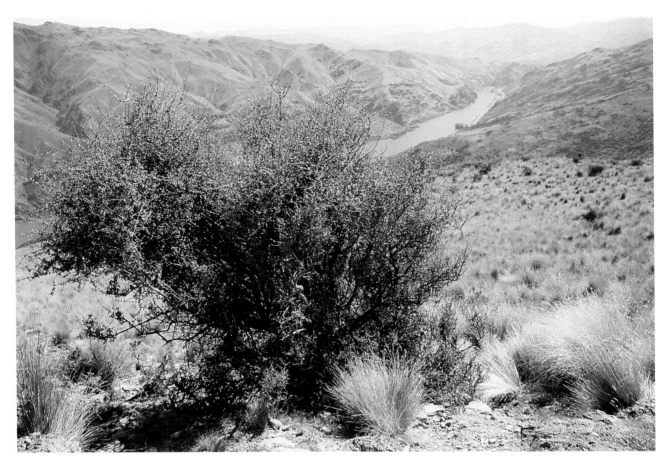

Above: A mature bush of *Olearia odorata* overlooking the Cromwell Gorge and Dunstan Reservoir. *Neville Peat*

Below: A lichen-clad rock at Bendigo. Two species stand out – the greyish *Physcia caesia* covering the top of the rock and a yellow *Xanthoparmelia* lichen, which belongs to a genus that is widespread in dryland areas. *Neville Peat*

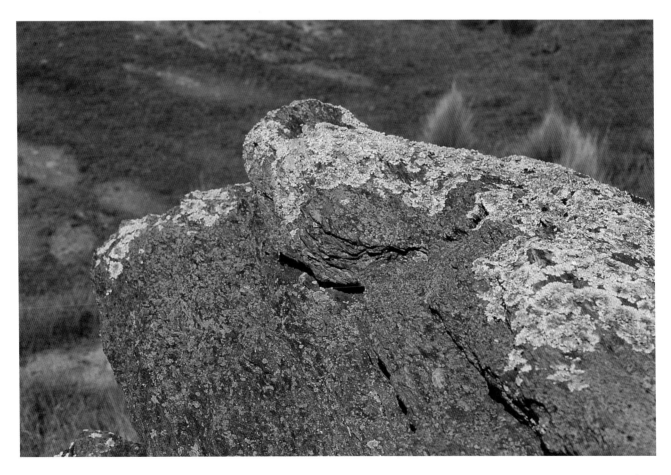

One of the rarest of New Zealand's five native nettles in the genus
Urtica is *U. aspera*. This specimen, in flower, is from the Cromwell
Gorge, at about 500m above sea level. The species has been found at
five locations in Central up to an altitude of 1,500m. *Brian Patrick*

Spur-winged plover attending eggs. *Ian Southey*

sweetly-scented flowers. The dependent fauna includes
beetles in several families, flies, wasps, bugs and many moths.
Twenty-three species of moth have been found to feed on
Olearia, with 15 species feeding only on this group of plants.

Bird Newcomers

Two of the Clutha region's most conspicuous native birds
have become established only in relatively recent times –
the spur-winged plover *Vanellus miles* and the white-faced
heron *Ardea novaehollandiae*. Because these species arrived
from Australia of their own accord, probably as a result of
being blown across the Tasman in a storm, they are deemed
to be native. They were not the first native species to blow
in, and surely will not be the last. Quite a few New Zealand
birds are descended from self-introduced Australian stock.

Unlike its distant cousin the white heron, which, since
pre-European times, has never managed to extend its
breeding range beyond a kahikatea forest near the Okarito
Lagoon on the West Coast, the **white-faced heron** has spread
through much of New Zealand in a few decades. Breeding

Tumbleweed Lichen
New Zealand's answer to the Wild West's tumbleweed is
perhaps the yellow lichen *Chondropsis semiviridis*.
Unattached to the ground, it is found drifting among grasses
and subshrubs in the drier lowland landscapes of Central
Otago, including the Cromwell Chafer Beetle Nature
Reserve and Flat Top Hill. A second species, the darker olive-
green *C. sorediata*, is much less common, with a scattered
distribution in the Mackenzie Country, Waitaki Valley and
Central Otago. It was discovered and described in 1986.
The closest relatives of these two lichen species live on the
Nullabor Plain in arid Australia. The two share their habitat
with other lichens, including up to four species of
Xanthoparmelia, which in contrast forms an attachment to
bare soil. *Brian Patrick*

The white-faced heron. *Ian Southey*

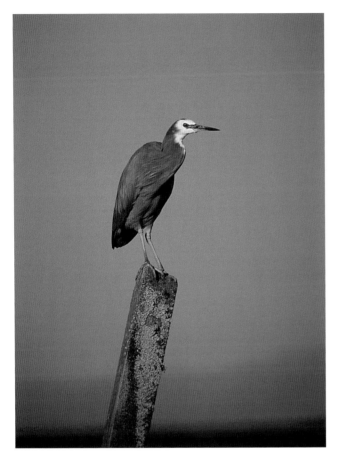

The little owl *Athene noctua*, also known as the German owl, was introduced from Germany in 1906-1910 and liberated in Otago and Canterbury to control the numbers of small introduced birds that were of concern to farmers and orchardists. Although pictured here with a dead sparrow, the little owl has a diet largely based on insects and other invertebrates. New Zealand has only two owls, the native morepork, which is found mainly in forested areas, and the little owl, which is more at home in farmed areas. *Rod Morris/DOC*

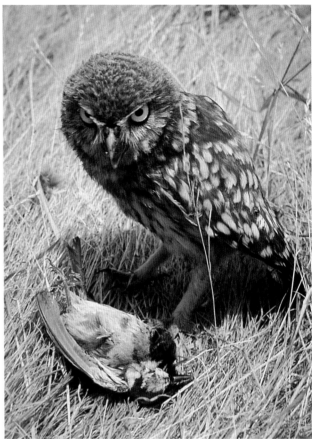

was first confirmed in 1941 in the Shag Valley, a short flight from Central. In the 1950s and 1960s, white-faced heron numbers increased sharply.

Wading birds, they are likely to be found on farm ponds and the shallows of any waterway but they also forage on damp pasture. Their diet comprises mainly worms, molluscs, crustaceans, small fish and frogs. They will also take mice. They often rake with one foot while feeding. For a while white-faced herons were accused of making inroads on trout fisheries but research showed that because they are partial to freshwater bullies, which prey on trout fry, they may even be good for the trout.

White-faced herons nest in spring or early summer, invariably in tall trees and usually close to water. In single pairs or scattered groups they build a flimsy-looking platform of sticks. Three to five eggs are laid but usually only two chicks survive. Their most common call is a harsh 'graaw'.

The **spur-winged plover** became established in Central Otago in the 1960s. Its raucous call, especially penetrating on a still Central night, is well known to farmers in many parts of the region. Breeding was first recorded in New Zealand at Invercargill in 1932, after which the species spread slowly north.

Like other members of the plover family, this one nests in the open, forming a shallow cup on the ground in which three to four eggs are laid. It puts up a fierce defence of its nest, launching into the air against any magpie or harrier that comes near. Territorial displays against its own kind on the ground are noisy and involve the birds strutting about with wing spurs exposed. The arrival of this plover in Central coincided with a decline in pied stilts. It is thought the stilts may have succumbed to competition from the newcomer, which likes feeding on riverbeds, lakeside pastures and paddocks with short cover. The spur-winged plover, called a masked lapwing in Australia, feeds on worms, grass grubs and other invertebrates.

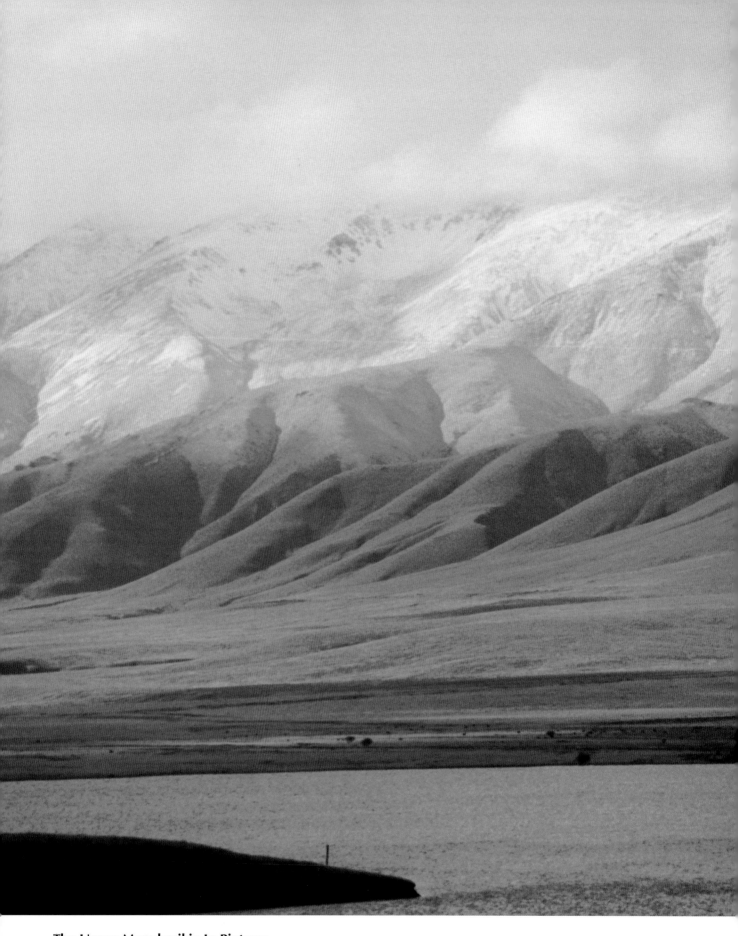

The Upper Manuherikia In Pictures

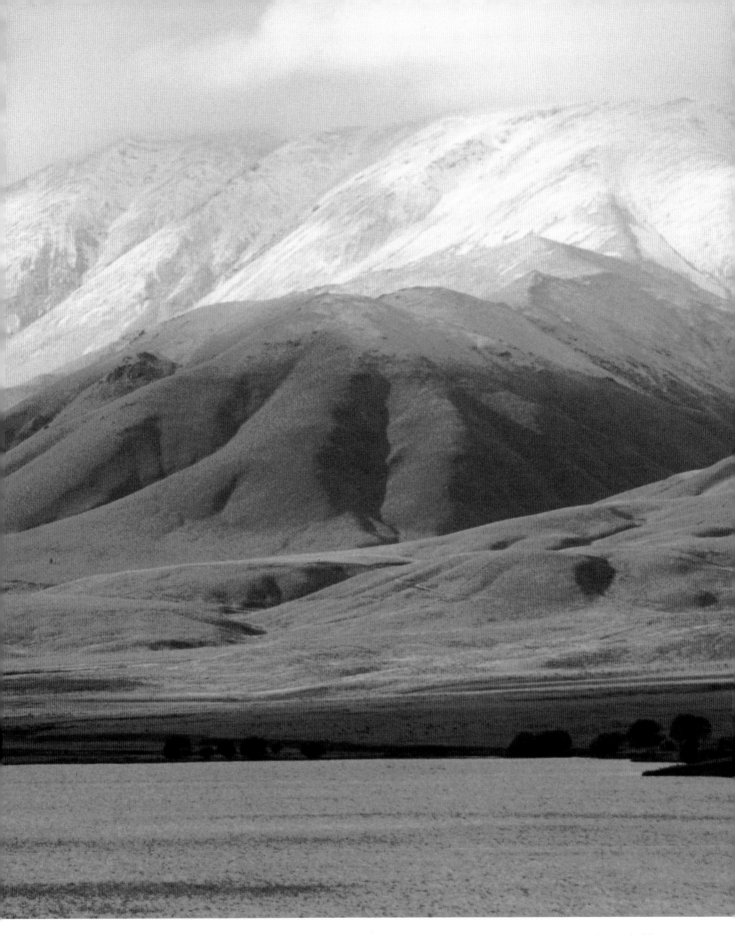

Late autumn snow dusts the Hawkdun Range near the head of the Manuherikia River. Extensive short tussock grassland is found on the north side of Falls Dam together with numerous wetlands, scattered shrublands and rocky sites. *Brian Patrick*

Snow tussock grasslands provide a soft foreground for the hard-etched skyline of the Hawkdun Range. *Neville Peat*

Below: A feature of the shrublands at the head of the Manuherikia River is the divaricating *Coprosma intertexta*. Although locally common here and at its southern limit, it is not particularly common further north. In this photograph, it is in the centre and left, taller and browner than the grey bushes of matagouri *Discaria toumatou* in the foreground. *Brian Patrick*

Opposite: The gorge of the Manuherikia River below Falls Dam is lined with diverse shrubland. There are special plants here, notably the threatened cress *Lepidium kawarau* and rare nettle *Urtica aspera*. *Neville Peat*

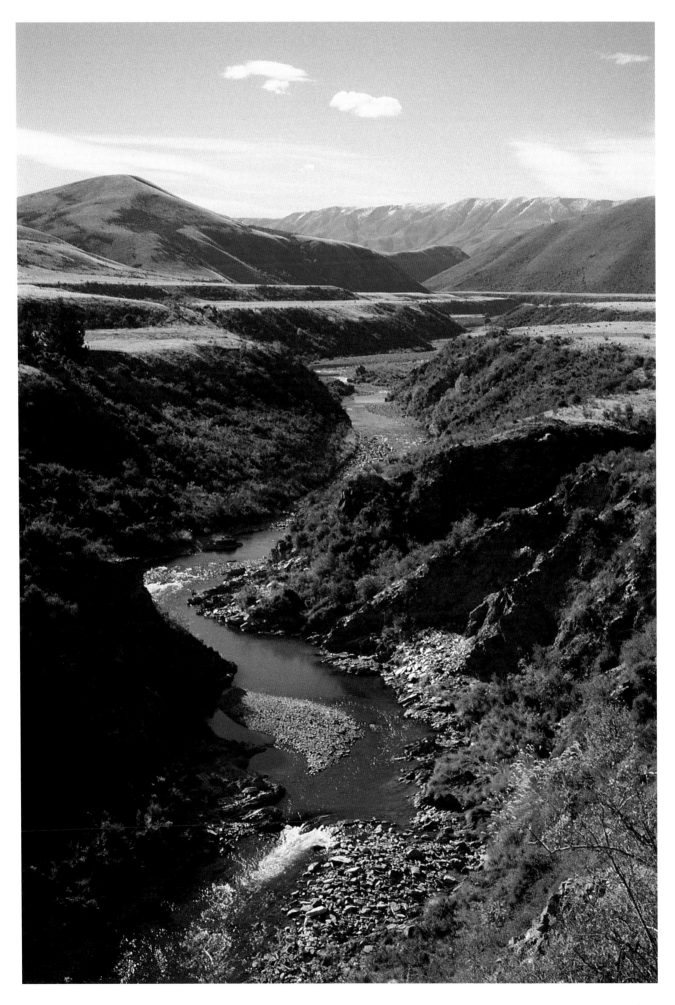

The newly protected saline site at Chapman Road near Alexandra.
Neville Peat

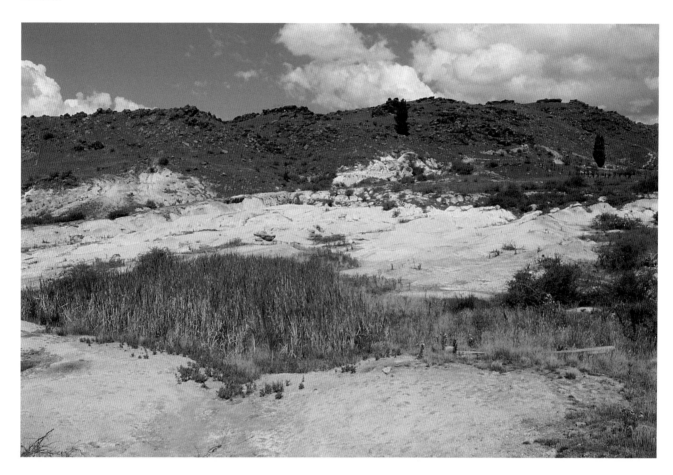

Saltpan Valley

The Lower Manuherikia Valley has more inland salty habitats than anywhere in New Zealand. Between Springvale and the Earnscleugh Flats there are hundreds of small sites but at only a handful of these are natural values largely intact. The source of the salts – whether from ancient marine incursions, airborne winds from the coast, or erosion of the schist rock – continues to be debated. Possibly a combination of all these factors has played a part in the assemblage of salty areas in Central. They represent a range of habitats – and inhabitants – that are quite distinct from present-day coastal saline areas.

Saltpans were once a significant component of the Central Otago-Waitaki Valley landscape but many sites have succumbed to land development, fertiliser application and irrigation schemes. Saltpan soils are highly alkaline (pH rating higher than 7) and are of no use to farming unless modified. Before humans arrived, saline soils covered an estimated 40,000ha of the basins and foothills of Central Otago. Today there are only about 30 significant sites left,

none of which is larger than 100ha. In the lower Manuherikia six sites are formally protected but many areas remain in private ownership.

Key sites are Galloway, Chapman Road, Chatto Creek, Blackmans, Conroys Road and Dam, and Flat Top Hill. Two important ones are at Galloway, 8km north-east of Alexandra, and Chapman Road, 4km south-west of the town. At both places, the ground is covered in white patches that appear barren.

Characteristically, saline soils are colonised by the most salt-tolerant species (halophytes). Twenty-two halophytes are listed for the Otago saltpans. They include flat grey mats of the herb *Atriplex buchananii* and the less common and larger chenopod *Chenopodium ambiguum*. Where least modified, a distinct zonation among salt grasses is found surrounding the bare saline patches. Forming concentric rings around the salt patches is the Central Otago endemic *Puccinellia raroflorens*, surrounded by the slightly taller *P. stricta*. Two taller exotic salt grasses often join these natives and form outer bands. Damp salty turf can contain *Apium* new species,

The thread-like endangered native cress *Lepidium kirkii* grows on the saltiest soils at Chapman Road. *John Douglas*

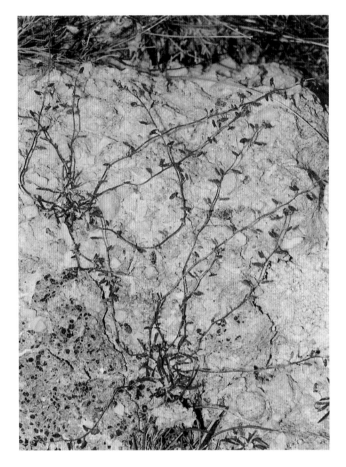

A saltpan specialist is this moth *Paranotoreas fulva*, which was rediscovered after 45 years of no sightings. The larvae of two moths, *P. fulva* and *Loxostege* new species, feed on *Atriplex buchananii* and are conspicuous and widespread on Central's saltpans. Lygaeid bugs and tiny beetles are also active by day among the sparse and open vegetation. *Brian Patrick*

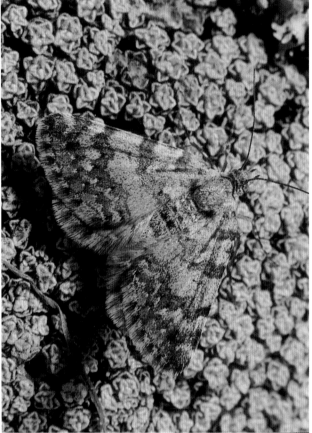

Selliera microphylla, Isolepis basillaris or *Samolus repens*. The two last named are rare in Central but feature on the 8ha Chapman Road reserve, across the Clutha River from Alexandra. Some exotic plant species have colonised Central's salty soils such as *Plantago coronopus* and barley grass *Hordeum* species. Native cresses in the genus *Lepidium*, although not now common on saltpans, are important for their strong association with soils of varying degrees of salinity. Of the three species involved, two are endemic to Central. The thread-like *L. kirkii* and rosette herb *L. matau* are both restricted to Central. The former is distributed from the Manuherikia Valley across to the Maniototo and is known from just 12 sites, including Chapman Road. There are probably only a couple of hundred plants in existence. On soils of less salinity grows the third cress *L. sisymbrioides*, also rare but distributed north to inland Canterbury. In Central it is locally common south of Chatto Creek and in the Maniototo.

A close-up view of the succulent red foliage and flowers of the salt-pan plant *Chenopodium ambiguum*. Uncommon in Central, it is found on a cluster of salty sites close to Alexandra, including the Chapman Road reserve. *John Douglas*

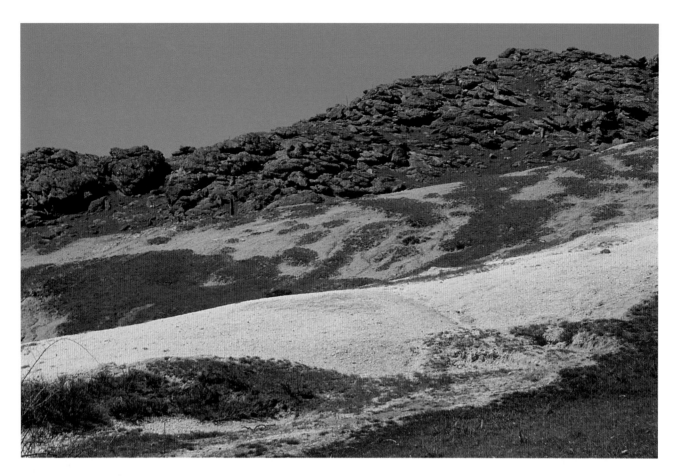

Saltpan Scenes

Contrasting colours at the Galloway salty site, home to a variety of halophytes, including a low-growing form of the native broom *Carmichaelia compacta.* Neville Peat

Below: Despite extensive pasture development, the grazed flats of the Ida Valley still harbour a few salty sites, including this one. The saltiness is indicated by the bare patches and the light-green foliage of various species of *Puccinellia.* Brian Patrick

Among the less common native herb species of salty soils is *Plantago spathulata*, which contrasts with the exotic and widespread *P. coronopus*. Only three saltpan areas have *P. spathulata* – Galloway, Ida Valley and Otematata. *Brian Patrick*

The rare native cress *Lepidium matau* is known only from several populations close to Galloway. The species is found among taller grasses on the margins and slopes around salty hillside exposures. It flowers in November. *Brian Patrick*

A close-up view of the foliage and tiny cream flowers of the halophyte *Atriplex buchananii* which forms grey mats on the saltiest and most desiccated areas. *John Douglas*

The smallest and most salt-tolerant species of saltgrass growing on the margins of saltpans in Central is the recently named *Puccinellia raroflorens*. Four saltgrass species are found in Central, two of them native, including *P. raroflorens*, which is aptly named as it has been observed flowering only twice in the last few decades. *Brian Patrick*

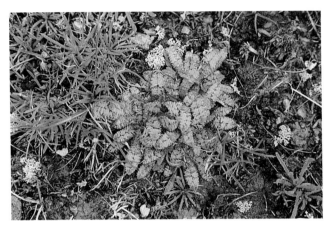

The Conroys Road area near Alexandra, featuring *Raoulia australis* cushionfield. This plant has become dominant in some of the driest areas, largely as a result of sheep grazing. *Brian Patrick*

The moth *Dichromodes ida,* pictured here on the lichen *Xanthoparmelia tasmanica,* is endemic to Central Otago. With another moth in the same genus, *D. simulans,* it is a lichen specialist.
Brian Patrick

One of the hardiest dryland plants is this conspicuous moss *Grimmia pulvinata,* seen here growing on a rocky surface with lichen companions. Lichens and mosses not only add colour to the exposed schist of Central; they also provide food for insects like the white larvae of the moth *Eudonia manganeutis,* which regularly tunnels the *Grimmia. Brian Patrick*

Ceratocephalus pungens, a tiny spring annual in the buttercup family, is endemic to Central. It is pictured here with its yellow flower. Its type locality is Fruitlands. *Brian Patrick*

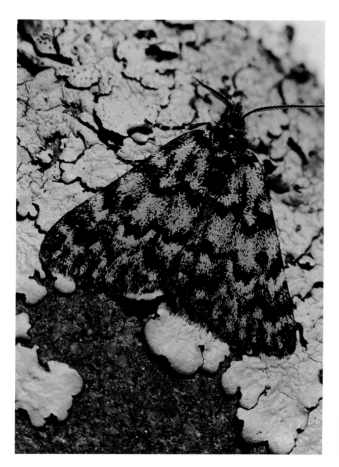

Hardy Plants – Diversity despite the dryness

Despite a desert appearance in places, New Zealand's most inland area retains an impressive array of native plants. This species richness reflects the diversity and contrast of the habitats, which include extensive rock outcrops, semi-natural grasslands, saltpans and wetlands.

Tors and rock faces, for example, are home to 12 species of fern. More important, this rocky terrain has given refuge to numerous native herbs, shrubs and grasses that have disappeared from rock-free areas as a result of pastoral farming. A stocktake of the flora in the Conroys Road area near Alexandra has catalogued 264 species, of which 152 are native – a surprisingly high diversity considering the low rainfall, skeletal soils and low stature of the vegetation.

How do all these species squeeze in? Niche sharing is one way. Some species emerge at different times of the year, complete their life cycle then disappear, to be followed by other species on the same space. Spring annuals are particularly adept at this strategy, and the Alexandra area is famous for its annuals. By August, when the ground is

beginning to thaw, four tiny herb species will pop out. In places they can carpet the ground. By mid-October it is all over for them and their foothold will be usurped by taller vegetation that has taken longer to respond to the increasing warmth. Until a few years ago all these species were poorly known and most were considered to be under threat of extinction. In fact, they can be locally common in the environs of Alexandra, especially within slight depressions. Two are buttercup relatives, *Ceratocephalus pungens* and *Myosurus minimus,* with the former having a hidden yellow flower. The white or yellow flowers of *Myosotis pygmaea* var *minutifolia* are equally hard to spot, being the size of a pinhead. Completing the four annuals is *Crassula tetramera,* which has reddish foliage. Key sites for them are Flat Top Hill, Blackmans and Conroys.

Where thyme has not become firmly established, native grasslands of several diminutive species are dominant. The smallest New Zealand grass, *Poa maniototo,* is common and flowers by spring. It is joined in the drylands by tough mounds of a small grass, *Rytidosperma maculatum,*which

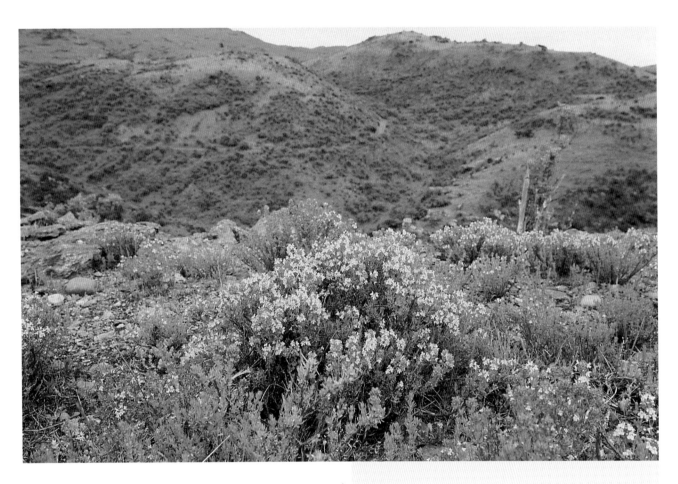

typically is interspersed by grey cushions of *Raoulia australis* and reddish patches of *Epilobium microphyllum*, one of eight native willowherb species occurring in the region. Up to five *Raoulia* mat or cushion species can be found in these situations, along with an assortment of five native bidibids including *Acaena buchananii*, and the herbs *Geranium sessiliflorum*, *Stellaria gracilenta* and *Vittadinia australis*. Where soils are deeper, fescue grassland dominates and is joined by shrubs of *Carmichaelia petriei*, *C. compacta*, *Coprosma propinqua*, *Aristotelia fruticosa*, *Olearia lineata* and *O. odorata*. The rigid porcupine shrub *Melicytus alpinus* is particularly abundant around tors. Dry tor overhangs typically support the weak grass *Poa imbecilla*, sedge *Uncinia elegans* (type locality in the area) and three ferns – *Cheilanthes humilis*, *Pellaea calidirupium* and the rare rock specialist *Pleurosorus rutifolius*. The last named is known from the hills east of Alexandra, near Cromwell and the Kawarau Gorge. Growing on tors is the herb *Anisotome cauticola*, a large carrot relative and a local hebe shrub *Hebe rupestris*. The latter, named for its rock-loving habit, has mauve-coloured flowers.

Aromatic Coloniser

Common thyme *Thymus vulgaris* has made a meal of Central's driest areas. A native of the Mediterranean, it is distributed from the Kawarau Gorge to the Roxburgh Gorge. In the hills around Alexandra, Clyde and Ophir it forms a dense heath-like cover to a height of 40cm. Its mauve flowers appear in November. Thyme copes with semi-arid conditions apparently by utilising essential oils to reduce water loss. Fine surface roots intercept rainfall filtering through the upper soil layers, and long roots tap water deep down. Individual plants may live for 25 years. Now accepted as a dryland landscape feature, the species is celebrated in Alexandra's annual Festival of Thyme. Research shows that thyme requires bare ground to spread and that native plants will struggle to overtop it. In the meantime, native fauna benefiting from its presence include several litter-feeding moths, notably the brightly coloured day flier *Hierodoris frigida*. Grasshoppers and skinks seem to tolerate thyme.

The Flat Top Hill summit, with a snow-topped Old Man Range in the distance. Grasses are regenerating at Flat Top Hill in the absence of grazing. *Brian Patrick*

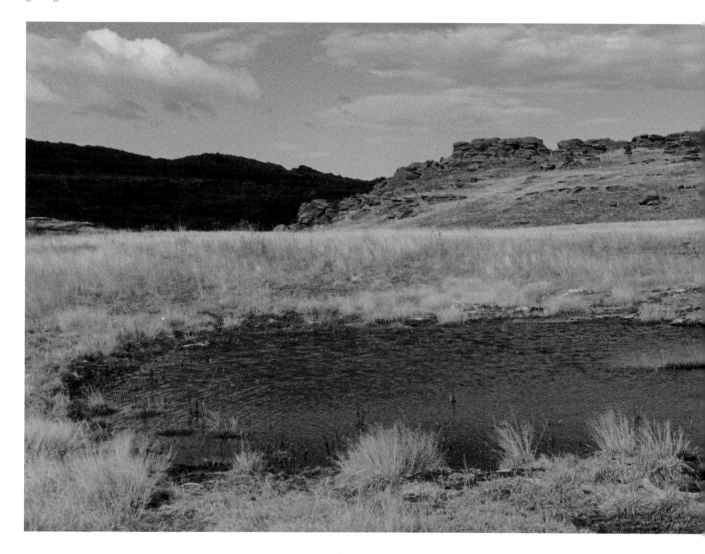

Flat Top Hill – A forget-me-not experience

Five kilometres south of Alexandra is the unique dryland ecosystem of Flat Top Hill, a bulging elongated foothill of the Old Man Range, with a canyon of the Clutha River on one side and Butchers Dam on the other. Nowhere in New Zealand's network of protected areas is there anything to match the 813ha Flat Top Hill Conservation Area. It is the country's driest rangeland reserve (rainfall averaging under 350mm a year), and in true desert fashion it blooms in the most surprising ways.

On salty, wind-eroded soils behind Butchers Dam an undescribed native forget-me-not, formerly *Myosotis pygmaea* var *minutifolia*, turns on a miniature flower show for a few weeks in spring. This tiny annual forms rosettes of hairy brown leaves smaller in diameter than a five-cent coin, and the single yellow flower at the centre of the rosette is of pinhead size. Two other diminutive spring annuals, both with restricted distributions, occur here – *Myosurus minimus* and *Ceratocephalus pungens*. As with the forget-me-not, you need to be on hands and knees to spot them. The spring

annuals contribute to a diverse community of plants at Flat Top Hill – 182 native species altogether. The average New Zealand forest has far fewer species. Significant shrub species include the native daphne *Pimelea aridula*, the shrubby wineberry relative, *Aristotelia fruticosa*, and the tree daisies *Olearia odorata* and *O. bullata*. From the shores of the dam to the summit at 550m the reserve contains several habitats, including the salty ground low down, tussock grassland, shrubland, cushionfield, seepages and wet zones, and rock outcrops.

With so many habitats to offer, Flat Top Hill supports a rich invertebrate community. Conspicuous among the insects are brightly-coloured day-flying moths that flourish on the sunny faces. They delight in basking on the warm surfaces of the tors. The rare Alexandra chafer *Prodontria modesta* (page 43) lives here. So does a broad-nosed *Irenimus* weevil, new to science.

Vegetation monitoring at Flat Top Hill, since it was acquired as a reserve in 1992, has recorded an increase in native grasses, especially the wheatgrasses (three species of

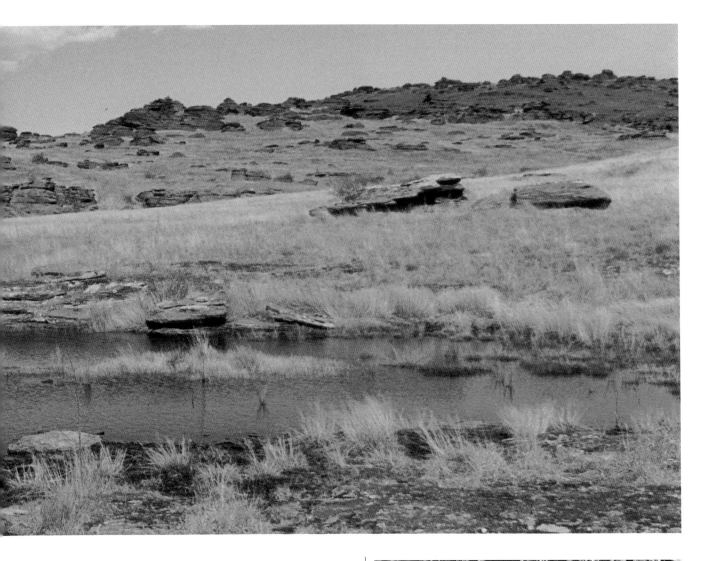

Elymus), which are distinguished by their long, drooping seedheads. On the other hand, thyme, ubiquitous in this district, has also spread, and briar *Rosa rubiginosa* has also gained ground in the absence of grazing by sheep and rabbits (intensive rabbit control work was undertaken through the mid-1990s).

Above all, Flat Top Hill is a showcase area for the semi-arid nature of Central Otago. Located just off State Highway 8, it is bound to become a popular place for a ramble.

Flat Top Hill's tiny native forget-me-not, compared in size to a woodlice (slater). There are yellow and white flowered forms of this species of *Myosotis*, the world's smallest forget-me-not. *Neville Peat*

Porcupine shrub *Melicytus alpinus* is common in rocky areas. Its white berries, shielded from birds by spiny rigid branches, are thought to provide food for lizards, which are probably responsible for dispersing the plant's seed. *Brian Patrick*

A close-up view of the spiny branches of *Melicytus alpinus*, with the orange lichen *Teloschistes velifer* adhering to them. This lichen, which colonises both rocks and plants, is found in Australia and South America. *Neville Peat*

Cottonwood *Ozothamnus* new species (formerly in the genus *Cassinia*), a common native shrub, is spreading at Flat Top Hill in the absence of grazing. So, too, is the native broom *Carmichaelia compacta*. *Neville Peat*

Wheatgrass *Elymus apricus*, seen here growing near an ephemeral tarn, is among the native grasses prospering from the withdrawal of grazing at Flat Top Hill. A distinctive feature of the *Elymus* is the way it presents its golden seedheads on long drooping stems. *Brian Patrick*

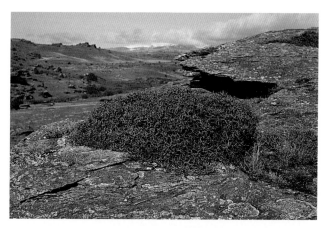

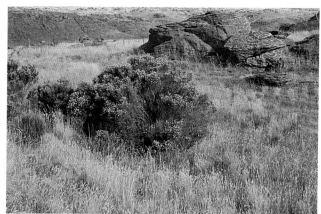

Earnscleugh Tailings – Grasshopper paradise

Historic gold-dredge gravel tailings a few kilometres upstream from Alexandra have been colonised by a surprisingly diverse collection of indigenous invertebrate life, including five grasshopper species, two of which are new to science. The Earnscleugh Tailings, the bulk of which are protected in a 170ha historic reserve, represent the development of gold-dredge technology from the 1890s to 1963, when the last dredge ceased operating. The tailings are an extremely demanding habitat for both plants and animals. Several river terrace species have managed to colonise the tailings as mining gradually destroyed their original habitat.

The grasshoppers are special. The two new species, well camouflaged, belong to the widespread genus *Sigaus*. One is named *S. childi* after its discoverer, the late Peter Child, an Alexandra naturalist, who was a keen observer of the insects and birds of Central Otago.

The other species is yet to be formally described. The Earnscleugh Tailings are an important habitat in both cases,

with the unnamed species seemingly confined to historic gold tailings in the vicinity of Alexandra. *S. childi* has a wider distribution east to the Crawford Hills. Other native fauna found on the tailings includes lycaenid (copper) butterflies and common skinks.

Century-old dredge ponds set among the tailings and now willow-lined provide habitat for a range of insects that specialise in wet or seasonally wet habitats. Deep, algae-filled water supports many insects including dragonfly larvae *Procordulia grayi* and the tiny bug *Microvelia macgregori* that runs over the surface preying on insect corpses. Spring brings lower water levels that expose a rich plant community on the margins, mainly native species. They include *Hydrocotyle hydrophila*, *Limosella lineata* and several species of willowherb *Epilobium*. These turfs are home to an assortment of insects that includes a suite of diurnal moths such as *Protithona fugitivana*, whose females hop. On drier soils, the tall willowherb *Epilobium melanocaulon* and patches of the wiry mat-forming subshrub *Muehlenbeckia axillaris* are among the surviving native plants.

Bottom: From the air, looking north, the Earnscleugh Tailings near Alexandra resemble the burrowings of an outlandish animal. The oldest tailings, adjacent to the Clutha River, were created around the turn of the twentieth century by the earliest gold dredges working the Earnscleugh Flats. The highest and widest sequence was the work of the giant dredge 'Alexandra' between about 1950 and 1963, when it ceased operating. The 'Alexandra' crossed the river from the right side of the picture about midway along the tailings (see narrow line of tailings at right angles to the river, near a series of ponds). It turned north to begin its convoluted run through the river terraces, ending up at the bottom left of the picture. The Fraser River is in the foreground. *Kevin Jones/DOC*

Below left: Suddenly appearing on bare ground or ledges in early spring in the driest parts of Central, including the Earnscleugh Tailings area, is the diminutive herb *Crassula tetramera*, a relative of stonecrop. *Brian Patrick*

Below right: The Alexandra grasshopper *Sigaus childi* was formally named in 1998. It is similar in size to the unnamed species from the Earnscleugh Tailings (females are about 24mm long) but is less agile, jumping only about 50cm at a time, half the distance achieved by the unnamed species. An identifying feature is the shell (pronotum) covering the thorax, smooth in the unnamed species but uneven in *S. childi*. *Brian Patrick*

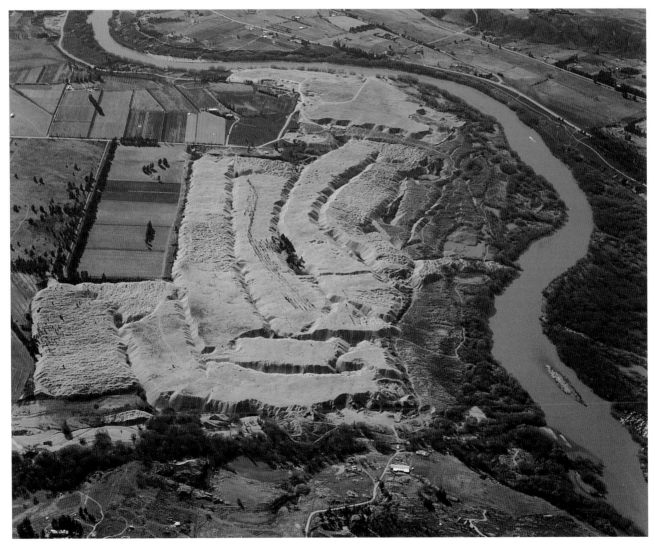

The drowned valley of the Clutha River downstream of Alexandra forms part of the reservoir for the Roxburgh dam. Steep slopes support diverse native shrublands, particularly in the gullies of the many tributaries that join the Clutha. Nearby in Gorge Creek the rare small-leaved shrub *Teucridium parvifolium* is known. *Brian Patrick*

The leaves of horopito, the pepper tree *Pseudowintera colorata*, add warm colours to the Rongahere Gorge forest. *Neville Peat*

Nestling in the Clutha downstream from Beaumont is 7 ha Birch Island, named after its beech forest cover. The island's near-natural condition has resulted from much lower levels of mammalian herbivores than usual and it acts as a small window into the pre-human invertebrate world of southern beech forests. *Brian Patrick*

The velvety peripatus below is an undescribed species endemic to the Blue Mountains area, including the Rongahere Gorge and Birch Island. Measuring up to 34mm long, it is a predator finely tuned to life in leaf litter and rotting logs. Peripatus belong to the class *Onychophora*, an ancient group of invertebrates, represented in New Zealand by about 12 species (see also Waikaia peripatus, page 88). *Brian Patrick*

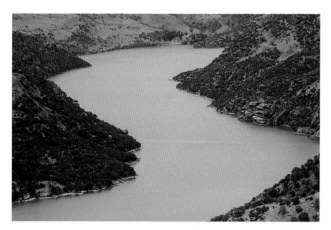

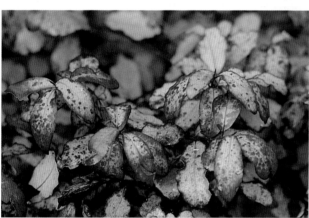

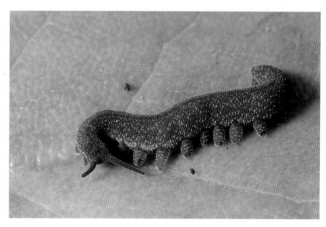

Rongahere Gorge

Rongahere Gorge is remarkable for its unbroken sequence of native vegetation, from the mixed beech valley floor through to low-alpine grassland and wetland on the summit of the Blue Mountains. This forest type is rare in the east of the South Island. Mountain, red and silver beech grow together on the alluvial terraces of the valley floor, mixed in places with kahikatea and matai, but giving way to small-leaved shrubs and sedges on frost flats and wetter ground. Among the understorey species are the small-leaved *Coprosma colensoi, C. rotundifolia* and rohutu *Neomyrtus pedunculata*, abundant ferns, the grass *Microlaena avenacea*, and several sedges, often set in a carpet of luxuriant moss. Wineberry *Aristotelia serrata*, pepper tree *Pseudowintera colorata*, marbleleaf *Carpodetus serratus* and kotukutuku *Fuchsia excorticata* are locally numerous on streamsides or in gaps in the forest. In places the rare riparian small-leaved shrub *Teucridium parvifolium* is found, here at its southern limit. On some slopes, kanuka *Kunzea ericoides* forest can be dominant, with patches of kowhai *Sophora microphylla* and occasional cabbage trees *Cordyline australis*. Bluffs harbour

the lily *Arthropodium candidum*, several ferns and the chickweed-related herb *Stellaria parviflora*, and are often surrounded by broadleaf *Griselinia littoralis* and the shrubs *Melicope simplex* and *Coprosma crassifolia*.

In keeping with the richness of the forest, native fauna has done well. Bush birds are plentiful, with brown creeper and rifleman found in good flocks. Of the 24 native bird species breeding here, mohua (yellowhead), yellow-crowned parakeet and South Island robin have nationally significant populations. The same is true for certain invertebrate groups, including the giant springtails, which are confined to the moist forest litter. Two species from the archaic family *Poduridae* are notable, including *Ceratrimeria brevispinosa*. Unlike other Collembola or springtails, this family contains species that cannot jump. Rongahere's land snails are also interesting. Thirty-nine species have been found here, including two in the genera *Cavellia* and *Flammulina* that are endemic to the area. Eleven species of carabid beetle, major forest floor predators, have been identified. Their presence indicates prey is available in abundance.

4 High Ground and Open Spaces

The heart of Central Otago is dominated topographically by a series of parallel ranges, the so-called block mountains, lying west of the Rock and Pillar Range. From east to west they are: Rough Ridge with its North and South units, Raggedy Range, Dunstan Mountains and Pisa Range.

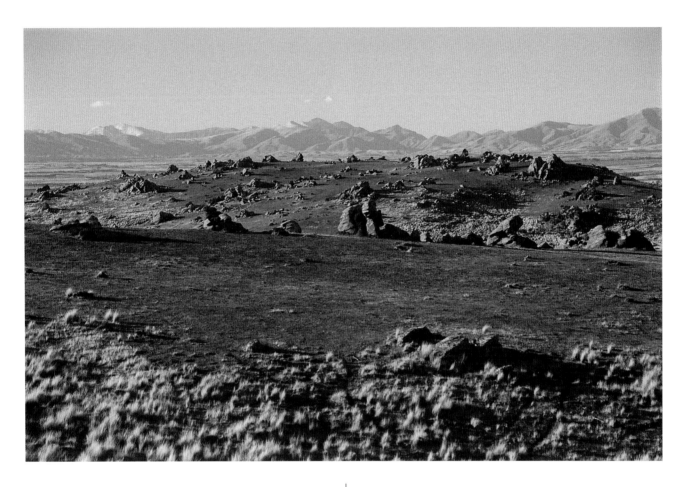

Of the intervening basins, the Maniototo Plain is by far the broadest and most open, and we shall present its special features in this chapter. To the south, lying obliquely to the parallel block mountains, are ranges that help create the rainshadow effect in the interior – Old Woman and Old Man Ranges and Umbrella Mountains. Adjacent to the Old Woman/Old Man complex are the Garvie Mountains, which hold the high ground in the wet-dry transition zone, and whose tops are sharp and angular and contrast strongly with the rounded landforms of the block mountains. Different again, well forested on their flanks, are the Blue Mountains, darkly guarding the south-east corner of the region.

Tectonic forces have acted differentially in the region to produce mountain ranges of varying age and height. The central parallel ranges are considered to be the youngest, at about three million years, and the highest are in the west, closest to the Alpine Fault. This makes sense because the Alpine Fault is a primary driving force for the mountain-building. To the south of the parallel ranges are mountains about two million years older – the Old Man and Old Woman

Ranges and the Garvie Mountains.

Not only are most of the mountain ranges physically distinct; ecologically they also differ, although the distinctions in flora and fauna are more pronounced for groups of ranges than for individual ranges. Combinations of climate, geological history, altitude and habitat influence the flora and fauna patterns, with unique species occurring in a few places. In a sense, therefore, the ranges can be grouped into ecological islands – eco-islands.

The Maniototo

The Maniototo comprises Central Otago's largest plain and the land immediately west of it – North and South Rough Ridge, the Ida Valley, and, for the purposes of this chapter, the sprawling upland plateau of the Manorburn, which cradles a series of significant reservoirs – Poolburn, Greenland/Manorburn and Lake Onslow.

The Maniototo Plain, about 45km north to south and up to 20km wide, is by far the broadest basin in Central Otago. It is parsnip-shaped, with its bulky northern end

Carmichaelia crassicaule, an unusual shrub that appears dead until magnificent cream and purple flowers emerge in profusion from its leafless stems. The species has a scattered distribution in the semi-modified grasslands of Central. *John Douglas*

Matagouri *Discaria toumatou,* a hardy native shrub, is ubiquitous in Central. Drought-tolerant, it has relatively little foliage and is able to carry out photosynthesis through its stems. Its leaves appear mainly in wetter periods. *Neville Peat*

The rare cress *Lepidium sisymbrioides,* seen here flowering in early November, is known from only four sites in Central Otago, among them the hillsides surrounding the Patearoa saline area. *Brian Patrick*

tapering off to the south. In terms of drainage it lies apart from the Clutha country. The upper Taieri River meanders through the Maniototo before rounding the northern end of the Rock and Pillar Range and heading for the Strath Taieri. The surrounding high ground is drained by numerous streams that carry animal names – for example, Ewe Burn, Wether Burn, Hog Burn, Sow Burn and Pig Burn. The largest Maniototo tributary of the Taieri is the Kye Burn, which captures run-off from the Kakanui Mountains and Ida Range (Mt Ida, 1,692m, is the highest point in the Taieri catchment).

A low saddle near Wedderburn divides the Taieri catchment from that of the Clutha. The Ida Valley, draining into the Clutha via the Manuherikia, has an unusual drainage pattern. Water from the south, carried by the Poolburn, meets water from the north end of the valley, carried by the Ida Burn, at about the halfway point, and from here it flows through the Poolburn Gorge (Raggedy Range) to meet the Manuherikia River near Lauder. At one time, however, before the Poolburn Gorge was cut down so

deeply, the Ida Valley would have drained into the Maniototo Valley and the Taieri.

Ranfurly is the main town of the Maniototo, with Naseby the next largest settlement (once New Zealand's smallest borough). The Maniototo's Maori name recalls bloody clashes in the distant past, hence Mania o Toto, Plain of Blood. With annual rainfall ranging from 800mm in the north down to about 400mm in isolated places, the district is prone to drought.

South of Patearoa and Paerau, low hills dotted with tors and rocky areas separate the main plain from the Styx Basin, where the Taieri River has created a natural phenomenon, a scroll plain.

The Patearoa saline area, one of the most important saltpan sites in Central, contains excellent populations of a number of native halophytes such as *Apium* new species and *Selliera microphylla*. The latter occupies the dark green flushes in the middle right of the photo. Hillsides surrounding the mosaic of bare salty patches are a bonus. They also support important remnant native vegetation such as the recently named and rare low shrubby broom *Carmichaelia vexillata* (foreground) and cress *Lepidium sisymbrioides*. This site is also a key site for native insects, which reflect the diversity and quality of the native vegetation and an abundance of bare ground. *Brian Patrick*

Vegetation

The main basin of the Maniototo has no native forest and minimal shrubland. Where farming has the strongest hold (thanks largely to irrigation schemes), native plant communities have been lost or severely modified. Nonetheless, there are significant areas where native plant diversity remains impressive. For example, rock bluffs and gorges opening on to the plain act as refuges for a range of shrubs, herbs and grasses.

Above the plain, gently sloping hillsides are broken by occasional rock outcrops. Pasture or short tussock grassland provides the cover here, with remnant shrubland of *Coprosma propinqua*, *Gaultheria antipoda*, matagouri *Discaria toumatou* and scattered *Carmichaelia crassicaule*. This last-named is a bizarre-looking shrub in the broom family (see opposite).

At Blackstone Hill (990m), on the Raggedy Range, more shrub remnants survive. These contain *Melicope simplex*, a new species of *Ozothamnus* (formerly *Cassinia*), the deciduous *Coprosma virescens* and the rare climber *Carmichaelia kirkii*. An increasingly uncommon speargrass *Aciphylla subflabellata* is found sporadically through these low altitude grasslands. At higher altitudes on Rough Ridge the narrow-leaved snowgrass *Chionochloa rigida* asserts its authority with extensive stands caressing the smooth slopes and crests.

Saltpans

Natural saline areas have survived in a few places on Maniototo Plain, as in the lower Manuherikia (see page 52). Two areas stand out for their naturalness – Belmont and Patearoa. Both are protected under Queen Elizabeth the Second National Trust covenants. The Belmont covenant is the only inland salty site known to contain glasswort *Sarcocornia quinqueflora*, which is a typically coastal halophyte. Across the valley is the superb Patearoa saltpan site. In addition to possessing a suite of salt-tolerant plants, this latter site has the best representation of native dryland vegetation on the Maniototo Plains. Halophytes include *Atriplex buchananii* and *Puccinellia raroflorens* with *Lepidium kirkii* nearby. Dryland species include *Leptinella maniototo*, *Vittadinia australis* and *Raoulia australis*.

The Upper Taieri Scroll Plain from the air . . . a mesmerising vista. The foothills of the Rock and Pillar Range are in the distance. *Neville Peat*

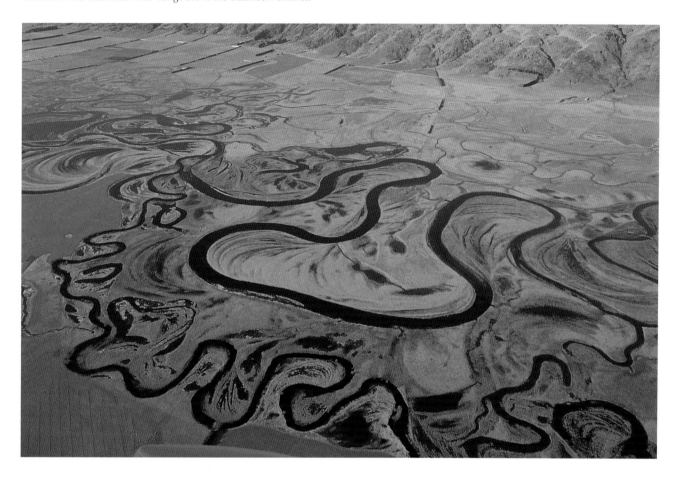

Grasses New and Rare

Marsh arrow-grass *Triglochin palustre*, although distributed widely across the world, is rare in New Zealand, having been found at only a handful of sites in Canterbury and Otago, including Linnburn Station in the Maniototo, where it is associated with a salty site. The second site, recently protected, is on the Cairnmuir Range. Marsh arrow-grass at up to 50cm tall is much taller than its relative *T. striata*, which is also found on salty soils, but within Central only in the environs of Alexandra.

A new species of rhizomatous grass, discovered on the screes of the Central Otago mountains, was formally named *Poa schistacea* in 1999, highlighting the possibility that other new plants may yet await discovery in the remoter parts of the region. It is found up to 2000m on mountain ranges from the Garvie Mountains westwards including its type locality, the Hector Mountains. Its distribution fits closely with the scree-inhabiting black mountain butterfly *Percnodaimon merula* in Otago, whose larvae are known to feed on this genus of small grasses.

Scroll Plain – An ornamental waterway

For sheer artistry in a waterway, there is nothing quite like the Upper Taieri Scroll Plain. Here, the river crosses the Styx Basin flood plain, 550m above sea level, in a maze of winding channels, half-crescents, cut-offs, ponds and backwaters. Before farming came along to modify the scene, these dark swirling ribbons of water would have been enscribed on an expanse of copper tussock, glossy and russet in low-angled sunlight. Although the pattern of the meanders cannot be gauged from ground level, the scroll plain remains a mesmerising vista from the air. Another meander pattern appears on the Maniototo Plain after the Taieri River emerges from a gorge separating the plain from the Styx Basin.

The New Zealand Landform Inventory accords the scroll plain a high rating, describing it as having scenic, scientific and educational importance. All stages of ox-bow formation are displayed. Wildlife values are exceptional. Fifty-two bird species have been recorded in the scroll plain and the meanders at the south end of the main plain. Native waterfowl known to be breeding include New Zealand

The flathead galaxiid *Galaxias depressiceps* (top) and roundhead *G. anomalus*. These species are small, slender fish. Like the other galaxiids, they lack scales and their skin is coated with mucus. Galaxiids have only one dorsal fin, set well back on the body. The genus name, *Galaxias*, refers to the array of gold patterns on the first species to be described, giant kokopu, whose coloration was seemingly reminiscent of the Milky Way galaxy. *Richard Allibone*

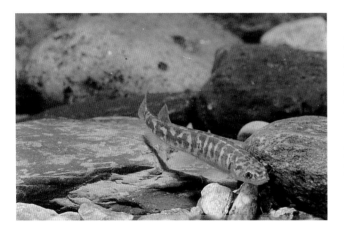

shoveler, grey teal, grey duck, black swan and paradise shelduck. Among the waders recorded are marsh crake, Australasian bittern, white-faced heron, pukeko, pied stilt and South Island oystercatcher.

Native fish do well, especially the long-finned eel. Also recorded are lamprey, common bully, and, in small tributaries, the upland bully and non-migratory galaxiids.

Copper tussock *Chionochloa rubra cuprea* is dominant on riparian margins in the Styx Basin. The large sedge *Carex secta* and raupo *Typha orientalis* are also prominent in the swamps and commonly offset by the smaller rushes *Juncus gregiflorus* and *J. effusus*. The introduced crack willow *Salix fragilis* occurs mainly as scattered trees on the riverbanks in the Styx Basin but on the Maniototo Plain it grows continuously along the riverbanks.

Galaxiids – Central's Freshwater Fish

A small mountain stream flowing into the Kye Burn just north of Danseys Pass is an exceptional spot for anyone interested in Otago's native freshwater fish fauna. Healy Creek is the only known place where two inland galaxiid species coexist – the roundhead galaxiid *Galaxias anomalus* and the flathead *Galaxias depressiceps*. Studies of the galaxiid group in Otago through the 1990s has revealed a greater diversity among them than was previously known.

Galaxiids are divided into migratory species, five of which contribute to the whitebait catch, and a number of non-migratory species that are less well known. By and large, the non-migratory galaxiids live in streams rather than rivers, and, where they have to share a waterway with introduced trout, they are in low numbers or entirely absent. Conversely, they tend to thrive in streams that have barriers to trout such as waterfalls and steep bouldery gorges. Slow-growing, they might take five years or more to reach a length of 15cm. They tend not to move far, either. Researchers using the electric fishing technique found one fish at exactly the same spot two years after it was tagged.

The non-migratory species do not readily associate with other species, except at Healy Creek. The roundhead *G. anomalus* has a patchy distribution south of the Waitaki catchment (Kyeburn, Manuherikia, Nevis and Von). Its type locality is a drain at Ophir in the Manuherikia catchment. It is found in habitats as diverse as small muddy streams in forested areas to swift bouldery streams in tussock country. The flathead galaxiid also occurs only south of the Waitaki. In Central, it lives in the Upper Clutha and Cardrona waterways as well as in the Maniototo, and tends to occupy streams at higher altitude than its roundhead cousin.

The Maniototo has another new but as yet undescribed galaxiid, tentatively named for its locality, Totara Creek. Otago, and in particular the Central region, is of major interest to freshwater fish scientists because of the number of new galaxiid species turning up. There are only 34 described species of native freshwater fish in New Zealand (the galaxiids are the largest group, with 18 species). Additions to the list occur infrequently. The Taieri catchment alone has 16, and the Clutha catchment 15. Common native species in Central include the upland bully *Gobiomorphus breviceps* and long-finned eel *Anguilla dieffenbachii*.

Ironically, the well-watered lakes region to the west has few native species, possibly because the ice ages and glaciers displaced them. In some places there are land-locked populations of koaro *Galaxias brevipinnis*, which is at home in mountain waters but is one of the whitebait species and normally has a juvenile phase at sea.

Upper Manorburn tussocklands on a summer's day, with light and shade adding texture to the landscape. *Neville Peat*

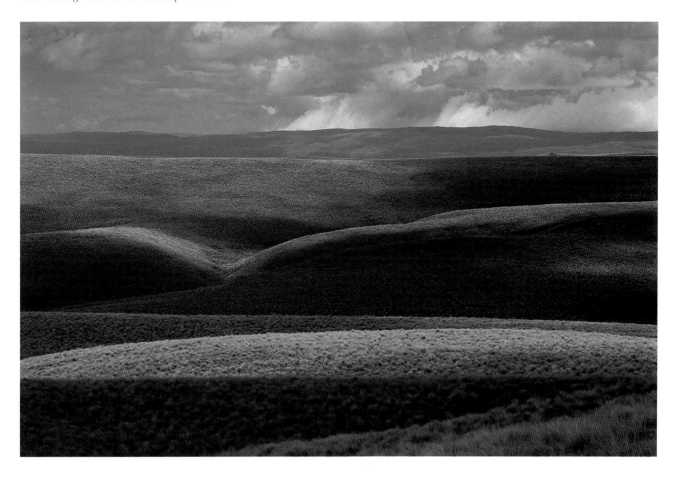

One component of the insect fauna of the Manorburn deserves special mention – the species that emerge in late autumn and early winter. These species breed in the wetlands or on wetland margins and wait until their habitat dries out before they emerge as adults. They include moths discovered only recently, among them *Eurythecta leucothrinca*, *Heloxycanus patricki* and *Scoparia apheles*. The newly discovered and undescribed day-flying tortricid moth above has been found in many low-alpine areas of Central since it was identified. *Brian Patrick*

Manorburn

The gently undulating landforms across much of the Manorburn area create a strong impression of Otago's ancient peneplain – a geomorphological feature that disappeared with the development of the range-and-basin landscape. The landscape is virtually treeless. Few rock tors catch the eye in a vista that is everywhere softened by tussock grasses. The Manorburn uplands spread northwards from the Teviot catchment. To the south-west Lake Onslow feeds the Teviot River, and on the rolling plateau itself, the Greenland and Manorburn Reservoirs retain water bound for the Manuherikia. About 10km north of the Manorburn Reservoir is the island-dotted Poolburn Reservoir, storing water for the Ida Valley. The Old Dunstan Road, the historic range-and-basin way to the goldfields of Central, passes by this reservoir.

The Manorburn's copper tussock grasslands, the most intact stands left at mid-altitude in Otago, are a prominent feature of the vegetation. Copper tussock *Chionochloa rubra cuprea*, is especially dense and tall around the Greenland Reservoir, but there are also significant stands in hollows

Copper tussock grassland at an altitude of 1,150m, below South Rough Ridge. A small creek meanders through a cushionfield containing a large number of species, including the grey-green *Celmisia argentea*, low woody *Dracophyllum muscoides* and compact *Oreobolus pectinatus*. Brian Patrick

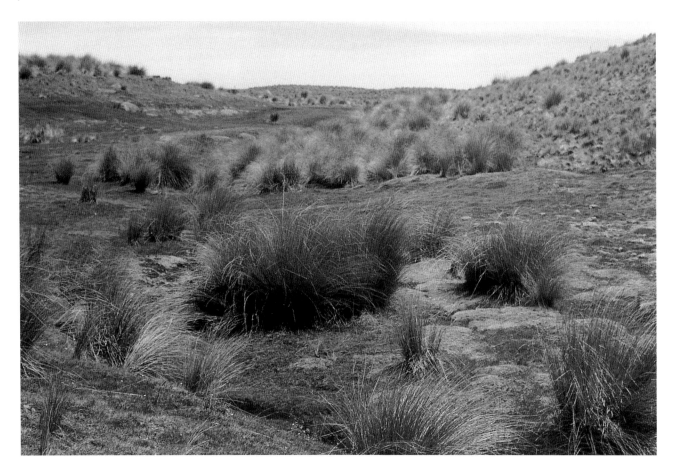

and gully heads right across the uplands. Narrow-leaved snow tussock *Chionochloa rigida*, the commonest tall tussock species of the Otago high country, holds sway on the Manorburn's higher ridges. The ridge topped by Pinelheugh (1,124m), defining the southern boundary of the Manorburn uplands, supports an association of *C. rigida* and the rarer slim-leaved snow tussock, *C. macra*. Elsewhere, the short fescue tussock *Festuca novaezelandiae* is dominant in the uplands where there has been a policy to convert the tall tussock to pasture. Where soils are deeper, silver tussock *Poa cita* survives, conspicuous by its dense tufts of glossy golden-silver leaves.

In South Rough Ridge, east of the Greenland Reservoir, the Waimonga Creek catchment harbours native shrubland of high ecological value. Shrub species include *Coprosma ciliata*, *C. propinqua*, *Olearia nummularifolia* and inaka *Dracophyllum longifolium*. Similar shrubland occurs in the upper reaches of nearby Deep Creek. The highest peaks reach only 1,174m, at the head of the Linn Burn. Only in the area of this peak does grassland give way to extensive wetlands and cushionfield. Wetlands are also an important feature of the

Flowers and foliage of the cushion daisy *Celmisia argentea*. The flowers are about 20mm across. Kelvin Lloyd

Tor city – the summit crest of the South Dunstan Mountains, with Leaning Rock in the distance. *Neville Peat*

Right: Protected slim snowgrass *Chionochloa macra* grassland on the North Dunstans, a conservation area. *Neville Peat*

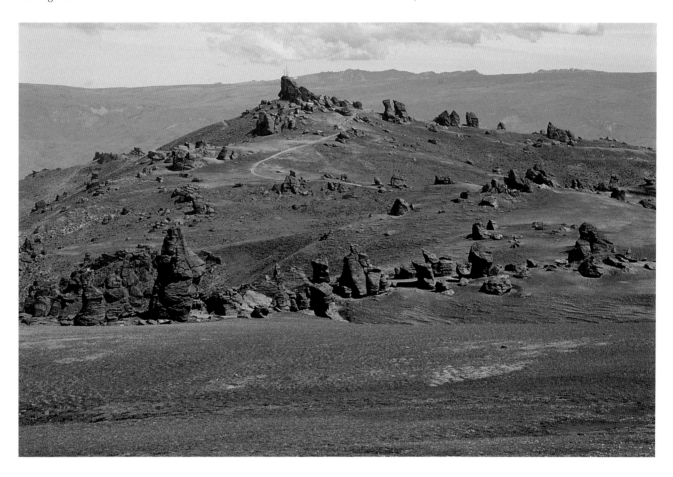

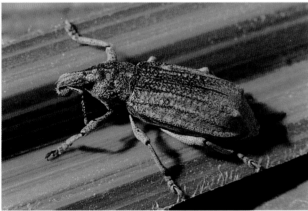

The chunky weevil *Anagotus lewisi* is a significant insect in the grasslands and wetlands of the Manorburn. Also significant are the rare moth *Asaphodes ida* and flightless caddis *Philorheithrus* new species. *Brian Patrick*

Manorburn area, with significant sites at the Greenland Reservoir and in the headwaters of Totara Creek on South Rough Ridge. These are rich in native herbs, sedges and mosses. Abundant species include the moss *Sphagnum cristatum*, carpets of the tiny blue-flowered lily *Herpolirion novaezelandiae*, eyebright *Euphrasia dyerii*, and the herbs *Schizeilema cockaynei* and *Stackhousia minima*. Snowbanks support the tiny daisy *Brachyscome humilis*.

On the western side of the Manorburn area, Gordon Peak (1,004m) and Pinelheugh (1,124m) are the highest peaks in the range dividing the Manorburn from the Teviot catchment. Lower stature grassland of blue tussock *Poa colensoi* cloaks these summits, together with an abundance of inter-tussock native species.

Sea birds above the snowline

How bizarre it is to see sea birds in these alpine zones. The southern black-backed gull and South Island pied oyster-catcher both breed high up on the Dunstan Mountains and Pisa Range. They come in the summer and seem able to cope with conditions that are often freezing. Black-fronted terns have also been recorded here, and small flocks of banded dotterels are not infrequently seen (see page 103).

Australasian harriers patrol these ranges, crossing the summit crests from time to time. New Zealand falcon, though less numerous, looks out for live prey and will engage in aerial chases or devastatingly effective swoops.

At lower altitudes, in the kanuka forest and shrublands, silvereye and grey warbler eke out a living, and New Zealand pipit fossick in the grasslands.

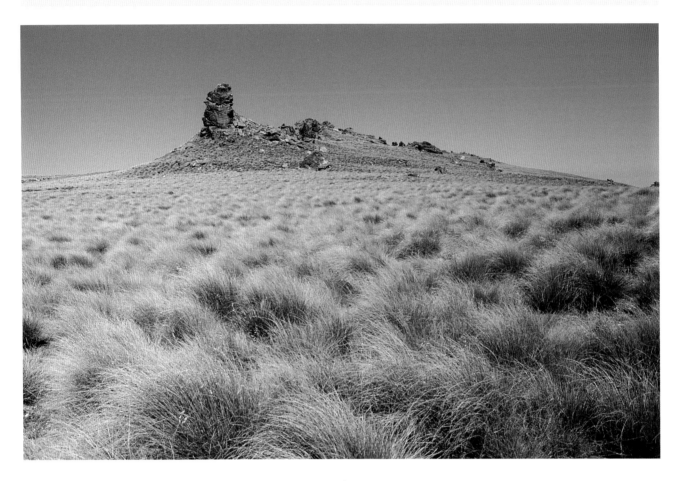

Dunstan Mountains and Pisa Range

The Dunstan Mountains and Pisa Range are the western-most block mountain ranges, rising imposingly and in parallel formation above the valley floor on each side of the Upper Clutha Valley. The Dunstan Mountains, divided into North and South units by the Thomsons Gorge, reach altitudes of 1699m in the south and 1670m in the north. Leaning Rock (1,647m) is a well-known landmark at the southern end of the Dunstans. For several kilometres north of this massive outcrop the summit crest is crowded with tors marching sentinel-like into the distance. This is a showcase area for them in terms of size and expressive individuality.

At the northern end of the range the 'grain' of the landscape is broken by the Chain Hills running almost at right angles. Beyond lies Dunstan Creek, the St Bathans Range and the transition zone between Otago schist and the greywacke and sandstone country further north.

The Dunstan Mountains have relatively steep and craggy eastern faces, with gentler slopes in the west, and that landform pattern is repeated for the Pisa Range, the highest of all the block mountains, rising to 1,964m at Mt Pisa. Cirque lakes, the products of past glaciation, occur on the Pisa Range. Snow patches often persist through summer in the highest cirques. The patterned ground is active and still developing as a result of the intense cold. There are spectacular tors at intervals along the summit, including one tower-like tor that was described by the surveyor-explorer John Turnbull Thomson in 1857 as 'a huge leaning rock remarkably like the Campanile Pisa', hence the range's name. The Pisa's summit plateau is vast, between six and nine kilometres wide, and it is drained mainly by two catchments – Luggate Creek in the north and Roaring Meg in the south.

The tops of both ranges support extensive plateaux dissected by numerous creeks. Despite the cold conditions, plant and invertebrate communities thrive, especially around water. Dense narrow-leaved snowgrass *Chionochloa rigida* clothes upper slopes where pastoral management has been conservative, and this grassland is mixed with occasional

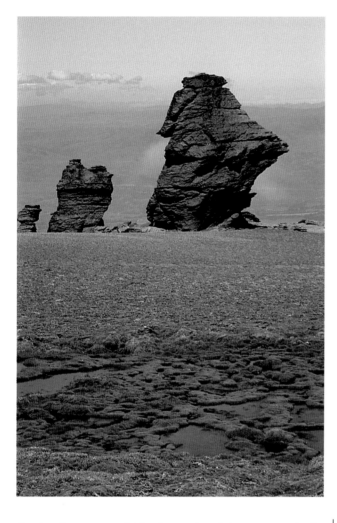

An 18m-high tor on the Dunstan tops, with a wetland in the foreground. *Neville Peat*

Mixed snowgrass/shrubland habitat in the Thomsons Gorge area. *Olearia odorata*, matagouri and briar are prominent shrubs. *Neville Peat*

shrubs of cottonwood (*Ozothamnus*) and the grass tree inaka (*Dracophyllum*). Higher up this habitat gives way to a grassland of lower stature, featuring slim snowgrass *Chionochloa macra* and dense herbfield, typified by the whipcord shrub *Leonohebe hectorii, Hebe buchananii, Ourisia glandulosa, Lobelia linnaeoides*, the grey-leaved *Brachyglottis haastii* and sharp-pointed tufts of *Aciphylla lecomtei*. The alpine daisy *Celmisia viscosa* forms extensive sticky-leaved clumps, as it does on other range tops, and blue tussock *Poa colensoi* is also common. Above the rich cushionfields are areas of rocky fellfield with sparse plant cover. Characteristic plants in this zone include low cushions of *Dracophyllum muscoides, Anisotome imbricata, Myosotis pulvinaris, Chionohebe thomsonii,* and *Raoulia youngii*, accompanied by herbs such as *Leptinella goyenii, Aciphylla hectorii,* and *Celmisia ramulosa*. Mounds of the orange-coloured speargrass *Aciphylla simplex* are locally common on the crest of the Pisa Range.

Uncommon species growing on the southern end of the Dunstan Mountains include the rare forget-me-not *Myosotis albosericea* and two other plants – *Kirkianella novaezelandiae* and *Ischnocarpus novaezelandiae*. The latter grows at 1,500m – the highest known population of this rare cress.

The two ranges share a diminutive blue-green grass *Poa pygmaea*, while *P. senex* is shared exclusively between the Pisa and Old Man Ranges. A dull greenish-grey, tightly packed cushion *Chionohebe myosotoides* is confined to the summits of the Pisa and Rock and Pillar Ranges.

Haven for Insects

The mountain ranges of Central Otago provide habitats for the most diverse and spectacular insect fauna found in any New Zealand region. On hot days the flurry of activity can be astonishing. Features of the fauna include its high degree of seasonality and host plant specificity.

Among the multitude of **beetles** in the Central Otago alpine zone, weevils both tiny and large are numerous. Most are active on hot days and feed on flowers. Bumbling over cushion plants is the large black chafer beetle *Scythrodes squalidus*, a flightless species that is endemic to southern New Zealand. The similarly flightless genus *Prodontria* is

Above: Mist sweeps over the crest of the Dunstan Mountains, highlighting the prominent tors. Sparse cushion plants are the only plants that survive in this harsh environment where frost action limits plant growth on the dry open pavements. *Brian Patrick*

Below: High alpine snowbanks on the Dunstan Mountains are the headwaters for various streams. Typically *Celmisia haastii* occupies the damper ground in the hollows and cushions of *Kelleria childii* and *Phyllacne colensoi* the margins. These open herbfields are a paradise for insects, with much activity on warmer days of summer. *Brian Patrick*

Below: The hepialid moth, *Aoraia senex*, is common on the Dunstan and Garvie Mountains, the Pisa and Old Man Ranges. Central Otago is the centre of diversity for *Aoraia*. Of the 13 large moths in the group endemic to New Zealand, nine are found in the mountains of Central and five are endemic to it. *A. senex* flies by day and the males (top) are spectacular as they bombard the flightless females (bottom). Other species are nocturnal or crepuscular (dusk flying). The female, larger than the male with body length of about 26mm, scatters her eggs on the ground. Larvae construct subterranean tunnels from which to emerge and browse on vegetation. The Umbrella Mountains have the most species of this genus, with four documented so far. Both *A.flavida* and *A.aspina* have their type locality there. *Brian Patrick*

Top: Aquatic insects such as the day-flying caddis *Periwinkla childi* are common on Central's ranges and many emerge from snow caves forming over streams. *P. childi* has jet-black wings that carry a small red mark. Larvae live within a distinctive case, which they carry around as they feed in the stony streams. *Brian Patrick*

Bottom: Adults of the stoner *Zelandoperla pennulata* are common streamside insects on all the mountains of Central. The fast-running, flightless adults, about 18mm long, are quite different in behaviour from the gregarious larvae, which are found on the undersides of submerged rocks. *Brian Patrick*

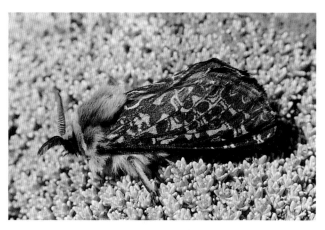

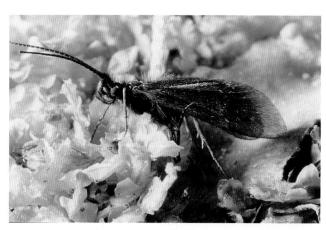

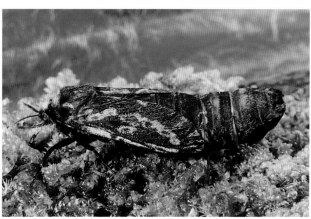

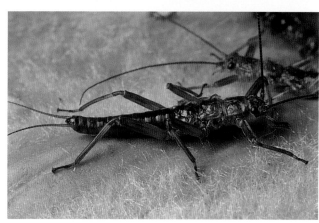

represented by five species in alpine Central, with the black *P. capito* being the most widespread. Restricted to a small area of the Hector Mountains is *P. pinguis*, while *P. patricki* is known only from Danseys Pass. Two species are found only on the Pisa Range, where *P. capito* shares the alpine grassland and herbfield with *P. regalis*.

Colonies of the attractive orange **cockroach** *Celatoblatta quinquemaculata* are a common sight across the alpine tops of Central. Found under stones, they share this habitat with a black shiny byrrhid beetle *Pedilophorus lewisi* and a broad-nosed weevil *Anagotus latirostris*. Black **cicadas** sing from rock outcrops or from the ground on the hottest days. Four species are found on Central Otago mountains, with *Maoricicada otagoensis* common in the alpine zone. Higher up, the smaller *M. nigra frigida* is found. Both these species are found south of the Clutha River, whereas *M. phaeoptera* is on the Dunstan Mountains and Hawkdun Range. A fourth species *M. clamitans* is on the mountains of North Otago.

Perhaps the most conspicuous insects in the alpine zone are the **grasshoppers**. Major defoliators in all stages of their lifecycle, they are represented here by six species in four genera. The large and hairy *Sigaus obelisci*, named from the Old Man Range, is widespread on the higher peaks. Meanwhile the bright green *Alpinacris tumidicauda*, with its orange rear end, is an inhabitant of snowbanks.

Three species of large **weta** are found on these ranges. The ground weta *Hemiandrus focalis* is widespread but the larger mountain weta *Hemideina maori* is very localised. Populations of the latter are known from the Umbrella and North Dunstan Mountains, Rock and Pillar and Ida Ranges, and the island of Mou Waho in Lake Wanaka. A giant weta species *Deinacrida connectens* lives in scree or summit rocky areas on the Ida and Kakanui Mountains.

Moths are abundant. More than 200 species are found in the alpine zone on each of the mountains of Central Otago. Each alpine zone has a complement of moths common to alpine zones nationwide, mixed with a regional fauna and sometimes a small endemic element. This moth fauna is distinguished by a high number of day-flying species that are brightly coloured or black and which tend to be

A towering rock wall in Thomsons Gorge. Cliffs like this are important refuges for dryland shrubs, herbs and grasses. *Neville Peat*

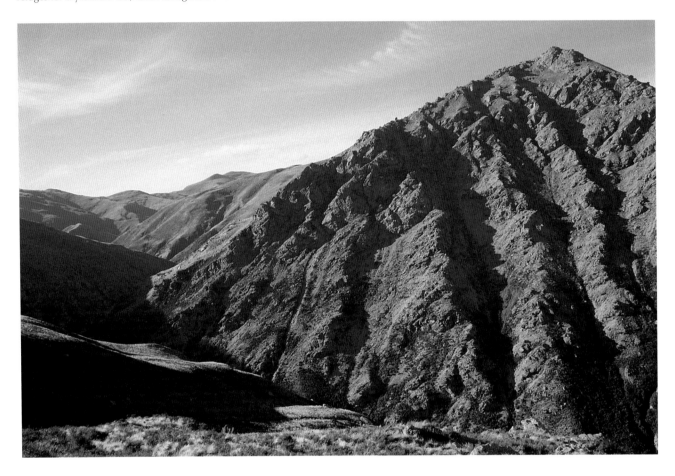

hairy. Reflecting the relative youth of our mountains, many alpine species are upland specialists, but very few genera are confined to this zone. Among the most conspicuous and colourful moths in the alpine zone are the day-flying geometrids. More than 40 species are found in Central in genera such as *Cephalissa*, *Notoreas*, *Dasyuris*, *Aponotoreas*, *Pasiphila* and *Paranotoreas*.

Butterflies are not nearly as numerous. Two species of tussock butterfly frequent the snowgrass zone on all the ranges. The faster flying *Argyrophenga janitae* is an alpine specialist, whereas *A. antipodum* breeds anywhere between sea level and the uplands. The closely related black butterfly *Percnodaimon merula* is more widespread nearer the main divide but extends as far east as the Garvie Mountains and the Pisa Range. Mostly it frequents screes, but the small form from the Pisa Range flies and breeds over summit fellfield. Red admiral butterflies *Bassaris gonerilla* are often sighted in the alpine zone, where they breed on the localised nettle *Urtica aspera*.

Many of the **aquatic insect species** are endemic to Central Otago uplands. These include a short-winged **stoner**

The yellow-flowered forget-me-not *Myosotis albosericea* forms silvery cushions. Known from only one site on the southern end of the range, at an altitude of 1500m, it is one of the most localised plant species in New Zealand. Forget-me-nots are a feature of the Dunstan Mountains, with no fewer than six species occurring in the alpine zone. The cushion *Myosotis cheesemanii* and *M. oreophila* grow on the northern end of the range, with the former found elsewhere only on the Pisa Range and the latter only on Mt Ida. The genus name *Myosotis* means 'mouse-earred'. *Brian Patrick*

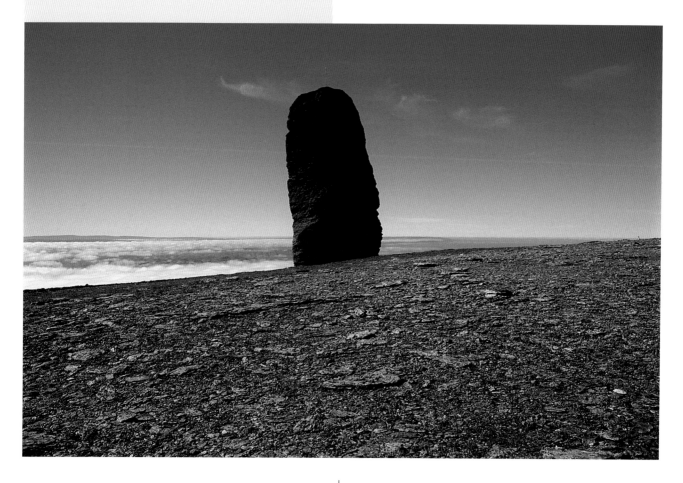

Zelandobius mariae, described from the Pisa Range and subsequently found on the Hector Mountains. Flightlessness is a feature of alpine stoner species and exemplified by the widespread *Austroperla cyrene*. Only in the alpine zone is it short-winged. On the Umbrella Mountains and Old Man Range a new species of stoner in the genus *Vesicaperla* was recently discovered. Wingless, it breeds on stream margins in the high alpine zone and browses the foliage of plants such as *Celmisia haastii* leaves. Fully-winged species include the black and white *Cristaperla waharoa*, *Taraperla ancilis* and *Spaniocerca longicauda*.

True bugs are also diverse in the alpine communities of Central Otago. Shield bugs such as *Dictyotus caenosus* and *Cermastulus nasalis hudsoni*, plus lygaeids in the genus *Rhypodes* are numerous on cushion plants and shrubs.

Southern Summits –
Old Man, Old Woman, Garvie, Umbrella

The Old Man Range conspires with the Old Woman Range to guard Central's semi-arid zone from moist weather systems arriving from the south-west. In this role they get some help from the Umbrella Range and Garvie Mountains. Together, the four ranges create a physical boundary between Otago and Southland, and a transition zone between moist northern Southland and the dry interior of Central Otago. The only through road, the Waikaia Bush Road, is impassable to most vehicles, even in dry summer weather, and blocked entirely by snow for months on end, although in dry spells, with the snow gone, the road to the Old Man summit from Fruitlands is negotiable with care. Between the pinnacled Garvie Mountains and the smoother Umbrella Range is the Waikaia Valley and its tributaries, supporting a wedge of beech forest that is significant not only because of its extent but also because of its interesting plant and animal life. These rangelands harbour some extraordinary physical as well as biological features. Running parallel with the crest

Hummockfield habitat at about 1,600m above sea level on the Old Man Range. The sticky-leaved daisy *Celmisia viscosa* dominates the hollows, with *Dracophyllum muscoides* on the sides of the hummocks and *Raoulia hectorii* on the tops. Many small herbs, mosses, lichens and sedges thrive among these cushions. Recent research confirms that the soil hummocks are still active because of differential freezing of the soil. *Brian Patrick*

of the Old Man Range are two back-to-back basins – the Fraser, whose meanders drain north to launch the Fraser River, and Campbell Creek, which initially flows south through a similar meander at 1,200m above sea level before turning to meet the Waikaia River. Bogs, seepages and tarns signal a wet alpine environment. The basins, bearing glacial cirques from the Pleistocene ice ages, are separated by a narrow ridge at Hyde Rock (1,672m).

The **Old Man Range**, a great hump-backed bulwark at the southern end of the Manuherikia Valley, has long been a landmark for Central Otago travellers. It is also steeped in tradition. Maori traditions tell of a giant named Kopuwai who lived in these mountains and preyed on unwary travellers with his pack of two-headed hunting dogs. The range had a fearsome reputation for early gold miners. In a snow storm in August 1863, 35 men reportedly died trying to negotiate a poled route over the range back to Alexandra from the diggings on the Southland side. The Old Man Range is still renowned for its harsh climate and its exposed landforms. The mean annual temper-ature on the 20km-long summit crest (1440m to 1695m) is close to zero. With wind speeds averaging 20kph, wind chill is commonly well below zero. On average, snow covers the summit for four to six months of the year. Cloud covers the tops six days in every 10, making the range six times cloudier than Alexandra. Precipitation on the summit averages 1620mm.

The signs of a severe climate are everywhere on the Old Man Range. Freeze-thaw cycles spawn hummockfields, and solifluction lobes sprawl downslope, widening wave-like as they go. The vegetation, dwarfed on the summit crest, resembles tundra, with sand-blasted cushion plants interspersed among areas of flat rock or gravel. A dominant fellfield plant is *Dracophyllum muscoides*. The cushion mountain daisies, *Celmisia viscosa* and *C. brevifolia*, are prevalent on more fertile ground, with blue tussock *Poa colensoi* the most prominent grass species. Snowbanks host bright green cushions of *Chionohebe glabra* and the herb *Geum pusillum*, which is a local endemic. The slim snow tussock *Chionochloa macra*, which occurs at the summit of other

The head of the Fraser Basin – a cirque on the Old Man Range.
Neville Peat

mountain ranges, notably the North Dunstan, struggles on to reach the crest of the Old Man. Below about 1,200m, tracts of narrow-leaved snow tussock *C. rigida* now occupy slopes that once supported alpine shrubland that was cleared by fire in pre-European times. The fire-hardy golden speargrass *Aciphylla aurea* shows out where the burning has knocked back the tall tussock. A number of plants and insects have their type locality on the Old Man Range. A native bidibid, *Acaena tesca*, found only on Central Otago ranges, was recently described, with the Old Man Range nominated as the type locality.

The **Old Woman Range** presents much the same picture again, although the summit crest, rising to 1,690m, is less rocky. At the northern end the 10km-long range drops away to Duffers Saddle (1300m), gateway to the lower Nevis Valley. Another gentle saddle, the Waikaia-Nevis Divide, separates the Old Woman Range from the Garvie Mountains, and in the 'armpit' defined by the contiguous Old Woman-Old Man Ranges and the Garvies lies an expansive alpine plateau, a favoured spot for winter snow recreation.

The **Garvie Mountains** rise to 1,889m at Rocky Mount. Pinnacles and rock buttresses give these mountains an appearance altogether different from the erosion-rounded ranges to the north. At the higher northern end, glaciation has left cirque basins with steep headwalls on the eastern side of the range. Some of the basins contain lakes. Blue Lake, over 1km long, is the best known of a series of lakes and tarns draining into the Waikaia. On the western side of the Garvies, a remarkable tableland the Nevis Plateau overlooks the Nevis Valley, decorated with a pattern of earth stripes that resemble paddocks roughly ploughed. Tall tussock grasslands reach about 1,800m, with slim snow tussock climbing higher than narrow-leaved snow tussock, which dominates the low alpine zone.

Parallel to the Garvies, the **Umbrella Mountains** form the high ground on the eastern side of the Waikaia Valley. Whitecoomb (1,453m), above Piano Flat, is the highest point. In the area where the Umbrellas meet the Old Man Range, the Pomahaka River starts life as two branches, normally little more than chuckling mountain streams. A

Campbell Creek, a tributary of the Waikaia River, meanders through an impressive basin near its headwaters on the Old Man Range.
Graeme Loh

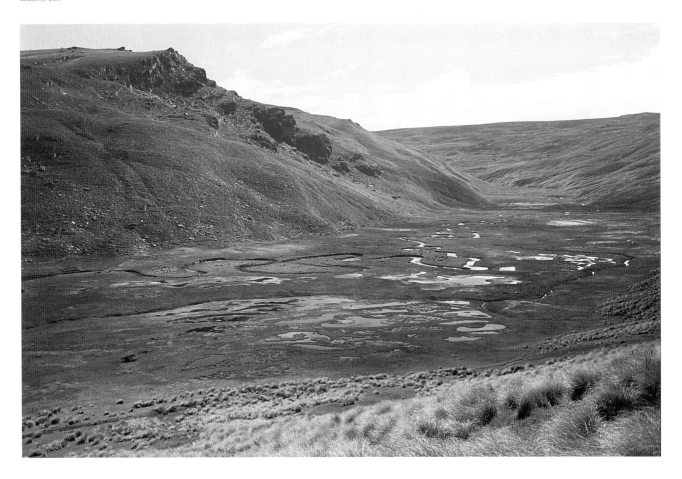

mosaic of open wetlands, cushionfield with diminutive snowgrass, and shrubland patches cover the range. The shrublands support *Ozothamnus, Leonohebe odora* and the more local *Pimelea poppelwellii*. Downstream, small patches of silver beech shade damp gullies in the Pomahaka Valley, with woodlands of the newly described *Olearia fimbriata* growing on nearby slopes and terraces. This tree daisy has both its largest population and type locality in the Pomahaka Valley. Within the remnant forests, damp zones carry diverse herbs, ferns and sedges. Forest margins support the uncommon liane *Fuchsia perscandens* together with the more abundant *Muehlenbeckia complexa*.

Mt Benger (1,183m), separated by high saddles from both the Umbrella Mountains and the Old Man Range, is an outlier to the south-east. It is clothed in snowgrass, which is in places mixed with dense and diverse shrubland of *Ozothamnus, Leonohebe odora* and *Dracophyllum uniflorum*. Pockets of silver beech survive in several steep gullies. On Mt Benger's broad summit there are cushionbogs, rich herbfields and steep snowbanks, all containing plant species

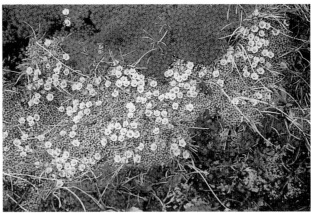

The cushion plant *Phyllachne rubra*, a Central Otago endemic, just below the Old Man Range summit crest. Cushion plants are common in the mountains, with no fewer than 17 families of plants expressing this growth form. The shape confers competitive advantages in an environment where high winds and heavy snow are normal.
Brian Patrick

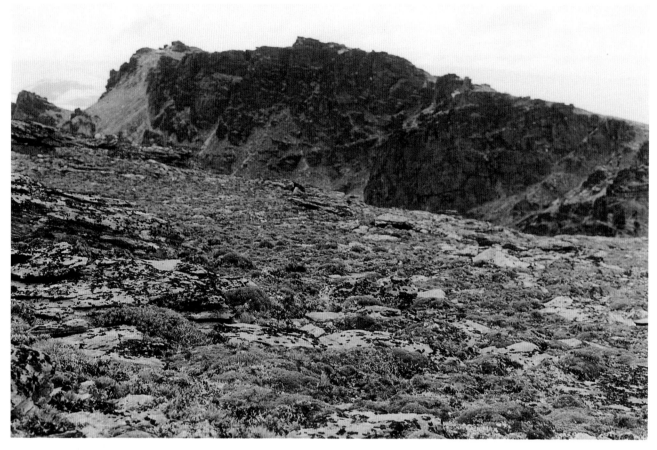

Rocky Mount, at 1,889m, is the highest point of the Garvie Mountains. Although bare rock dominates the ground in places, numerous herbs and cushions coexist in this harsh landscape. Prominent in the photo are orange cushions of the speargrass *Aciphylla simplex*, olive-green cushions of *Dracophyllum muscoides* and patches of the dark green *Celmisia brevifolia*. Black crustose lichens are prevalent on the rock surfaces. *Brian Patrick*

Below: Depleted slim snow tussock grassland on the Old Woman Range. The stream is draining a snowbank. *Brian Patrick*

The most common speargrass species in the dry core of Central Otago is the golden speargrass *Aciphylla aurea,* in flower here at the Poolburn Reservoir. *John Douglas*

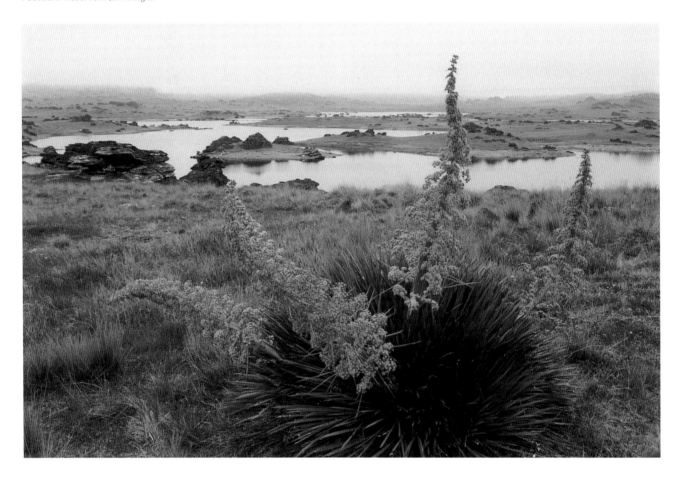

typical of Central Otago's wetter zone.

Only a few bird species frequent the alpine zone of any of these ranges. On the Old Man, banded dotterel, southern black-backed gull and South Island pied oystercatcher are breeding on or close to the summit crest, and New Zealand falcon is sometimes seen in the vicinity. Falcon and New Zealand's celebrated alpine parrot, the kea, are occasionally found among the crags of the Garvie Mountains, and kea are even known to drift across to the Umbrella Mountains. They are no doubt grateful for the beech forest of the Waikaia Valley to find food and shelter in when the weather turns stormy.

Rare Grass

In rock refuges on the mid-slopes of the Old Man Range lives one of New Zealand's rarest grasses, *Simplicia laxa.* It is a short mat-forming grass, known only from about five other sites in North and East Otago. The largest population, however, is located on a massive rock outcrop called Castle Rock on the slopes overlooking Fruitlands. It was discovered there in 1969.

Massed Mosses

Of the nine species of sphagnum moss found in New Zealand, no fewer than seven occur in water-logged sites in the uplands of Central Otago. The commonest are *Sphagnum cristatum* and *S. squarrosum.* One pale brownish-green species, *S. simplex,* a New Zealand endemic, is found on the Old Man Range and Garvie Mountains. *S. compactum* is another species only locally common.

In the high alpine zone of the Old Man Range is found the rare orange lichen *Solorina crocea*, pictured here growing within the cushionplant *Abrotanella inconspicua*. *John Douglas*

The mountain daisy *Celmisia brevifolia* is common on the mountains of Central Otago. It is pictured here at the head of Obelisk Creek on the Old Man Range, where it dominates an area among tors. *John Douglas*

An undescribed species of woollyhead in the genus *Craspedia*, pictured with alpine grasses on the Old Man Range. This Australasian genus contains many as yet unnamed species. *John Douglas*

Ida Valley Beetle

Rarer than the Cromwell chafer, the Ida Valley beetle *Mecodema laeviceps* was last seen near Oturehua in 1964. Past records suggest it is sparsely distributed. A Central Otago endemic in the carabid group, it is shiny black and reaches a length of about 28mm. It feeds at night and shelters by day under rocks or in holes. Its plight highlights the problems faced by large insects living in the valley floors of Central. Survivors include the tenebrionid beetles *Mimopeus rugosus* and *M. lewisianus*, both described from the Maniototo.

Caught in the act! A colourful male tiger moth *Metacrias huttoni* has tracked down a mate, hidden under a rock high up on the Old Man Range. The buff-coloured female has tiny wings, so must 'call' a male by the use of scents known as pheromones. He detects the scent with his antennae and flies towards the highest concentration of the chemical to find her and mate. The larvae of our three tiger moth species are reddish brown and extremely hairy. They can be locally numerous on Central Otago alpine areas. *Brian Patrick*

The larvae of the noctuid moth *Meterana meyricci* are difficult to discern on its shrubby host *Pimelea poppelwellii*, seen here at Gem Lake on the Umbrella Mountains. Fortunately this distinctive moth with spectacular pink body and hindwings feeds on other *Pimelea* species because this host is endemic to Central and has a narrow distribution. *Brian Patrick*

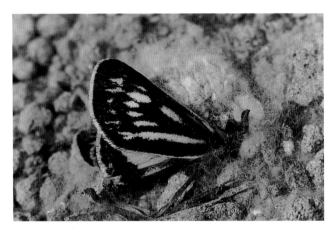

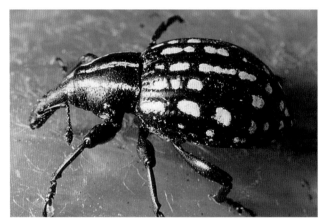

Above: Among the 26 species of alpine caddis recorded from the myriad streams on the Old Man-Old Woman plateau areas is *Hydrobiosis torrentis*. It belongs to New Zealand's most species-rich caddis family and genus. Typically the green larvae predate other aquatic invertebrates and later pupate within a stone and silk shelter they construct attached to the underside of river stones. Whereas *H. torrentis* has a wide South Island distribution, another newly described caddis *H. taumata* is endemic to Central Otago, being found only on the Eyre Mountains and the Old Man and Old Woman Ranges. *Brian Patrick*

Centre right: Of the three species of speargrass weevil on the Garvie-Old Man-Old Woman-Umbrella plateaux, *Lyperobius hudsoni* is the most common. It is often seen by day crawling over cushion vegetation or feeding on various carrot family relatives. *Brian Patrick*

Right: The tiny stoner *Zelandobius alatus*, just 6mm long, is among the 13 stoner species found only in Central Otago ranges. It is seen here at an altitude of 1,600m on the Old Woman Range. The larvae of this species live in swift summit streams and the flightless adults are active by day on the stream margins. *Brian Patrick*

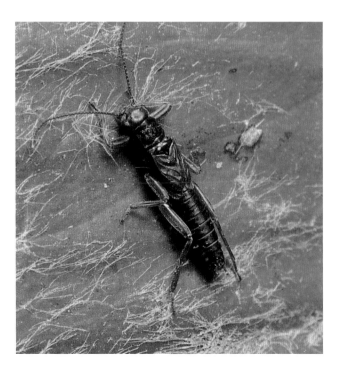

Alpine carrot: *Anisotome capillifolia*, a member of the carrot family *Apiaceae*, grows on steep cirque walls above Gem Lake in the Umbrella Mountains. The plant is host to large-bodied weevils of the genus *Lyperobius* and caterpillars of *Dasyuris* moths. *Brian Patrick*

A special plant of the Central Otago summit plateaux is the small creeping herb *Leptinella goyenii,* seen here flowering amidst *Dracophyllum muscoides* on the Old Man Range. It tolerates the most exposed and severe environments. *John Douglas*

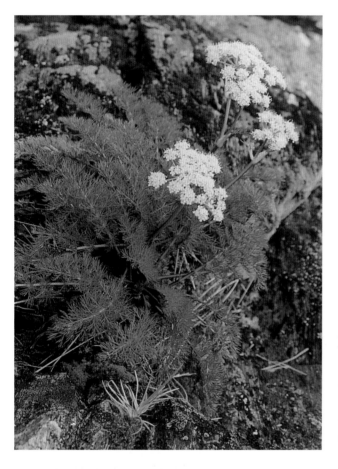

Only one species of giant land snail is found in Central Otago region. The olive green shells of *Powelliphanta spedeni* are distributed eastwards from Mt Burns in Fiordland across the ranges of northern Southland to Mt Benger and the Umbrella Mountains. Described from the Mataura Range, it also lives in the Eyre and Garvie Mountains as well as the Umbrellas. Characteristically it is found both just below and above the treeline. *Brian Patrick*

Nokomai – A wetland with a head for heights

High on the Garvie Mountains is a wetland of major importance – the largest upland patterned mire in Australasia. The extensive Nokomai complex, of about five square kilometres, comprises stepped pools, string bogs, wetland fingers and a multitude of islands. It is between the head of the Dome Burn and Roaring Lion Creek at an altitude of 1,250-1,400m, with hillside flushes feeding the system rising to 1,500m.

Dominated by mosses, including several species of sphagnum, the Nokomai wetland supports a diverse flora of low-growing sedges, herbs and grasses, and some prostrate shrubs. Recent research on pollen trapped in the peat of this wetland complex has shed light on the changes that have occurred in the vegetation cover of Central Otago in the past 12,000 years.

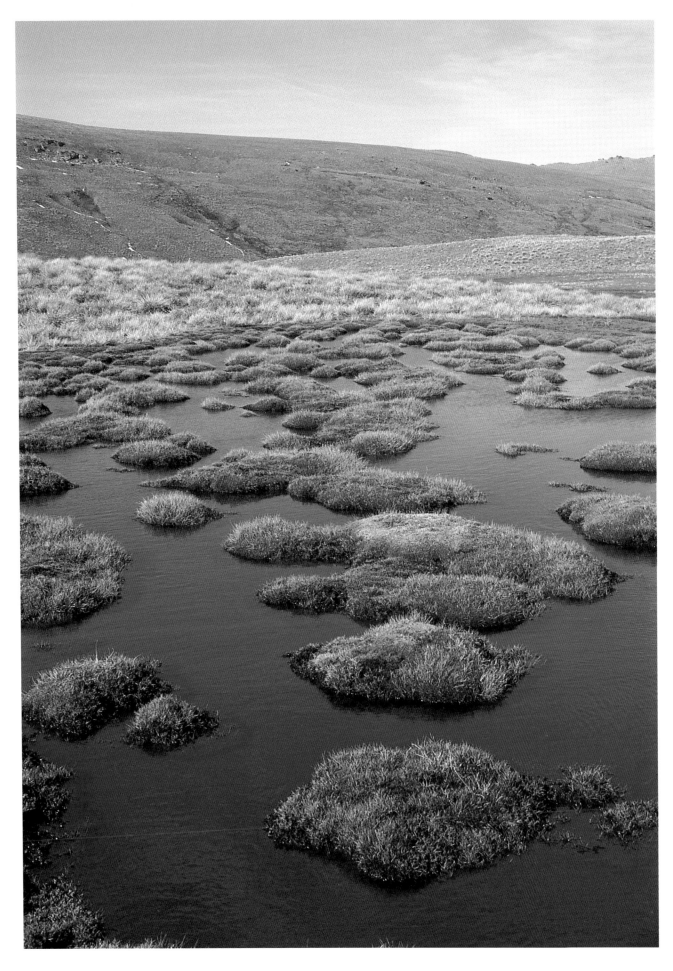

Ponds, string bogs and flushes contribute to the Nokomai wetland complex at the head of Roaring Lion Creek. *Kelvin Lloyd*

Waikaia Bush from the treeline after an autumn snowfall, looking towards Titan Rocks on the skyline. Where the treeline meets the Old Man Range the spars of burnt beech trees are dotted across the slopes. The forest here was destroyed in the Big Fire of 1882, lowering the treeline by over 300m. Regrowth has possibly been impeded by cold-air drainage. *Neville Peat*

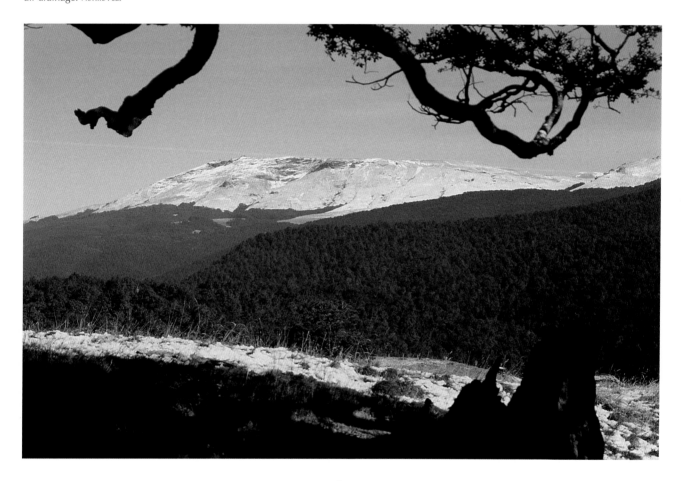

Waikaia Bush

Waikaia Bush, sometimes referred to as Waikaia Forest, is a large wedge of beech forest sandwiched between the Umbrella and Garvie Mountains and totalling over 10,600ha. Three species of beech – red, silver and mountain – dominate the dark-green canopy. The picturesque Waikaia River, a tributary of the Mataura River but a substantial river in its own right, flows the length of the forest, collecting water from large areas of the Old Man, Garvie and Umbrella catchments. The focal point for visitors is Piano Flat Domain, 26km north of Waikaia township and 230m above sea level. It is an open grassy area, popular for camping and picnicking. About a dozen cribs surround the domain. The forest here, tracked on both sides of the river, supports an impressive array of native plant and animal life. The most conspicuous birds are the confiding South Island robin and South Island pied fantail, both of which relish the way people inadvertently stir up insect life – a quick meal. Rotting logs and forest litter conceal some unusual invertebrate life, including a unique spider and two new species of peripatus.

The road north of Piano Flat narrows as it negotiates the forested ridges on the eastern side of the valley. On this sunnier side are stands of tall red beech. After crossing Whitecoomb Creek, the road rises to meet an artificially depressed treeline at about 750m (natural treeline is thought to be around 1,100m). This is the Waikaia end of the infamous summer-dry Waikaia Bush Road, which crosses the Old Man Range via a saddle at 1,410m. Roxburgh is only 13km from here in a direct line, but the road is badly cut up and difficult in places, even for off-road vehicles.

Vegetation

Within the predominantly mixed beech forest is found a wide range of small-leaved shrubs, herbs, ferns and mosses. The stands of magnificent red beech *Nothofagus fusca*, while dominating large areas, often have a sparse understorey due to the drying out effect of these giants. Hall's totara *Podocarpus hallii* is a minor canopy tree in this setting. Conspicuous understorey shrubs include *Aristotelia fruticosa*, *Coprosma rhamnoides*, *Myrsine divaricata*, lancewood

Red beech forest, with a sparse understorey, on a ridge above Piano Flat. *Neville Peat*

Top right: South Island pied fantails are common in Waikaia Bush, where they fly close to people on the walkways, hoping to catch insects in the air. They can raise up to five broods in the breeding season (August to February), which accounts for their abundance. Their nests, typically 3m from ground level, are built in shrubs or fine branches of larger trees. The nest is often distinguished by a 10cm tail of the fine material used in its construction. *Neville Peat*

Bottom: South Island robin at Piano Flat. Listen for the full territorial song of the males through spring and early summer. Robins tend to stick with the same territory and partner year after year, and they often build their nest in a fork in a tree. Up to four eggs are laid. On thin long legs they search the forest floor for worms, spiders and insects. The robins of the Waikaia Valley and adjacent areas comprise one of the most isolated populations, with the nearest robins being east of Lake Te Anau and around the head of Lake Wakatipu. *Neville Peat*

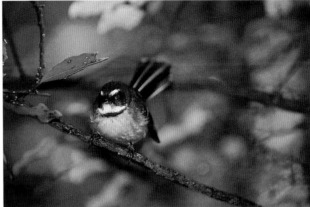

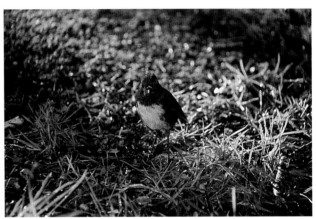

Pseudopanax crassifolius and pepper tree *Pseudowintera colorata*, with the liane *Clematis paniculata* locally common and in spring producing spectacular clusters of white flowers. Openings within the forest, often water-logged, provide habitat for various sedges and herbs. Damp zones on the forest floor typically support the small nettle *Urtica incisa*, ferns *Grammitis billardierei* and *Hymenophyllum multifidum*, and sedges *Uncinia rupestris* and *U. angustifolia*. At the treeline, the most common shrubs are inaka *Dracophyllum longifolium*, celery pine *Phyllocladus alpinus*, and the tree daisies *Brachyglottis buchananii* and *Olearia nummularifolia*. Another two tree daisies have a perilous grip on survival on the margins of Waikaia Bush. On the valley floor flats *Olearia hectorii* is represented by at least two distant individuals, while at treeline *O. fimbriata* is locally rare.

Of the twenty-three species of native bird recently recorded from Waikaia Bush, the most noteworthy are mohua, brown creeper, South Island robin, yellow-crowned parakeet and rifleman. Surveys in the late 1990s suggest there are only a few mohua *Mohoua ochrocephala* left in this

forest. Long-tailed bats have been reported from the Waikaia forest. A giant land snail *Powelliphanta spedeni* is found at the treeline and above it.

Isolation has produced a highly distinctive invertebrate fauna. Four species are endemic to the Waikaia Bush area. One of these is a ground-hunting spider *Pianoa isolata*, the only species in its genus. Also living here is an undescribed peripatus and a fern-feeding weevil *Megacolabus garviensis*, the largest in its genus. This weevil, about 1cm long with a knobbly back, can be found at night feeding on the foliage of shield fern *Polystichum*. Strangely the species has only been found twice here, with a third find from the nearby Pomahaka Valley in 1999. A fourth invertebrate endemic to this area is a large chafer beetle *Stethaspis pulchra*, which is known only from two collections in the Gow Creek-Titan Rocks area above Waikaia Bush. It is a robust species, 13.5mm long, with bright green wing cases (elytra) hiding the wings. Overall, the forest and river harbour a rich invertebrate fauna of beetles, caddis, stoners and moths.

Ancient spider

The secretive nocturnal spider *Piano isolata*, found only in the Waikaia Bush area and named after Piano Flat, belongs to the ancient Gondwanan spider family *Gradungulidae*. It provides convincing evidence of the links between eastern Australia and New Zealand far back in geological time. The family consists of 15 species, three of which (in three separate genera) are endemic to New Zealand and the rest to parts of eastern Australia. The New Zealand spiders comprise *Pianoa isolata*, as well as a giant cave spider of North-west Nelson and a West Coast species. These primitive spiders have several features that set them apart from more modern species. They have four book lungs for breathing (as opposed to two in more modern spiders) and diagonally orientated fangs. Advanced spiders have trachea for breathing and sideways orientated fangs that enable them to live an arboreal web-spinning life. In contrast, *P. isolata* and its fellow gradungulids are sentenced to a life in moist environments such as the decaying leaf litter and logs on the forest floor. Unusually long claws on their front legs allow them to seize prey as a praying mantis does. At Waikaia Bush, this primitive spider has been found through the valley floor up to about 500m altitude.

Ray Forster

Blue Mountains

The hump-backed Blue Mountains, locally known as the 'Blueys', stand proud of the surrounding landscape in the south-east corner of Central Otago. Geologically, the range comprises schist in the north and igneous rock in the south, and the plant and animal life is similarly diverse. Although the highest point, Tapanui No.2, reaches only 1,019m, a surprising number of alpine communities coexist near the summit crest. Only one species of beech is found in the forest – silver beech *Nothofagus menziesii*. A strip of beech forest extends for 17km along the eastern side of the range and is bounded by pine plantations in places. Plantations, mainly of *Pinus radiata*, predominate on the western slopes, facing the town of Tapanui. Above the beech is a shrubland zone, dense and impenetrable in places, featuring species such as celery pine *Phyllocladus alpinus*, inaka *Dracophyllum longifolium*, yellow-flowered *Brachyglottis revolutus*, cottonwood *Ozothamnus vauvilliersii* and *Leonohebe odora*. Higher up, the shrubland gradually thins out and is replaced by narrow-leaved snowgrass *Chionochloa rigida* and megaherbs such as

Waikaia's 'missing link'

This Waikaia peripatus, in the genus Oopeeripatellus, was discovered in the 1997-98 summer. It has 13 pairs of legs, lays eggs and is probably the same peripatus as that which occurs in the Nevis Valley. Females grow to about 50mm, males to about 100mm. Another species was discovered at the same time around Piano Flat – a peripatus with 15 pairs of legs. This other species bears live young. Both species were found living together at Piano Flat, a very rare thing in the peripatus world. At one site they were found on the same log, with the egg-layer at the drier upper end and the live-bearing animal at the wetter end. Up north, egg-laying species tend to be in drier places than this and in alpine sites. Peripatus are carnivorous, entrapping prey by shooting out streams of sticky fluid from turrets on their heads. A Piano Flat peripatus was observed feeding on glow-worms. Peripatus, sometimes called velvet worms, belong to an ancient order of invertebrates believed to be the missing link between worms (*Annelida*) and centipedes, insects, spiders and crustaceans (*Arthropoda*).

Dianne Gleeson

In contrast to the northern end of the Blue Mountains, the terrain in the south is gently rounded with extensive wetlands. Islands of shrubland, dominated by inaka *Dracophyllum longifolium*, are set among copper tussock *Chionochloa rubra cuprea* and rich cushionfield. Dominant cushion species include comb sedge *Oreobolus pectinatus*. Mosses include the common *Sphagnum cristatum*. *Brian Patrick*

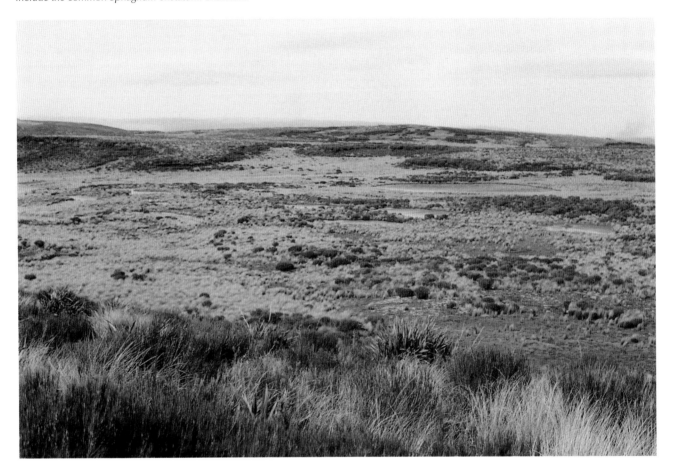

the daisy *Celmisia semicordata* and the giant speargrass *Aciphylla scott-thomsonii*. The *Celmisia* genus is well represented here, with no fewer than eight species inhabiting the range. Myriad smaller inter-tussock species are found, including the purple-fruited *Myrsine nummularia*, trailing daisy *Anaphalis bellidioides*, larger daisy *Celmisia densiflora* and sprawling *Kelleria dieffenbachii*. Attached to rocky sites is edelweiss *Leucogenes grandiceps* and the large flowered *Raoulia grandiflora*. But peat bogs constitute the biological highlight of the range. Rich in colour as well as life, they occur at both ends of the range, but are much more extensive in the south. A range of cushion species including *Donatia novaezelandiae*, *Phyllacne colensoi*, *Celmisia argentea* and comb sedge *Oreobolus pectinatus* grow side by side with prostrate shrubs such as *Dracophyllum prostratum*. Lichens and mosses are abundant. Amongst the wetland herbs are patches of *Celmisia glandulosa*, the insectivorous *Drosera arcturii*, rare *Oreostylidium subulatum*, southern gentian *Gentiana lineata* and *Actinotus novaezelandiae*. In the south copper tussock *Chionochloa rubra cuprea* and wirerush

Empodisma minus are common, reflecting the strong biogeographic links to the south.

Birds of the 'Blueys'

In the Blue Mountains beech forest, the most significant native bird is the mohua or yellowhead *Mohoua ochrocephala*. A population estimate in the mid-1990s suggested there were at least 2,300 mohua on the range. Numbers are especially good in the Rankle Burn and Blackcleugh Burn catchments. No mohua have ever been reported moving through the pine plantations, although other native birds, notably brown creeper, are found in the pines as well in native bush. The brown creeper is in the same genus as mohua. South Island fernbirds, a threatened species, have been seen in small numbers flitting over shrubland areas near the beech, and New Zealand falcons occasionally patrol the margins.

The migratory long-tailed cuckoo *Eudynamus taitensis* announces its presence in the forest with a penetrating shriek. These cuckoos arrive in spring from wintering grounds in the tropical South Pacific and lay their eggs in

An isolated but strong population of the threatened forest songbird, mohua or yellowhead *Mohoua ochrocephala* inhabits the beech forest of the Blue Mountains. The species, renowned for its beautiful canary-like trilling, was once widespread in South Island beech forests but is struggling to hold its own against stoats and other predators. The nearest populations to the Blue Mountains are in the Catlins Valley and, in small numbers only, Waikaia Bush. Mohua are highly social. They often forage in noisy family groups, moving steadily through the forest canopy in search of insects. They nest in holes high up in mature trees. *Ian Southey*

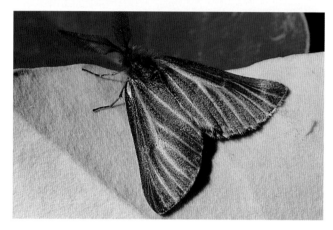

the nests of much smaller native birds, primarily mohua and brown creeper. Banding studies have shown they tend to return to the same breeding area year after year. The shining cuckoo *Chrysococcyx lucidus* also arrives in spring from the tropics, mainly from Melanesia. Its main host is the grey warbler, of which here are good numbers in the Blue Mountains. South Island fantails, both pied and black phase, are plentiful, as are South Island tomtits and bellbirds. Yellow-crowned parakeets occur in small numbers. There are no robins in the Blue Mountains forest, and tui are also absent.

Other forest birds of the Blue Mountains are New Zealand pigeon, morepork, silvereye and rifleman. Paradise shelduck commonly nests around logs and holes in the ground, somewhere near water, but in forested areas like the Blue Mountains they are likely to nest in holes in trees, well above ground level.

Invertebrates

Invertebrate life is especially rich in and around streams and wetlands. Numerous alpine streams provide habitat for seven caddis and sixteen stoner species, with New Zealand's only scorpionfly *Nannochorista philpotti* common in pools. One caddis *Tiphobiosis quadrifurca* is endemic to the range. A feature of the wetlands is a large species of hepialid moth *Aoraia oreobolae* that is endemic to the Blue Mountains. Adults emerge in autumn, but the females are flightless. Larvae feed within the cushions of comb sedge and *Gaimardia setacea*.

Dense shrublands and more open grasslands support an array of bugs, flies, beetles and moths, although the grasshopper and weta populations are less diverse that elsewhere, with only two species in each group. Of interest is a fully black cockroach, belonging to the genus *Celatoblatta* but yet to be formally described. It is elsewhere known only from the Umbrella Mountains. Sunny days bring out many day-active species, both winged and flightless, in open habitats. Conspicuous amongst this fauna is the tiger beetle *Neocicindela parryi*, a flightless bug *Rhypodes anceps*, a wingless undescribed stoner *Apteryoperla* and wetland moths *Orocrambus scoparioides* and *O. thymiastes*. Fifteen geometrid moths are also diurnal, with the elegantly patterned *Dasyuris transaurea* noteworthy.

5 Lakes Backdrop

Like enormous holding tanks, the southern lakes of Wakatipu, Wanaka and Hawea
catch the run-off from the region's highest lands away out west.

By any measure, these lakes are substantial bodies of water. Wakatipu, a 77km-long zig-zag, is the second largest lake in the South Island (after Te Anau), and Wanaka is the fourth largest. With Hawea, they supply water to the Clutha River system.

All three lakes are the products of glaciation. They were carved by rivers of gouging, grinding glacial ice that grew to be hundreds of metres deep at the climax of the ice ages. When the glaciers retreated after their most recent advance, they left lake basins scooped out to well below sea level. The rock on the surrounding landscape was planed smooth. Valley walls bear this planing impact of the glaciers. Hills were scraped smooth on their upstream sides – the 'roches moutonnées', rocks rounded like the backs of sheep – but on their downstream sides the rocks were 'plucked' and made craggy by the moving ice – an effect that is well demonstrated at Mt Iron, just outside the town of Wanaka. When the Wanaka Glacier retreated about 12,000 years ago, it left a lake about 30m higher than present levels. Falling lake levels have left old strand lines and beach deposits. Every

glacier lake is in transition – that is, it is continually accumulating sediment in its basins through the run-off, which is laden with sediment during flood rains.

As a rule, the rivers feeding these glacial lakes carry water one or two degrees colder (7-8° Celsius) than the lake surface temperatures (9-10°). The arriving river water sinks and flows for a distance as a bottom current that forms channels along the lake bed. The lake waters are cold and poor in nutrients.

Wakatipu is fed by the Dart and Rees Rivers at its head and the Greenstone/Caples and Von Rivers in its upper leg. Wanaka's main rivers are the Makarora at its head and the Matukituki in its south-west reaches. Hawea's main inflows are from the Hunter River. Lakes Wanaka and Hawea are separated by a 1.6km-wide ridge known as The Neck. Like most of the glacial lakes east of the main divide, they have an axial trend running north-north-east. Wanaka has five islands and Wakatipu has three in its upper reaches (see page 94). Hawea has just one island, Silver Island, which was created when the lake was raised for hydro-electric power generation in 1958. A 30m-high earth dam was built at the

Previous page: Mt Iron (centre) is a prominent landmark in the Wanaka area, and an example of a 'roche moutonnée' formed by glaciation. Significant shrublands, featuring kanuka, occur on its slopes and on the flatter land beside the Clutha River, which is in the foreground. Also visible are Albert Town at left, with Roy's Bay (reading from top right to left), Wanaka and the Cardrona Valley in the distance.
Neville Peat

A spring-time view of The Remarkables from Bob's Peak, showing glimpses of Lake Wakatipu. *Neill Simpson*

Lake Facts

Wakatipu

Surface area	293 sq km
Long axis	77 km
Maximum width	5.5km
Maximum depth	380m
Height above sea level	311m
Catchment area	2,674 sq km

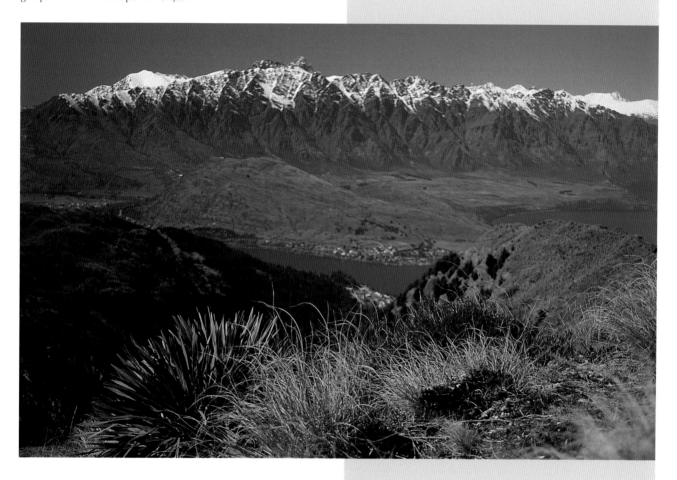

outlet to provide storage for the Roxburgh station. When lake levels are low, north-west gales can whip up dust storms that trouble Hawea residents.

Being of glacial origin and lying close to the Alps, the lakes are cradled by mountains. They form a striking backdrop. The highest and steepest mountains flank Lake Wakatipu , notably The Remarkables, Hector Mountains and Eyre Mountains. Between Lakes Wakatipu and Wanaka is a broad, complex landscape containing the Richardson and Harris Mountains and the Shotover catchment, with its numerous tributaries. From its headwaters at the edge of the West Matukituki Valley, the Shotover River runs due south for 55km before emptying into the Kawarau River.

Shoreline Vegetation

Despite the gravelly and bare-looking nature of the lake shorelines, native aquatic plants do have a foothold. The dominant species at depths of up to 6m is a primitive fern, the quillwort *Isoetes kirkii*. It can grow as short tufts in shallow water or as carpets up to 20cm thick. Water milfoil

Wanaka

Surface area	180 sq km
Long axis	45.4km
Maximum width	11.6km
Maximum depth	311m
Height above sea level	279m
Catchment area	2,590 sq km

Hawea

Surface area	138 sq km
Long axis	42km
Maximum width	13.5km
Maximum depth	384m
Height above sea level	347m
Catchment area	1,394 sq km

The Lakes area is a stronghold for the threatened cress *Ischnocarpus novaezelandiae*, which occurs at six rocky low-altitude sites in the Lakes area including Bob's Cove, Wye Creek, Waterfall Creek and the islands of Mou Waho and Mou Tapu. It was discovered on Mou Tapu in 1998. Once widespread in the eastern South Island, the plant survives only in rocky refuges out of reach of browsing mammals.
Brian Patrick

The black-fronted tern *Sterna albostriata* breeds mainly on shingly riverbeds and lake shores in Central and other inland areas of the South Island through spring and summer. In Central, a few birds also breed in the mountains, notably on the Pisa Range. Smaller and darker than the white-fronted tern, which is common at the seashore, the rarer black-fronted tern migrates to the coast in autumn. Inland, it feeds in flocks on the rivers, dipping its bill in the water while in flight to take emergent mayfly nymphs and other invertebrates. Farmland provides worms and beetle larvae. *Ian Southey*

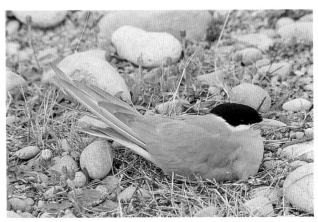

Myriophyllum triphyllum actually prefers a gravel bed to silt and will form feathery clumps up to 70cm tall in water up to about 4m deep. Red pondweed *Potamogeton cheesemanii* can handle similar depths, and grows to 3m in height. Leathery terminal leaves, floating at the surface, reveal its presence. The common rush *Juncus gregiflorus* is encountered in places along the shoreline. Higher up, manuka *Leptospermum scoparium* is often the closest shrub to the water, and it can tolerate flooding of its foothold for a time.

Introduced aquatic plants pose a serious threat to the native species. Of prime concern is the spread of *Lagarosiphon major*, the first exotic species to be found in the waters of Lake Wanaka – and the most aggressive. It was recorded in 1973, and has since spread down the Clutha River to establish in the Dunstan reservoir. Dense forests of *Lagarosiphon* can smother native aquatic plants and restrict recreational activity (see page 130).

Above left: The Australasian shoveler or kuruwhengi *Anas rhynchotis*, formerly called New Zealand shoveler, has a close relative in Australia. It is found mainly on fertile dams and ponds where its food sources – aquatic plants and invertebrates – are available. It has a heavy bill with extended sides containing comb-like lamella that filter out food items such as water beetles and freshwater snails. Shovelers tend to move around a lot, and they come into land with a swift distinctive jinking flight. They nest in tussocks, sedges or thick grass. Being only partially protected, the shoveler has a relatively short life expectancy. Studies show that 65 percent die before they start breeding as one-year-olds. *J.L. Kendrick/DOC*

Above right: A diving duck, the New Zealand scaup *Aythya novaeseelandiae*, also known as black teal, is common on the large lakes. Its food comprises bottom plants and aquatic invertebrates. Although scaup can stay underwater for up to a minute, their dives generally last 15 to 20 seconds. Unlike the Australasian shoveler, scaup are rarely found on shallow coastal lakes or rivers. Numbers have declined since European settlement through habitat modification and shooting, but the species is fully protected now. Nests are built in dense cover close to water. *Neville Peat*

Wakatipu's three islands – Pigeon (the highest), Pig and tiny Tree Island. *Neville Peat*

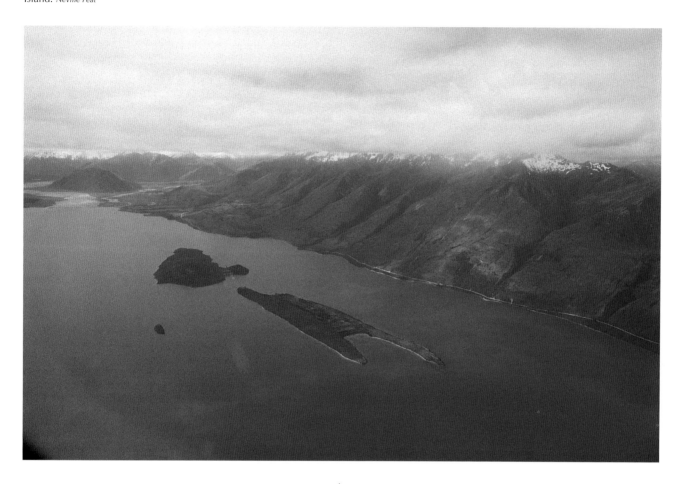

Island Life

The three islands in Lake Wakatipu, five in Lake Wanaka and one in Hawea represent rocky areas that managed to resist the grinding impact of long-gone glaciers. The largest of them, well vegetated, have become sanctuaries for plant and animal life, and in some cases they act as windows on the biota and habitats of the past. All the islands have suffered varying degrees of disturbance but their isolation has meant they have undergone much less change than adjacent areas of the mainland.

A cluster of three islands – Pigeon, Pig and Tree – is situated towards the northern end of **Lake Wakatipu**. All three are significant for their flora and fauna. **Pigeon Island** (168ha), known to Maori as Wawahi-Waka, is the largest. It rises 125m above the lake. Despite many fires, it retains a small patch of red beech forest as well as podocarp trees such as kahikatea, matai and totara. Pokaka *Elaeocarpus hookeranius*, a flowering tree up to 14m in height, is associated with the podocarps. It produces tiny greenish-white bell-like flowers. Native mistletoe *Peraxilla colensoi* drapes its glossy

leaves (and red flowers around Christmas time) through the beech canopy, and native jasmine *Parsonsia* is a common climber. Regenerating fernlands and shrublands of coprosma, manuka and matagouri cover most of the island, and they support a high diversity of native plant species. Being free of stoats and rats, Pigeon Island is a haven for forest birds. There are high numbers of grey warbler or riroriro *Gerygone igata* and good populations of other small insectivorous bush birds – South Island fantail, tomtit and brown creeper. The forest even supports New Zealand pigeon and yellow-crowned parakeet. Pigeon Island has become a sanctuary for an endangered species as a result of its predator-free status. In October 1993, seven mohua (yellowhead) – three pairs and a juvenile – were transferred from the Dart Valley by helicopter. They behaved in surprising ways. Instead of staying close to the tall forest, which is what they do elsewhere, they ventured out into the shrublands. There were eggs by November that first year and chicks by Christmas. The mohua also utilised the island's food resources in unusual ways. They were observed feeding

The high ground of Mou Waho features a small lake, Arethusa Pool.
Neville Peat

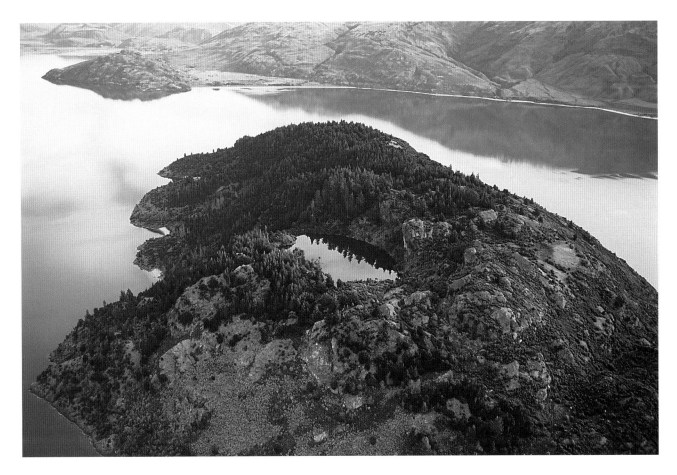

on a mass emergence of stoners, *Acroperla trivacuata* and *Zelandobius furcillatus*, which breed on a sheltered shore of the island.

The other two islands are relatively low-lying. **Pig Island** or Matau (109ha) has only tiny remnants of podocarp and beech forest left. A shallow depression occurs almost over the entire length of the island. Wetlands have developed in the hollows in the schist bedrock, and an important short tussock grassland supports a variety of herbs and characteristic insects. Manuka, cabbage tree, *Coprosma propinqua* and flax surround the wet areas. Both Pig and Pigeon are scenic reserves.

Tiny **Tree Island** (2 ha) has important skink and gecko populations and a relict population of a medium-sized snail *Rytida otagensis* that is endemic to southern New Zealand but with a very scattered distribution. Elsewhere it is known from the Rongahere Gorge, Eyre Mountains and eastern Fiordland.

On **Lake Wanaka**, the most significant islands biologically are Mou Waho or Harwich Island, in the middle reaches of the lake, and Mou Tapu or Crescent Island, which is visible from the town of Wanaka. Both are reserves. Being roches moutonnées, the two islands have craggy bluffs on their 'downstream' side, where glacial ice plucked the rocks as it moved southwards. The high points are about 200m above the lake.

Mou Waho (literally Outer Island) is the larger at 140ha. It is 1.5km long. Large insects such as the weta *Hemideina maori* have survived here, presumably because the island has been largely free of rodents and mustelids. Elsewhere this weta is found only on the tops of ranges such as Mt Ida, North Dunstan Mountains and Rock and Pillar and in Mt Cook's Hooker Valley. Among the native birds, New Zealand pigeon, tomtit and grey warbler are common. Mou Waho has regenerating shrubland and forest of kohuhu, kanuka, fierce lancewood *Pseudopanax ferox* and bracken set among stands of introduced conifers. Near its summit is an 11m-deep lake named Arethusa Pool. Ancient totara logs have been preserved in the cold water of the pool. **Mou Tapu** (Sacred Island, 117ha) has retained more of its original

Northern faces of Mou Tapu, featuring kowhai in flower and cabbage tree. *Neville Peat*

Lake 'Tides'

There are 'tides' affecting large lakes like Wakatipu, Wanaka and Hawea. On Lake Wakatipu small rhythmic fluctuations, known as seiches, leave 'tide marks' at intervals of about 50 minutes. On Lake Wanaka the fluctuations occur roughly every 40 minutes. This phenomenon is usually caused by steady winds blowing the surface water in one direction until it is forced to balance itself and swing the other way. Variations in atmospheric pressure, flood inflows and landslides can also cause seiches.

According to Maori legend, the fluctuations are caused by the heartbeat of a giant, who was killed by local people for abducting a chieftain's daughter. The giant was burnt as he slept, and the fire was so intense it created a deep hole into which the mountains poured their streams to create Lake Wakatipu. The giant's heart sank to the bottom of the lake, which rises and falls to this day with its beating.

'Duck Itch'

People swimming in Lake Wanaka are sometimes exposed to an irritation of the skin known as 'Duck Itch' or, to give it its medical name, *Schistosome dermatitis*. It is caused by the seasonal appearance of a tiny parasite *Cercaria longicauda* that migrates through the skin and into the liver of warmblooded hosts, commonly ducks or small mammals. Humans are involved only accidentally, with the parasite penetrating no further than the epidermis and being killed by the immune system. This causes itchy spots to develop followed sometimes by lumps that may persist for several days. In its host, however, the larval cercaria matures into an adult trematode. In the next stage, after its eggs are excreted and hatch, motile larvae infect a native water snail *Lymnaea tomentosa*. A sporocyst develops in the snail, from which hundreds of cercaria are produced to continue the cycle through ducks, in Wanaka's case possibly New Zealand scaup. Research work on snail control has been carried out at Wanaka, with a view to ridding the area of 'Duck Itch'.

vegetation – a mixed forest of kohuhu, southern rata, broadleaf, fierce lancewood, cabbage tree and kowhai. The large weta also lives here, as does a species of cave weta and gecko.

Stevenson's Island or Te Peka Karara (65ha) in Stevenson's Arm is **Lake Wanaka**'s third largest island. It has a relatively gentle terrain and lies only 200m from the mainland. In vegetation terms the island is dominated by 6m-high kanuka, with a dense understorey of mingimingi *Cyathodes juniperina* in places. Other common shrub species are weeping matipo *Myrsine divaricata*, the broom *Carmichaelia petriei* and daisy shrub *Helichrysum lanceolatum*. Herbs and grasses are mostly confined to rocky headlands and areas behind the main gravel beach. A feature of the island is the extensive lake-edge turf that is exposed when lake levels are at their lowest. Plant species include *Eleocharis acuta, Isoetes kirkii* and *Myriophyllum pedunculatum*. In addition three mistletoes, including the yellow-flowered *Ileostylus micranthus*, are known from various hosts on the island.

Bull Islet near the entrance to Stevenson's Arm is sparsely vegetated with cabbage tree, *Corokia cotoneaster*, porcupine shrub *Melicytus alpinus* and several small-leaved coprosmas. A gecko population thrives here. In Roy's Bay, where the town of Wanaka is located, lies tiny **Ruby Island**, the most modified of all the islands in Lake Wanaka.

Formed by the raising of Lake Hawea, **Silver Island** (25ha) is close to the lake's eastern shore. Heavily wooded, it rises to 100m above the lake. Kanuka is predominant but a significant mountain beech forest grows on the eastern side.

Richardson and Harris Mountains

The Shotover catchment, fabled for its gold deposits, reaches far back into the Richardson and Harris Mountains and the dissected landscape between Lakes Wakatipu and Wanaka.

Botanically, this is a highly intriguing place. Steep cliffs offer refuge to myriad native plant species that elsewhere have lost the battle with grazing animals. Examples are the threatened cress *Ischnocarpus novaezelandiae* (see page 93) and aniseed *Gingidia montana*. At higher altitudes are other endangered plants, notably the whipcord *Leonohebe*

A view of Lake Wanaka from the Harris Mountains shows the mouth of the Matukituki River (centre left) and the islands of Mou Tapu and Mou Waho beyond. *Brian Patrick*

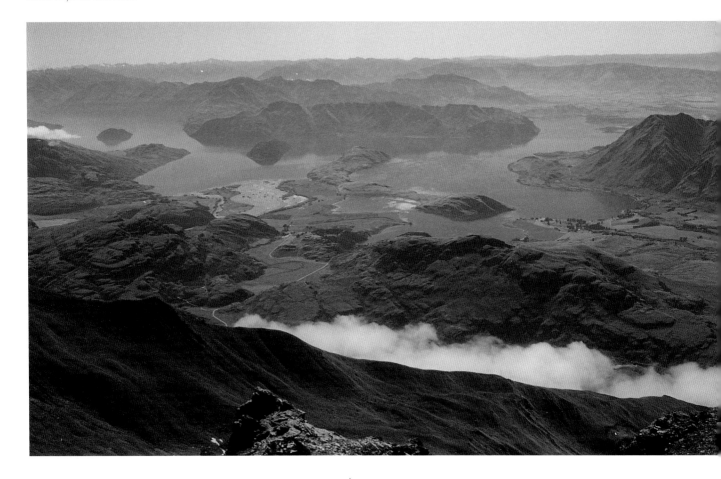

cupressoides, which has its largest population nationally in the Shotover catchment. Distinctive communities occupy braided rivers and broad gravel terraces where cushion plants such as *Raoulia tenuicaulis* and herbs in the genus *Epilobium* are prominent. Damper sandy sites may support a diversity of herbs such as *Gunnera dentata*.

Extensive *Carex*-dominated wetlands occupy former river channels in some areas. Above and beyond the river terraces lie scattered shrublands of the ubiquitous matagouri *Discaria toumatou*, native broom *Carmichaelia petriei* and silver tussock *Poa cita*. A feature of the Matukituki Valley is the presence of remnant tree daisies that are often growing isolated in farmed fields. All three species, *Olearia fragrantissima, O. hectorii* and *O. lineata* have suffered a significant decline in abundance and range, and the Matukituki populations are important for the continued survival of the species. On surrounding slopes, bracken and cabbage trees demonstrate they can withstand countless fires. Rocky gullies may contain mountain beech forest but large stands are rare. This forest has its limit of growth between 1,000 and 1,050m, above

which a well-developed shrubland is often found. Snow totara *Podocarpus nivalis*, celery pine *Phyllocladus alpinus*, mountain lacebark *Hoheria lyallii*, *Brachyglottis cassinioides* and inaka *Dracophyllum longifolium* are the main constituents of these shrublands, which at times grow dense and impenetrable.

As this woody component thins out higher up, tall grasses such as *Chionochloa pallens cadens* and *C. rigida* come into their own, often mixed with reddish shrubs of *Dracophyllum uniflorum*. Grasslands completely dominate large areas of these mountains to 1,950m, with occasional tarns and seepages attracting a rich assortment of herbs and sedges. The recently recognised grass *Chionochloa vireta* is a feature of these ranges. The high-alpine zone is characterised by large areas of scree, rock bluffs, fellfield and snowbanks. The snowbanks are floristically rich, with an assortment of cushion species such as *Hectorella caespitosa*, *Kelleria croizatii* and *Raoulia subulata*. Surrounding slopes often have dense patches of the low rush *Marsippospermum gracile*. Meanwhile, fellfield is dominated by lichen-encrusted rocks with islands of low vegetation that includes cushions

End Peak in the Harris Mountains exemplifies the variety of high-alpine communities found in these mountains. Fellfield, *Chionochloa macra* grassland and naturally eroded slopes all contribute to the biodiversity of flora and fauna. Some native plants thrive on the open margins of erosion scars. In the foreground false speargrass *Celmisia lyallii* and small speargrass *Aciphylla kirkii* are common. *Brian Patrick*

No fewer than 12 species of speargrass grow in the Lakes District of Central. Among these is *Aciphylla montana*, pictured here flowering on End Peak in the Harris Mountains. *Brian Patrick*

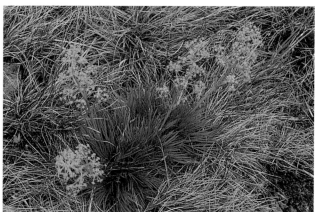

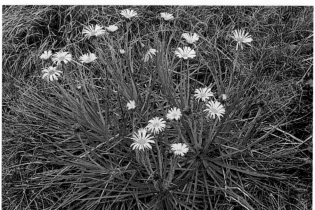

of *Chionohebe ciliolata* and *Raoulia youngii.* Taller herbs such as the fine daisy *Celmisia verbascifolia,* speargrasses *Aciphylla montana* and *A. kirkii* and shrub *Leonohebe hectorii* are also found in the high-alpine zone. Still higher, occasional tufts of the grass *Trisetum youngii* and the tough cushion plant *Anisotome imbricata* hang on in the harsh rocky environment.

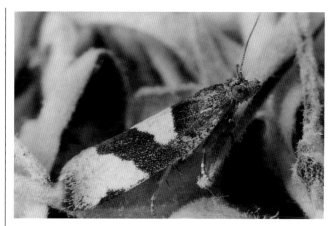

Right: Conspicuous in the Matukituki Valley are groves of the threatened tree daisy *Olearia hectorii.* The valley is a stronghold for the distinctively shaped mature trees. Juveniles are rare, however. The plant, like other deciduous *Olearia* species, is rich in insects, including this undescribed moth (above) in the genus *Pyrgotis. Brian Patrick*

Above: Dwarf cirque vegetation at the head of the Leaping Burn in the Harris Mountains below Black Peak. Even in late summer snow patches occur in shady gullies. *Brian Patrick*

Left: The native daisy *Celmisia lyallii* dominates large alpine areas in the Harris Mountains affected by regular burning. Because its foliage resembles that of speargrass it is called false speargrass. *Brian Patrick*

Above: Mount Aspiring from the Harris Mountains with Treble Cone to the left. Note the steepness of the mountaintops strongly contrast with the plateaux-topped mountains further east. *Brian Patrick*

Below: A flowering cushion of *Hectorella caespitosa*, a characteristic species of snow-banks and cushionfield on the Otago mountains. Both the genus and family to which it belongs are named for Sir James Hector, a geologist and explorer. It is a unique species – the only New Zealand alpine plant without relatives below treeline here. *John Douglas*

Below: The exquisite day-flying moth *Notoreas ortholeuca*, about 10mm long and shown here on *Kelleria childii*, frequents alpine slopes up to 2,300m on the mountains surrounding Lake Wakatipu. It was first found on and described from Stony Peak on the Richardson Mountains. Its larvae are adept at boring into the dense cushions of the larval foodplants *Kelleria childii* and *K. croizatii*.
Brian Patrick

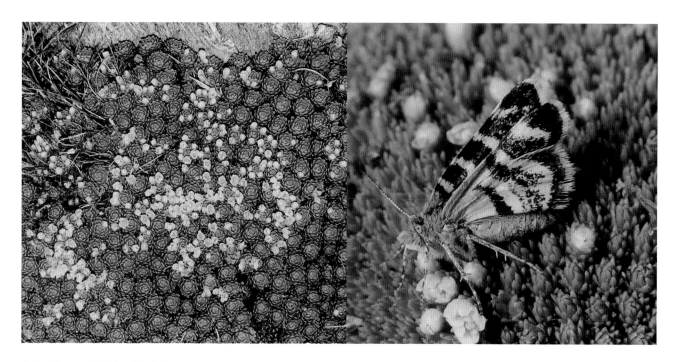

A mature Otago skink and two juveniles beside a protective crevice.
Ian Southey

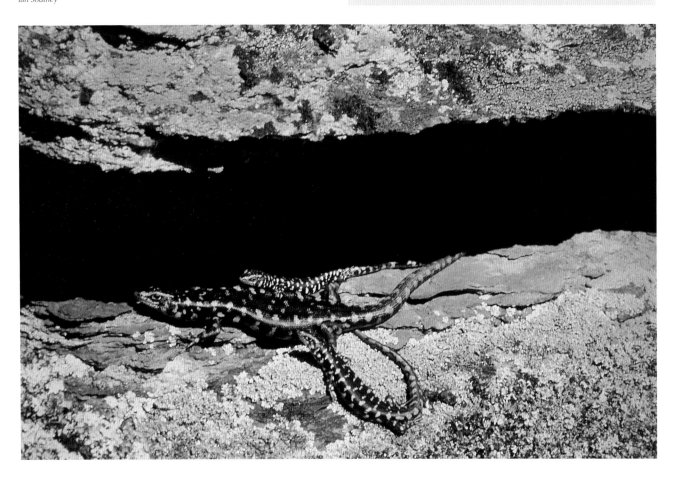

A Land of Lizards

Central Otago is a centre of diversity in New Zealand for lizards. Its importance has been revealed through the recent recognition of new species and fresh discoveries. In early 1998 there was an exciting discovery near Wanaka. Close to the summit of Roys Peak (1,581m), which overlooks Lake Wanaka, a tramper found and photographed a gecko that looked entirely out of place in the rocky terrain close to the summit. There are geckos in the area but this animal was not the usual mix of grey, brown and olive colours. It had orange patches on its back and head and a striking orange mouth lining – coloration in keeping with the forest gecko *Hoplodactylus granulatus*. The orange colour was similar to that of a common lichen *Teloschistes velifera* (see page 60 – lichen on porcupine shrub). In two different places in the Fiordland mountains, geckos with similar colour, pattern and body form have been found in recent years. The Wanaka discovery has raised the question of whether a new group of geckos exists on cloudy mountain tops in southern New Zealand.

The wider Central Otago region boasts an impressive array of lizards – seven skink species and seven gecko species. Except for the commonest skinks, they are not easily seen or frequently encountered. Some of the skinks have very restricted distribution and most of the geckos emerge only at night or around dusk. In the world of lizards, it is remarkable to have so many species occurring at such southerly latitudes. All southern lizards bear live young in contrast to the bulk of the world's lizards, which lay eggs.

Heading the list in terms of rarity and stature are the **Otago skink** and **grand skink** – the largest of all lizards in the South Island. Nose to tip of tail, they can measure up to 30cm. Once widely distributed in Otago, they are found now only in the Macraes-Strath Taieri district and, in smaller numbers, in the Hawea and Lindis areas. They live on rock outcrops in tussock grassland and dry shrubland. Both species live to at least 10 years of age.

Next largest are the scree skink and green skink. Like the species above, the **scree skink** is found in low numbers. Pale brown or grey and less robust than the Otago skink, it

A green skink on a schist boulder. *Graeme Loh*

Bottom: The nocturnal common Otago gecko. *Ian Southey*

McCann's skink on a lichen-encrusted rock. *Ian Southey*

Bottom: An Eyre Mountains gecko, in the genus *Hoplodactylus* but yet to be formally described, licks its lips. Small, robust and a uniform dark olive colour, this gecko lives in rocky terrain in the low-alpine zone. It also occurs on The Remarkables, Hector Mountains and Slate Range, and is sometimes found associating with the larger common Otago gecko. Overall length is only about 70mm. The Gorge Burn area near Jane Peak is especially good for lizards, with three skinks (green, McCann's and cryptic) and the two geckos recorded there. *Ian Southey*

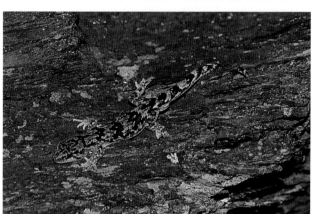

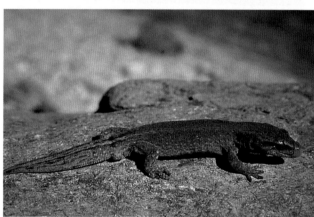

inhabits loose screes and dry streambeds in the mountains of northern Otago, Canterbury and Marlborough east of the main divide (see page 117). The **green skink**, so named for the deep metallic green colour of its back, is found only in southern New Zealand. The Manuherikia Valley and Strath Taieri are among the areas where it has been recorded. Its main habitats are streambeds and damp tussock grassland, shrubland and boulderfield. The smaller **McCann's skink**, light brown or grey, is the species most people catch a glimpse of scuttling for cover. It is widely distributed through Central, especially the Wakatipu Basin, Upper Clutha and middle reaches of the Clutha. It has been found at altitudes as high as 1,500m. The **common skink**, brown with prominent stripes, grows to about 14cm in length. The **cryptic skink**, reddish-brown above, lives at scattered sites in shrublands and herbfields of Otago and Southland, from sea level to the subalpine zone. In Central it has been recorded in the Nevis area, Eyre Mountains and Wakatipu Basin. Tree Island in Lake Wakatipu is the type locality for the cryptic skink.

The geckos are in the process of being redescribed and renamed. The nocturnal rock-dwelling grey-green common gecko in Otago, once known as *Hoplodactylus maculatus*, is proving to be a more diverse animal than was once thought. As the list opposite shows, new species have proliferated. The stoutly built **common Otago gecko** is widespread and abundant in rocky areas throughout Central Otago except for the Wanaka area. The **Cromwell Gorge gecko** is another new species in the *H. maculatus* complex. It has a limited distribution, having been identified so far from the Cromwell and Kawarau Gorges and the Upper Clutha/Wanaka area (records from Pisa Range, Luggate, Mt Iron and, somewhat surprisingly, Ruby Island). It is a brownish gecko, slightly built with narrow toes and green eyes. More restricted still, although found in good numbers, is the **Danseys Pass gecko**, which occurs only in the area between the Kyeburn Diggings and Danseys Pass. The **Southern Alps gecko** inhabits Central's northern greywacke country (Hawkdun and St Bathans Ranges) and overlaps with the Cromwell Gorge gecko around Wanaka. A large stocky lizard, it is adapted to

A Versatile Bird – Banded Dotterel

The banded dotterel *Charadrius bicinctus*, known to Maori as tuturiwhatu, breeds on lake shores, riverbeds, river terraces and stony fields in Central Otago, but is just as likely to be seen nesting on the stony summit crests of the region's ranges. A member of the plover family, and in New Zealand the most abundant and widespread member of the group, the banded dotterel is predominantly a South Island species. After the summer breeding season, flocks often gather at the seacoast and many birds migrate to the north of the North Island or even across to Australia.

Central Otago is a stronghold for the species because of the availability of suitable breeding habitat and food resources. Scurrying along the ground in short sharp bursts, the banded dotterel eats as it goes. Invertebrates such as beetles, weevils, caterpillars, worms, caddis and spiders make up the bulk of its diet. Its breast-bands stand out only in the breeding season – a narrow black upper band and a broader chestnut lower band. The birds begin returning to Central through August and September and first nesting occurs on the lowlands. On the mountains nesting can start as late as November. The nest is a simple scrape in gravel, sand or soil, sometimes incorporating vegetation. Two to four eggs are laid and the adults share incubation. Banded dotterels will defend their territory and greet intruders with a 'broken wing' display to try to distract them away from eggs or chicks. Although victims of predation from stoats and wild cats, banded dotterels are resilient and adaptable and appear to be holding their own.

Top: A banded dotterel and chick at a nest site in the Queenstown area. The chick is superbly camouflaged to resemble a round speckled river stone. *George Chance*

Bottom: Feigning injury, this bird is trying to distract the photographer from its nest, flapping noisily and flopping on the ground. South Island oystercatchers may also perform this 'broken wing' display near their nests. *George Chance*

live at high altitude and is sometimes found at the snowline.

Among the Central geckos, the odd ones out are the **Eyre Mountains gecko**, a small animal, growing to only about 70mm in overall length (photo page xx). It inhabits the Eyre and Hector Mountains, The Remarkables and Slate Range. It overlaps with the western (Wakatipu) form of the common Otago gecko. Lastly, there is the **jewelled gecko** *Naultinus gemmeus*, a bright-green tree gecko, which is found in open forest and shrubland in the Ida Valley and Beaumont. It catches insects by day, perched in branches, using its tail for grip as well as its feet. It grows to about 16cm in length.

All lizards are fully protected, and since October 1996 it has been illegal to catch, own or trade in any lizard without a permit from the Department of Conservation. Until then, common skinks and geckos could be freely collected and kept in captivity.

Central Otago Lizard List

Skinks
Otago skink *Oligosoma otagense*
Grand skink *O. grande*
Green skink *O. chloronoton*
Scree skink *O. waimatense*
McCann's skink *O. maccanni*
Cryptic skink *O. inconspicuum*
Common skink *O. nigriplantare polychroma*

Geckos
Common Otago gecko *Hoplodactylus* new species
Cromwell Gorge gecko *H.* new species
Roy's Peak gecko *H.* new species
Southern Alps gecko *H.* new species
Eyres Mountains ('Southern Mini') gecko *H.* new species
Danseys Pass gecko *H.* new species
Jewelled gecko *Naultinus gemmeus*

The upper Wye Valley in The Remarkables is full of botanical interest. Flowering here is the daisy *Celmisia viscosa*. Double Cone, high point of The Remarkables, is prominent. *Neill Simpson*

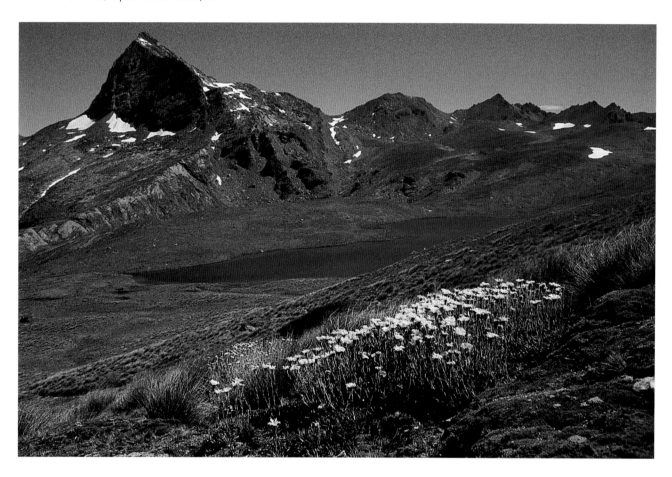

The Remarkables

A national landscape icon, The Remarkables rise 2,000m above Lake Wakatipu. The great western wall of the range, daringly steep, bare-faced and crowned in jagged glory, contrasts sharply with the comparatively smooth tussock-draped block mountains to the east, for The Remarkables have been shaped and sculpted by glaciation. Although built of the same schist rock as the block mountains, The Remarkables contain many glacial features, including aretes, cirques, cirque lakes and hanging valleys. Double Cone (2,324m) is the high point. Behind the western wall – perhaps the most photographed mountain in New Zealand – lies a dissected alpine landscape dotted with some 60 small lakes and tarns occupying glacial depressions. Lake Alta (1,830m), dammed behind a moraine in a classic armchair cirque, is the best known of them. It nestles under Double Cone in the headwaters of the Rastus Burn.

The extent of bare rock on The Remarkables is a feature. Between 1,100m and 1,500m, bare ground constitutes about a quarter of the total area, and above 1,600m, the range is an expanse of bluffs, screes, fellfield and rock outcrops. The snowline cuts in at about 1,500m, although snowfalls to 1,000m are common in winter and spring.

To the south, separated from The Remarkables by the two branches of Wye Creek, lie the more extensive Hector Mountains, capped by Ben Nevis (2,240m). Their western faces, overlooking the southern arm of Lake Wakatipu, are less steep than The Remarkables, and from Ben Nevis south the range gradually loses height to merge with the Nokomai Range (1,100m). The Slate Range, rising to 942m, is an outlier, as is Mid Dome (1,478m) to the south.

Plants of The Remarkables

The Remarkables not only represent a geographical boundary, with Fiordland mountains looming to the west and the dry interior of Central out east; they are also an important botanical frontier – a meeting place for native plants from the wet west and drier east, a sort of botanical 'halfway house'. Several western species reach their eastern limit here, notably snowpatch tussock *Chionochloa oreophila*,

Lower Wye Valley, looking across Lake Wakatipu to the Lochy Valley and Eyre Mountains. Shrubs in the foreground include *Ozothamnus*.
Neville Peat

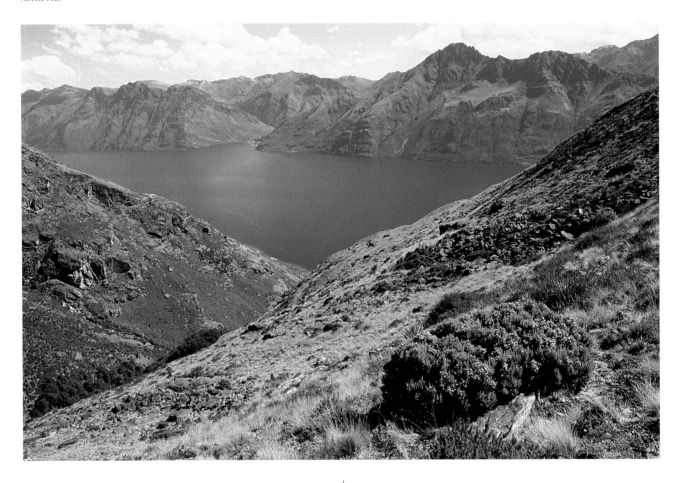

which occurs on snowbanks in the upper Wye Basin, and the spectacular white buttercup *Ranunculus buchananii*, which is found in the high-alpine zone above the level of Lake Alta. *R. buchananii* hybridises here with a more common Central Otago cousin, the smaller-leaved yellow-flowered *R. pachyrrhizus*, to produce a buttercup hybrid with creamy or pale-lemon flowers. One of the rarest plants of The Remarkables is the straggling sub-shrub *Parahebe birleyi*, which occurs only on the summit of Double Cone – its eastern limit. Forming low mats up to about 20cm across, it is usually found in the Southern Alps between Mt Cook and Fiordland. Other significant species are the carrot relative *Anisotome capillifolia*, which has distinctive hair-like leaves, and a purple-stemmed form of the alpine daisy *Celmisia verbascifolia*. Also occurring high up on The Remarkables are loose cushions of the forget-me-not *Myosotis glabrescens*, and, on bluffs, the cress, *Cheesemania fastigiata*, which belongs to an alpine genus found only in New Zealand.

The subalpine shrublands of the Wye Creek Basin support some unusual associations and species. This is a habitat for the rare and threatened *Leonohebe cupressoides*, one of four whipcord hebes occurring here. The others are *Leonohebe propinqua* and *L. hectorii*. Common shrubs of The Remarkables include *Coprosma propinqua*, *C. ciliata*, porcupine shrub *Melicytus alpinus*, and the tree daisy *Olearia cymbifolia*. Speargrasses are diverse on The Remarkables. There are five species, occupying habitats between low and high alpine zones – *Aciphylla horrida*, *A. lecomtei*, *A. kirkii*, *A. hectorii* and the orange-leaved cushion-like *A. simplex*. All species except *A. hectorii* are restricted to the western Otago region. *A. lecomtei* is found only on The Remarkables, Garvies and Eyres.

Although herbfields and alpine bogs are less common than on the block mountains, The Remarkables is well endowed with grasslands. Silver tussock *Poa cita* and hard tussock *Festuca novaezelandiae* hold sway below about 900m. Above this, narrow-leaved snow tussock *Chionochloa rigida* dominates until it merges with slim snow tussock *C. macra* at an altitude of about 1,500m. Of the snow tussocks, the less lofty *C. macra* holds the highest ground, ranging up to about 2,100m. At its upper limits *C. macra* merges with blue tussock

Parahebe birleyi, an alpine plant with perhaps the highest overall elevation of any New Zealand alpine species. It never descends below 2,000m and reaches its eastern limit on The Remarkables and Hector Mountains. *Neill Simpson*

Often encountered bumbling over cushion and herbfield vegetation in the uplands of Central and Western Otago is the chafer beetle *Scythrodes squalidus*. The size of a ten-cent piece, it is an impressive sight, feeding *en masse* on mountain daisies or other herbs. This beetle is confined to uplands west of the Umbrella Mountains. *Brian Patrick*

Cushion plants such as the moss-like *Raoulia subulata* (pictured) can be crawling with bugs, moths, flies and weevils, such as this undescribed species from the Harris Mountains. This spectacular species with metallic blue scales is in the genus *Sargon*. *Brian Patrick*

Loose cushions of *Myosotis glabrescens* in flower near the summit of Double Cone on The Remarkables. This rare species of native forget-me-not is endemic to The Remarkables. *Brian Patrick*

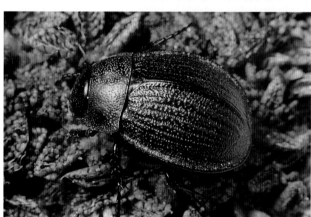

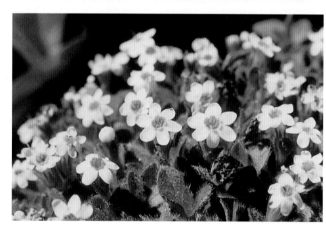

Poa colensoi or ends abruptly at stony fellfield. The dark foliage of *Dracophyllum uniflorum* is prominent among the snow tussock in the alpine zone. In the gorges of Wye Creek and nearby Staircase Creek, in the Hector Mountains, there are remnant stands of mountain beech *Nothofagus solandri* var *cliffortioides*.

The daisy *Celmisia hookerii* occurs in Nokomai Gorge and on the Slate Range. The only other known population is in north-eastern Otago. A rich shrubland exists on the Nokomai Range. Species include *Leonohebe propinqua, L. odora* and *Dracophyllum uniflorum*.

Birds of The Remarkables

Birdlife on The Remarkables is characteristic of the Central Otago high country. The beech forest and subalpine shrubland provide habitat for grey warbler, South Island fantail, tomtit and bellbird. Higher up and breeding on the range are banded dotterel, South Island pied oystercatcher and southern black-backed gull. New Zealand falcon and New Zealand pipit are also found in these mountains but

the bird that attracts more notice than any other species is the kea *Nestor notabilis*.

The kea population here is an eastern outlier of main divide strongholds. Kea, found only in the South Island, are intensely inquisitive birds. As many trampers and skifield visitors can testify, these strong-billed mountain parrots can tear or prise open almost any object that takes their fancy. They are active day or night, although they generally rest in the middle of the day. They eat a wide range of foods, including the fruits of mountain wineberry *Aristotelia fruticosa* and snowberry *Gaultheria* species, the roots and stems of plants such as speargrass and *Celmisia* daisies, and the nectar of mountain flax *Phormium cookianum*.

Breeding has been recorded near the headwaters of the Rastus Burn. In the mid-1980s the developers of the skifield here complained of damage to newly installed equipment and five birds, thought to be the culprits, were transferred north. This led to protests from Forest and Bird and other people, and as a result five replacement kea were released in the Rastus Burn headwaters.

Upper Billy Creek, a tributary of the Lochy River, in the Eyre Mountains. Shrublands are dominated by *Leonohebe odora*. The top of Double Cone on The Remarkables is just visible. *John Barkla*

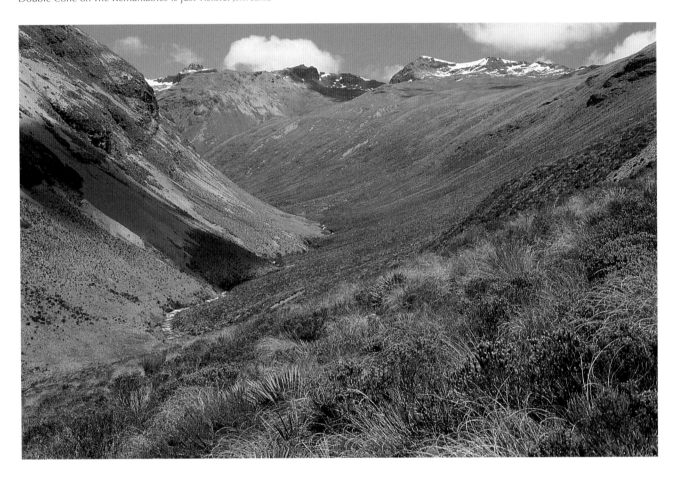

Eyre Mountains – A centre of endemism

Well off the beaten track, the Eyre Mountains retain an air of mystery – a rugged seldomly visited corner containing a unique mix of elements, some Central Otago, some northern Southland and some Fiordland. Accordingly, the Eyres have fauna and flora associations that are found nowhere else and some species that are endemic to these mountains. Bounded on two sides by arms of Lake Wakatipu, the Eyre Mountains have no roads and few tracks through them. Major valley systems such as the Lochy, Long Burn, Robert Creek and Acton and Irthing Streams, tend to be aligned northeast/southwest. The high points are Jane Peak (2,035m) on the western side and Eyre Peak (1,968m), which is more or less in the centre. The long-established sheep stations of Walter Peak, Cecil Peak and Mt Nicholas cover much of this country but there are also large reserves protecting important natural features. Most biological interest centres on slopes surrounding Jane and Eyre Peaks.

Plant life

The bulk of the forest is in the wetter south. Three beech species are represented – red, silver and mountain. Valley head treelines are formed by silver beech, with red beech in the better sites, but lower down in the valleys, where conditions are drier, mountain beech prevails interspersed with thorny thickets of matagouri and corokia. Subalpine shrublands are diverse and dense and feature the daisy family members *Brachyglottis cassinioides*, *B. revolutus* and *Olearia moschata*. In some places vegetation sequences from valley floor to the mountain tops are largely unmodified and the narrow-leaved snow tussock is head high.

Two mountain daisy species are endemic to the Eyres. *Celmisia thomsonii*, a curiosity because of its pink or pink-and-white petals, inhabits shady rocky ledges and crevices in the high-alpine zone. *Celmisia philocremna* is crag-loving, as its species name suggests. It lives on rock bluffs in low- to high-alpine areas, forming compact, thick-leaved cushions up to 1m across. It is distributed through just two streams of the central part of the Eyre Mountains. Another Eyres

Eyre Peak (1,968m) cuts an impressive profile from the scree slopes of Centre Spur in the Eyre Mountains. *John Barkla*

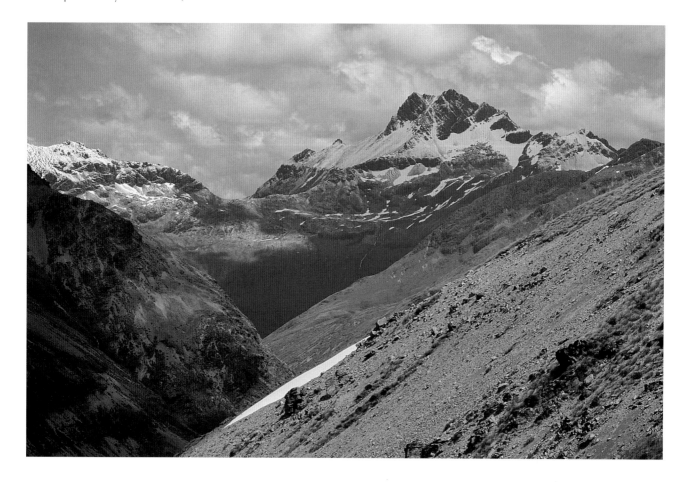

endemic is a subspecies of the scree buttercup *Ranunculus haastii – R. haastii piliferus.* Long stout stems allow it to survive scree movement. Although its leaves are distinctly glaucous, it is not an easy plant to spot. When it is in flower, though, its bright yellow petals stand out against the rocky background. It can be found at altitudes between 1,000m and 2,000m. A high-alpine species found only in the Eyres (except for one record from the Gertrude Saddle) is the pink-tipped speargrass *Aciphylla spedenii* which is virtually restricted to fellfield. A robust cress *Cheesemania wallii,* endemc to this area, is still locally common on shaded bluffs in alpine areas. The rare herbs *Senecio dunedinensis* and *Euchiton ensifer* have some of their most important populations in rocky areas of the Eyre Mountains.

The Lochy catchment contains a number of plants that are listed as nationally threatened. They include the rare cress *Ischnocarpus novaezelandiae* and the oblong-leaved parasitic shrub *Alepis flavida*, which typically attaches to mountain beech trees and produces yellow-orange flowers.

The daisy *Celmisia philocremna*, inhabiting alpine crags, is endemic to the Eyre Mountains. *Neill Simpson*

Streamsides are the preferred habitat of the speargrass *Aciphylla pinnatifida*, which is abundant in places in the Eyre Mountains. Restricted to south-west Otago, northern Southland and Fiordland, the plant stands out when flowering because of the large orange sheaths on its flower stems. *Neill Simpson*

The yellow-flowered shub *Brachyglottis cassinioides* is particularly abundant in the valley floors and slopes of the Eyre Mountains. *Neill Simpson*

The Eyre Mountains buttercup *Ranunculus scrithalis* is small and inconspicuous in its rocky habitat. Found only in the Eyre Mountains, it bears a single flower that dominates the foliage. Its species name refers to the scree habitat. *John Barkla*

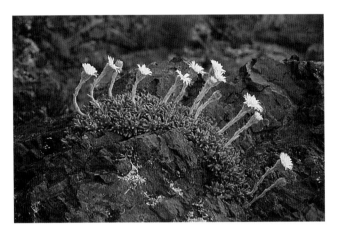

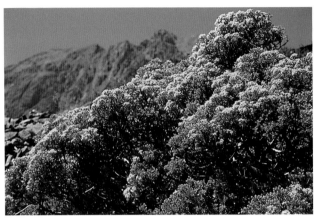

Mayoral Interest

The shrub *Pimelea poppelwellii* (pictured left), a member of the daphne family, was named in honour of a former mayor of Gore, Dugald Poppelwell. Mr Poppelwell and a fellow town councillor of Gore, James Speden, were indefatigable botanists, together exploring and reporting on the alpine plants of mountains in their region from the late 1800s. Their contribution is recognised in the names of a number of plants including, in Mr Speden's case, the speargrass *Aciphylla spedenii*, which he discovered. *P. poppelwellii* is endemic to the wet mountains of northern Southland and Central Otago, from the Eyre to Umbrella Mountains. *Neill Simpson*

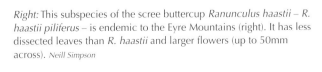

Right: This subspecies of the scree buttercup *Ranunculus haastii* – *R. haastii piliferus* – is endemic to the Eyre Mountains (right). It has less dissected leaves than *R. haastii* and larger flowers (up to 50mm across). *Neill Simpson*

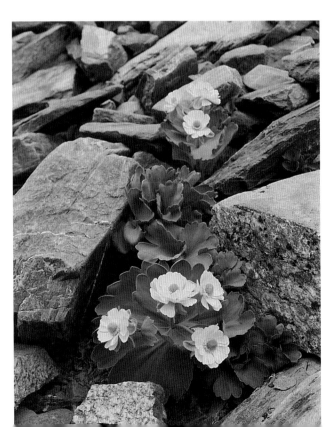

Ourisia remotifolia in flower on the slopes of Jane Peak in the Eyre Mountains. It is found in alpine areas from mid-Canterbury to Fiordland. *Neill Simpson*

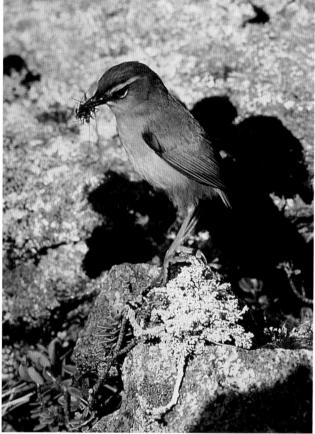

The rock wren *Xenicus gilviventris* was a surprising find for scientists surveying the Eyre Mountains in the mid-1980s. It was the first rock wren population to be discovered away from the Southern Alps in this region. This male has caught an insect. Truly alpine birds, rock wren pairs establish territories above the treeline and build a nest in a rock crevice or hollow bank, well-protected from the elements. Even in winter they will remain high up in the mountains, feeding on whatever insects, seeds and fruits they can find. *C.R. Veitch/DOC*

Western Insects

The loftier and steeper mountains of the Lakes area create harsh habitats such as extensive scree, boulderfields, rock faces and permanent ice, where only the hardiest insects survive. Many more species thrive lower down in snowbanks, cushionfields, wetlands and grasslands, however, and they contribute to the astounding diversity of the alpine insect fauna of New Zealand. Like the ranges of the Central Otago interior, the Lakes mountains also contain an endemic element on each set of adjacent tops. In addition, the ranges surrounding Lake Wakatipu are well known as a biogeographic centre for many groups, a kind of crossroads where species with different distributions overlap. An example is the **dragonfly** genus *Uropetala*, which has two species – *U. carovei* in the west of the South Island and *U.chiltoni* in the east – but only in the Lake Wakatipu area do both of these giant dragonfly species occur. This biogeographic pattern is repeated in many groups, including the tiger moths where all three *Metacrias* species meet in this region.

Weevils of all sizes abound on these mountains, including the medium-sized and appropriately named *Zenagraphus metallescens* and *Sargon sulcifer*. The former has metallic reflections and is active by day. Lower down, the chunky bear weevil *Rhyncodes ursus* is a familiar sight on the trunks of beech trees in the valley floors. Among the three large-bodied speargrass weevils found in these mountains is *Lyperobius spedeni*. Adults feed on the foliage and flowers of various speargrass species, including *Aciphylla pinnatifida*, *A. simplex*, *A. lecomtei* and appropriately enough *A. spedenii*. Other conspicuous alpine beetles include the flightless chafers *Scythrodes squalidus* that crawls over low herbage and the black *Prodontria capito*. The latter does not live west of Lake Wakatipu. Ground hunting carabid beetles in the genera *Mecodema*, *Holcaspis* and *Megadromus* are frequently found under rocks or in tunnels in the soil.

Grasshopper diversity is at its maximum in the Eyre Mountains, where six species are known, with each occupying certain altitudinal zones and communities. Diversity drops off to the west and north.

Cicadas are represented by at least eight species. These

The carabid *Mecodema chiltoni* is a ground beetle of south-western Otago forests and grasslands. At nearly 40mm long it is a fiercesome predator. Substantial populations have been found in the valley-floor forests of the Eyre Mountains. It is now rare in former strongholds on the Nokomai and Carrick Ranges and in the Nevis Valley. Sometimes it is encountered searching for prey by day. *Brian Patrick*

Most larentiine moths are fussy feeders and the silver-coloured *Xanthorhoe frigida* is no exception. Its larvae, like the rest of the genus, devour the foliage of the crucifer family, in this case the local endemic *Cheesemania wallii*, a cliff-dwelling alpine herb. Both moth and host occur in The Remarkables, Eyre and Harris Mountains. *Brian Patrick*

Inhabiting swift streams that tumble off the steepest and highest slopes of the Harris Mountains is the local endemic stoner *Holcoperla magna*. The wingless adults are over 22mm long and very agile in their dynamic environment. *Brian Patrick*

New Zealand's rarest shield bug is *Hypsithocus hudsonae*, a nimble species that is endemic to alpine parts of Otago. Recent surveys have located good populations on the Eyre, Umbrella and Harris Mountains and the Old Man Range. It is pictured here from End Peak in the Harris Mountains. *Brian Patrick*

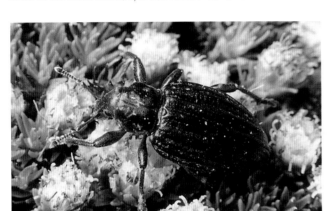

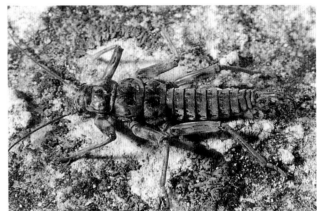

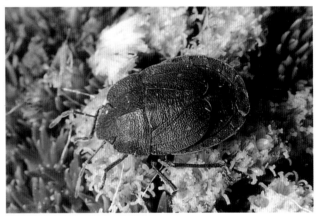

include the pink-bodied *Kikihia rosea* that sings from shrubland and the small and black *Maoricicada campbelli* that frequents bare stony habitat. Both these species can live below and above treeline. Four other black species in the alpine zone have males that are adept at avoiding capture by throwing their voices. These include *Maoricicada oromelaena* and *M. nigra nigra* of the higher western ranges.

Native **butterflies** are relatively diverse, with at least 10 species breeding in the region, eight of which live above treeline. Notable among these species is the main divide specialist *Erebiola butleri*, whose larvae feed on snowgrass. This gentle-flying, dark-brown species is locally common on the Harris, Humboldt and Richardson Mountains.

The diversity of **moths** exceeds all expectations in this region, both by day and night. Steep bluffs harbour the larval hosts of two special geometrids. Both *Gingidiobora subobscurata*, with larvae on the aniseed *Gingidia montana*, and *Xanthorhoe frigida*, with larvae feeding on the cresses in the genus *Cheesemania*, are large and increasingly rare species that have strongholds in this region. Higher up, a tiny blue

unnamed species in the genus *Scythris* has larvae that feed on the scree shrub *Leonohebe epacridea* on The Remarkables. Dark-coloured species such as *Orocrambus cultus* are typical of high altitude snowbanks, where they fly swiftly by day. Three alpine geometrid moths typical of this region are *Helastia salmoni*, *Asaphodes periphaea* and *A. exoriens*. All are naturally endemic to this area whereas *A. stinaria*, a pretty yellow species that was once widespread in New Zealand, is now increasingly confined to the forests of western Otago.

Aquatic insect groups are well represented as well, with a surprising wealth of species breeding in the headwaters of the numerous streams. Large wingless **stoners** such as *Zelandoperla pennulata* and *Holcoperla magna* are joined by smaller winged species such as *Spaniocercoides howesi*, *Zelandobius montanus* and *Z. mariae*, which is known only from the Pisa Range and Hector Mountains.

Flightlessness at high altitude is also found amongst the **caddis**, with *Costachorema hebdomon* and populations of *Tiphobiosis childi* being good examples. Caddis restricted to this region are *Atrochorema macfarlanei*, *Hydrochorema lyfordi*

Numerous tarns, cataracts and high conical peaks characterise the Ben Nevis area of the Hector Mountains. Mid-summer snow is restricted to shady areas above 1,900m. Bare rocky areas above the snow are colonised by the straggling shrub *Parahebe birleyi*, soft cushions of *Kelleria childii* and *Myosotis glabrescens*, low shrubs of *Leonohebe epacridea* and clumps of the speargrass *Aciphylla simplex*.
Brian Patrick

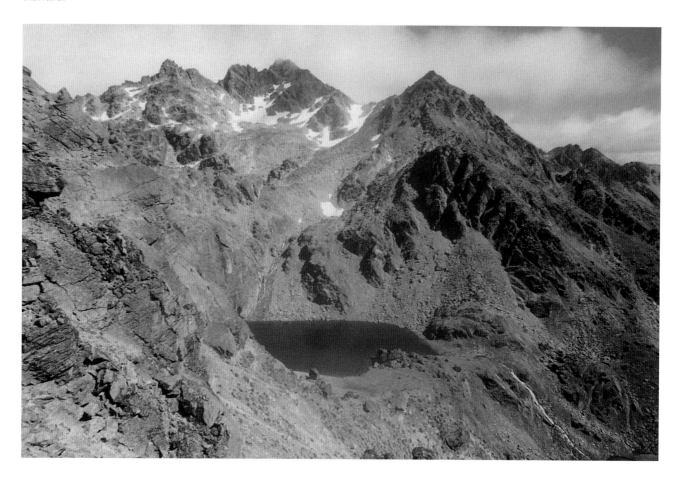

and *Olinga christinae*. The last-named was only recently discovered, breeding at a tarn outlet on a peak east of Lake Hawea. It has larvae that feed from within a case.

Two of New Zealand's largest aquatic insects are features of insect life in the valleys of western Otago. The **dobsonfly** *Archichauliodes diversus* is common and widespread in larger rivers and streams. Larvae are important predators and often called toe-biters because of their fearsome appearance.

More local is the large ornate **lacewing** *Kempynus incisus*, also a predator in its larval stage. It specialises on fly larvae, which it searches for on stream and waterfall margins.

One of the largest land **snails** in southern New Zealand *Powelliphanta spedeni* (see page 112) has its biggest known population in the low-alpine zone of the Eyre Mountains, while at the other extreme in terms of size an undescribed micro-snail is known from over 2000m in the nival zone on The Remarkables.

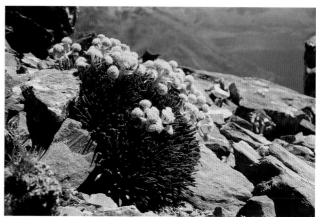

The speargrass *Aciphylla simplex* is a high-alpine specialist, pictured here on a bluff on The Remarkables overlooking Lake Wakatipu. The species is confined to bluffs, ledges, fellfield and other rocky places between 1,500m and 2,000m above sea level. *Neill Simpson*

6 Northern Ramparts

Central Otago is separated from the Waitaki Valley and South Canterbury by the formidable Hawkdun Range and its southern extension, the Ida Range. Together with the St Bathans Range, they form a geological unit distinct from the other mountains of Central Otago.

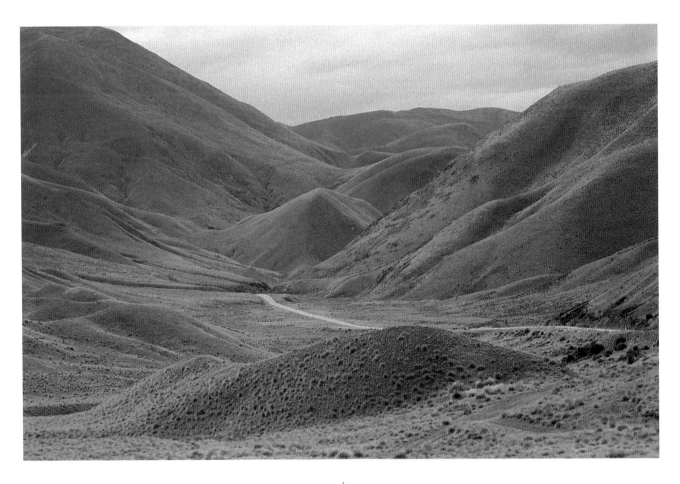

These ranges lie in the transition zone between Otago schist and Canterbury greywacke – a shift in rock types that is expressed by the development of rock slides or screes on the eroding steeper faces of the greywacke country. The Hawkdun Range is also remarkable for a lack of summit-crest tors. By contrast, across the Manuherikia Valley, the Northern Dunstan Mountains summit is crowded with them. Viewed from the Manuherikia, the 50km-long Hawkdun Range has a crest that is uncannily even and sharp-etched. The escarpment rises 1,000m from the valley floor of the Upper Manuherikia, reaching an altitude of 1,871m. Behind the crest lies a broad plateau deeply incised by a series of streams running mainly north-east – a land of fellfield and screes, tarns and tussock. Cirque basins, containing tarns up to 5ha in area, are carved into the north side of the summit crest.

Contiguous with the Hawkdun Range is the relatively short Ida Range, capped by Mt Ida (1,692m). At the eastern end of this range are Mt Kyeburn (1,636m) and Mt Buster (1,333m), the latter being the scene of a nineteenth-century goldfield – one of New Zealand's highest. This historic site is a curiosity because, despite its altitude, it is an alluvial goldfield where the miners sluiced a sequence of river-worn quartz gravels, uplifted on the range by the mountain-building of the past five million years.

The St Bathans Range divides the Upper Manuherikia from the deep and narrow valley of Dunstan Creek. This range, undulating for about 18km, surpasses its neighbours for altitude, with an unnamed peak reaching 2,134m near the middle and Mt St Bathans just to the south attaining 2,088m. From the bed of Dunstan Creek the range rises up to 1,600m. Western slopes are generally formed of semi-schist but the eastern slopes, facing the Hawkdun Range, are chiefly composed of greywacke and argillite.

North-west of the St Bathans Range and Old Man Peak (1,827m) on the Dunstan Range is tussock-draped Lindis Pass (971m), carrying the only tarsealed highway linking Central Otago and the Mackenzie/Waitaki landscape. It was put on the map by explorer-surveyor John Turnbull Thomson on 17 December 1857, and named by him after

In the northeast corner of Central Otago is Danseys Pass (930m), a saddle between the St Marys Range to the north and the Kakanui Mountains to the south. This view from the west shows the Kye Burn draining a peak at 1,295m immediately to the north of the pass. To the right the scenic road snakes towards the pass on its way to Oamaru. *Brian Patrick*

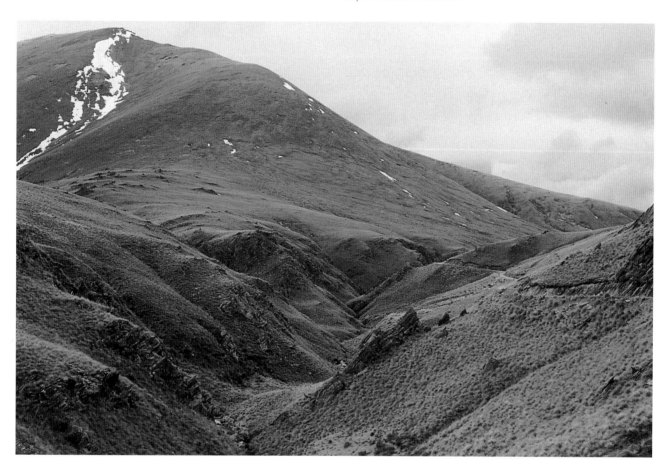

Lindisfarne, an island in north-east England. The monument at the pass marks the liberation of red deer in this region in 1871. Away to the east, beyond the Ida Range, is Danseys Pass (900m), whose narrow gravel road connects Central Otago with the middle reaches of the Waitaki Valley. This pass intersects the Kakanui Mountains to the south-east and the lofty St Marys Range to the north-west. Prominent peaks on the St Marys Range, which overlooks the Waitaki Valley, are Kohurau (2,015m) and Mt Domet (1,942m). The highest peak of the Kakanui Mountains is Mt Pisgah at 1,643m. Kakanui Peak (1,528m) marks the eastern edge of Central.

A Distinct Vegetation

The special nature of the flora and fauna of these northern mountains reflects their geological setting, which is distinct from that of the broad schist summits to the south. The northern ranges have extensive scree slopes and summits of sparsely vegetated fellfield. This is essentially the southern limit of scree vegetation characteristic of the eastern South Island. Specialist scree plants occurring here include the cryptic buttercup *Ranunculus crithmifolius*, giant buttercup *R. haastii*, the cress *Notothlaspi rosulatum*, willowherbs *Epilobium pycnostachyum*, *E. crassum*, scree chickweed *Stellaria roughii*, *Schizeilema hydrocotyloides*, and the spreading daisy *Haastia sinclairii*. In addition the black-flowered daisy *Leptinella atrata*, *L. pectinata*, forget-me-not *Myosotis australis*, the summer-green *Lobelia roughii*, the glaucous grass *Poa buchananii* and the spreading shrub *Leonohebe epacridea* are also inhabitants of the extensive scree slopes.

Adding to the distinctiveness of the vegetation is a number of species that live on other mostly rocky habitats such as stable fellfield. These species include the large vegetable sheep *Raoulia eximia*, the broom-like *Exocarpos bidwillii*, small shrubby *Raoulia petriensis*, speargrasses *Aciphylla dobsonii* and *A. gracilis*, pea family member *Montigena novaezelandiae* and daphne *Pimelea traversii*. On rocky sites edelweiss *Leucogenes grandiceps* and the whipcord shrub *Helichrysum intermedium* are often present, while in alpine herbfield *Celmisia angustifolia* and *Leonohebe*

The schist plateau of Mt Buster looking towards the St Marys Range with the exposed gravels of the gold diggings in the distance. Snowgrass *Chionochloa rigida* dominates the vegetation together with abundant wetlands and cushionfields. The grey patches in the centre of *Schoenus pauciflorus* are indicative of wet ground. In contrast the steep slopes of the St Marys Range carry mostly scree. *Brian Patrick*

Inset: Stark quartz gravels of the Mt Buster diggings lie exposed at 1,200m on the eastern edge of the Ida Range. The schist-greywacke boundary passes through this sector of the range, with the gold workings being confined to the schist side. *Brian Patrick*

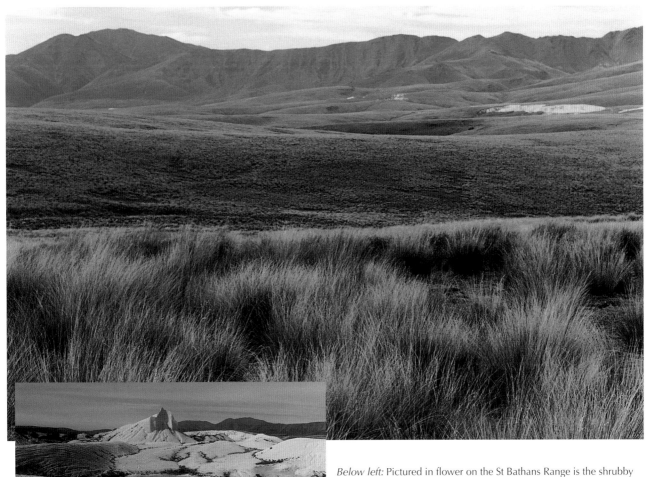

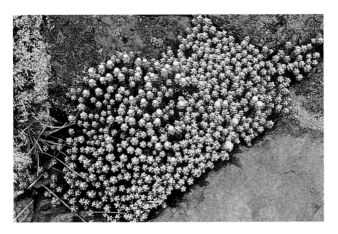

Below left: Pictured in flower on the St Bathans Range is the shrubby cushion *Raoulia petriensis*. This distinctive species is confined to the higher mountains flanking the Waitaki Valley, where it is very local in occurrence. Perhaps its largest population is found on stable fellfield on Long Spur, north of Mt Ida. It is named in honour of Donald Petrie, an early Otago botanist and teacher. *Brian Patrick*

Mountain shieldfern *Polystichum cystostegia* is common among fellfield rocks on all the northern mountains and on other ranges in Central as well. *Brian Patrick*

Mt Kyeburn (1,636m) rises to the east of the Ida Range and has extensive areas of scree. Only small areas of cushion vegetation, such as those in the foreground, are present. These contain plant species that include *Phyllacne colensoi, Raoulia hectorii* and *Kelleria villosa*.
Brian Patrick

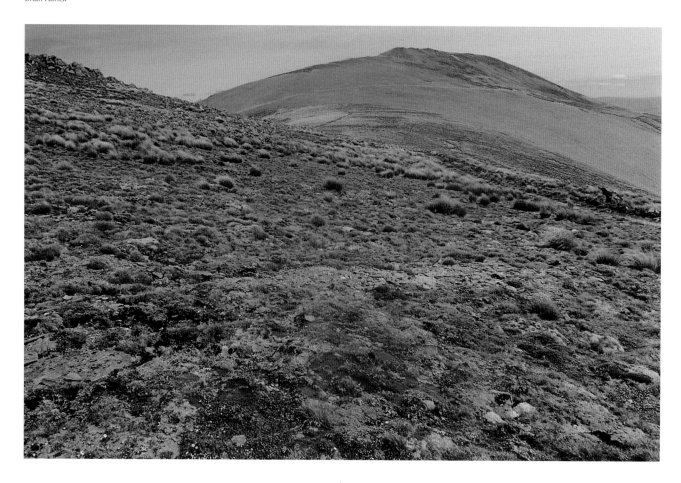

lycopodioides are a distinctive element. Many of these species are at their southern limit of distribution in New Zealand. Others such as *R. petriensis* and *A. dobsonii* are endemic to a small number of mountains in northern Otago and South Canterbury. Tightly-packed leaves give the upcurving stems of *R. petriensis* a corrugated texture and whipcord appearance.

Despite the differences in the vegetation here from that of the schist mountains further south, some typically Otago-wide species also thrive on the northern ranges. They include the low shrub *Dracophyllum muscoides*, and cushions *Hectorella caespitosa* and *Chionohebe thomsonii*. Bright green cushions of *Phyllacne colensoi*, silvery tufts of *Kelleria villosa*, the sticky daisy *Celmisia viscosa* and cushions of *Raoulia youngii* are common in the alpine zone. A suite of wetlands that includes tarns, seepages and flushes are found sparsely across these summits. A wide assemblage of herbs, sedges and mosses live in these habitats including the local *Kelleria paludosa*. Damp gullies lower down support the giant speargrass *Aciphylla scott-thomsonii* and shrubs such as *Coprosma serrulata*,

C. rugosa and *Aristotelia fruticosa*. Drier gullies support celery pine *Phyllocladus alpinus* and snow totara *Podocarpus nivalis*. The latter is found spreading into the alpine zone. Still drier shrublands contain *Olearia odorata, Coprosma intertexta* and remnant Hall's totara *Podocarpus hallii*. Bluffs in the montane zone provide a stronghold for the carrot relative *Anisotome brevistylis*.

The predominant species in the tussock grasslands of the Hawkdun, St Bathans and St Marys Ranges and the Kakanui Mountains is the narrow-leaved snow tussock *Chionochloa rigida*, which reaches altitudes above 1,000m. Higher up, slim snow tussock *C. macra* becomes established, and in the wetter areas copper tussock *C. rubra* occurs, sometimes hybridising with *C. rigida*.

Although the dry mountains of northern Otago do not rival the schist mountains in terms of the range or richness of habitats, they nevertheless have a diverse flora. This results from the mixture of four floristic elements – eastern South Island, New Zealand-wide alpine, Otago-wide species and a local endemic element.

Scree Scenes

Top: The scree skink *Oligosoma waimatense* on Little Mt Ida. Paler, smaller and more lightly built than the Otago skinks, which live at lower altitudes, the scree skink is found on screes and dry streambeds to an altitude of about 1,400m. It is considered to be a threatened species. *Ian Southey*

Bottom: The Kakanui Mountains contain a volcanic enclave, comprising Kattothyrst (left) and Mt Dasher, whose slopes support wetlands and screes of dark-grey volcanic boulders. In the distance are Mt Kakanui (1,528m) and at right Mt Pisgah, at 1,643m the highest point in the Kakanui Mountains. *Brian Patrick*

Bottom: The scree grasshopper *Brachaspis nivalis* inhabits these ranges. Found in scree situations on other ranges in the eastern South Island, it is here at its southern limit of distribution. Three other grasshopper species are known from the tussock grasslands of these mountains. *Brian Patrick*

Scree pea

Montigena novaezelandiae (formerly in the genus *Swainsona*), a member of the pea family, is a rare alpine species endemic to the eastern South Island. Pictured here from the St Bathans Range, this long-lived woody subshrub is known from a number of sites in northern Otago, its southernmost localities. Strongly rooted, it is the only New Zealand legume at home on screes, although it prefers the screes to be partly stable. It produces deep-lavender flower and seed pods of extraordinary size. Related to the kaka beak and native broom, this unique species is found at altitudes of up to about 1,400m in the northern mountains of Otago. Its genus name means 'mountain born'.

John Barkla

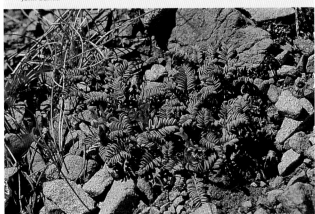

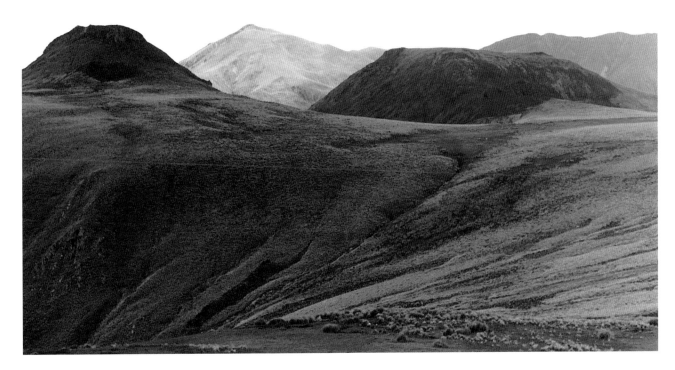

Right: Large black day-active spiders are a feature of the invertebrate life in the high-alpine zone on the St Marys Range. Belonging to the wolf spider family, the species is undescribed. *Brian Patrick*

Typically the highest slopes of the mountains of northern Otago, at 1,800 to 2,000m, are almost devoid of vascular plants. Among the shattered and lichen-encrusted rocks of the St Marys Range are scattered orange cushions of the local endemic speargrass *Aciphylla dobsonii,* larval host plant for a black-and-white weevil *Lyperobius barbarae,* recently named in honour of Dunedin entomologist Barbara Barratt. It is active in the daytime, feeding on the flowers of its host. *Brian Patrick*

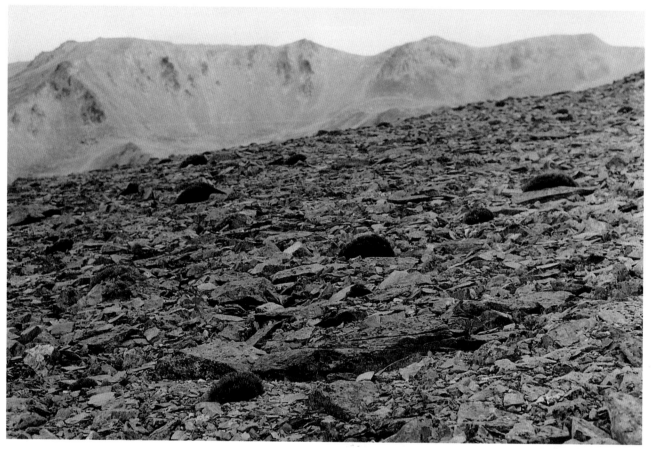

Insects of the North

The insects and other invertebrate fauna of the northern mountains, like the plants, are well adapted to scree and fellfield habitats. New discoveries continue to be made. An undescribed peripatus has been found up to an altitude of 1,000m in rocky areas of Danseys Pass. Also found here is a newly described flightless chafer *Prodontria patricki,* discovered by one of the authors. More survey work is required to determine the full distribution of these taxa. Extensive scree and more stable rocky areas support two species of large-bodied weta.

The scree weta *Deinacrida connectens* and smaller *Hemideina maori* have a wide but patchy distribution through these mountains. Also attached to scree and rocky areas are a cryptic grasshopper *Brachaspis nivalis* and a form of the black butterfly *Percnodaimon merula.* Both depend on 'islands' of vegetation within these sites for sustenance. Moth species that are specialised to the scree habitat include *Orocrambus melampetrus* and *Scoparia sideraspis,* both of which fly rapidly in sunshine.

Prickly clumps of the speargrass *Aciphylla dobsonii* grow in fellfield on the summit crests of the mountains of northern Otago and South Canterbury. The plant is endemic to this area. Individual clumps can be up to 60cm in diameter and it is often the dominant vascular plant in these situations. *John Douglas*

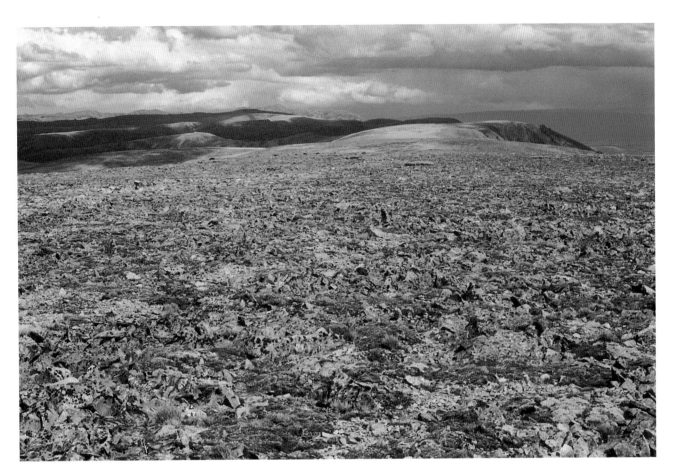

Above: The Otago peneplain surface is well preserved on many of the range-tops of Central Otago. Here at 1,860m on the crest of the Hawkdun Range, looking east to Mt Ida, an area of patterned ground displays stone nets, stripes, solifluction terraces and frost boils. The low vegetation consists mainly of cushions of *Dracophyllum muscoides*, *Hectorella caespitosa* and *Raoulia hectorii*. Brian Patrick

Below: Slim snow tussock *Chionochloa macra* grasslands form a patchwork pattern among the screes high up on the Hawkdun Range. The cirque in the distance has a tarn in its basin. Philip Grove

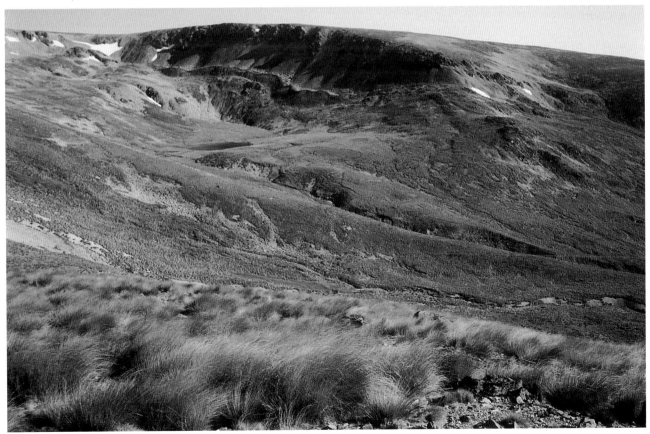

The slopes of the St Bathans Range are typical of the mountains of northern Otago. In contrast to the stark and almost bare rock of the summits of these ranges, flushes and wetlands below are bustling with life. Seepages set amidst moss-bogs are habitat for a large number of herbs and sedges, with distinctive insects inhabiting both the aquatic and terrestrial zones. *Brian Patrick*

Among the three black cicadas species that occur in the mountains of northern Otago is *Maoricicada phaeoptera*. It is found in fellfield at up to 1,600m. On hot summer days the males attract a female by their distinctive song. *Brian Patrick*

Growing on greywacke scree on the St Bathans Range is *Trisetum spicatum*, here in flower. Very few other flowering plant species can grow in this demanding habitat. *John Douglas*

Two species of speargrass weevil are endemic to the mountains of northern Otago and South Canterbury. The smaller *Lyperobius barbarae* is found up to the limits of vegetation where it is attached to speargrasses including *Aciphylla dobsonii* and *A. gracilis*. In contrast the much larger *L. patricki* (to 28mm long) feeds on *A. scott-thomsonii* and *A. aurea* down to at least 900m and must be susceptible to predation by introduced animals. On a hot summer's day diurnal insects engage in a flurry of activity in the grasslands, wetlands and cushionfields of these mountains. The moth genus *Gelophaula* is prominent, with five species known to occur here. The larvae bore into the stems of various mountain daisies (*Celmisia* species), often killing them in the process. This genus is among the few moth genera not represented below the alpine zone.

Moth species whose presence underlines the strong link with the schist mountains to the south include the wetland species *Eudonia xysmatias, Orocrambus scoparioides* and *Scoparia famularis*. All three elegant species are active by day. Seepages and small streams are habitat for many aquatic insects,

including the mayfly *Austroclima jollyae* and caddis *Tiphobiosis cataractae, Hydrobiosis kiddi* and *H. torrentis*. Stoners are represented by a short-winged population of *Austroperla cyrene*, a newly discovered wingless species of *Vesicaperla* and *Zelandobius childi*. Adjacent *Sphagnum* wetlands are larval habitat for the carnivorous giant dragonfly *Uropetala chiltoni*.

The shield bug *Dictyotus caenosus* can be locally abundant on the mountains of northern Otago from 1,500-1,900m. *Brian Patrick*

The rounded light-grey cushions of vegetable sheep *Raoulia eximia* are a feature of stable, frost-shattered fellfield on the greywacke mountains of northern Otago. The cushions can grow to 50cm across. Endemic to South Island mountains east of the main divide, the species is at its southern limit here. *Brian Patrick*

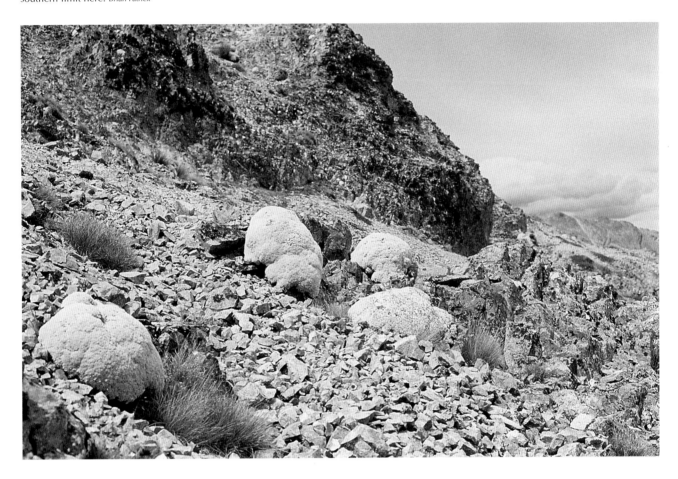

Orange underwing moths sunbathe on tracks and fly up as walkers approach. They are a feature of New Zealand mountains. Of the five species, three live in these mountains, including *Paranotoreas ferox* (pictured). These species use a flash of orange coloration to avoid predators. The pursuing predator believes it is chasing an orange moth, but on settling the moth hides its orange hindwings and merges with the background, thus avoiding capture. *Brian Patrick*

An adult of an undescribed species of *Notoreas* moth that is characteristic of the mountains of northern Otago. The mountains of Otago are the centre of diversity for this New Zealand genus of day-flying moths, represented here by at least 12 species. Seven species, including two that are undescribed, are found in northern Otago. All the species feed as larvae on the daphne family of plants, *Thymelaeaceae*, containing two genera *Pimelea* and *Kelleria*. Species occurring here include *Notoreas paradelpha*, *N. hexaleuca* and *N. ischnocyma*. Each species emerges within a certain altitudinal zone at a different time of the season. *Brian Patrick*

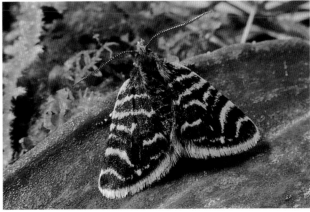

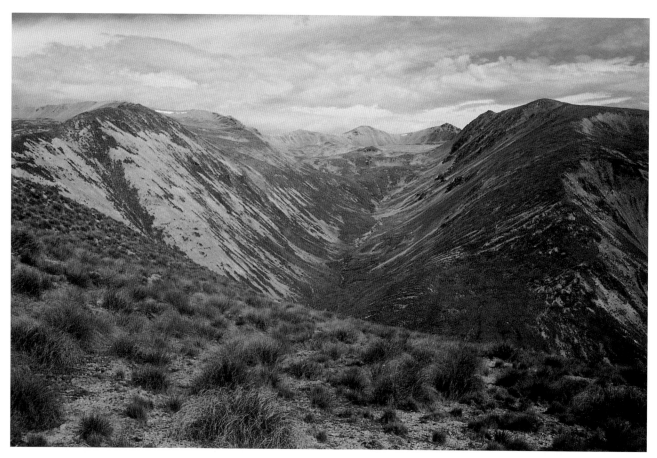

Above: This broad landscape of eroding scree slopes and tussock grasslands is at the heart of the Hawkdun Range in the back country of the Otamatapaiao River, which drains north to the Waitaki. In the distance is part of the Ewe Range. *Philip Grove*

Below: High-altitude vegetation surrounding a flush at about 1,650m on the Hawkdun Range. The mountain daisy *Celmisia haastii* occupies the moist ground and the pale *Raoulia hectorii* shows out on the drier hummocks. An assortment of grasses and sedges contributes to the mosaic. *Philip Grove*

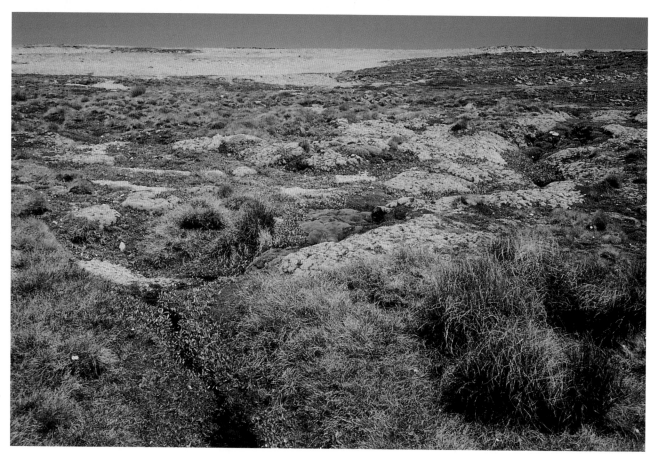

7 A Question of Ethics

In less than half a generation, Central Otago has gone from being a region grossly under-represented in the national network of protected areas to a region that now has large tracts of land reserved for their conservation value. This transformation has been nothing short of revolutionary, and the process continues.

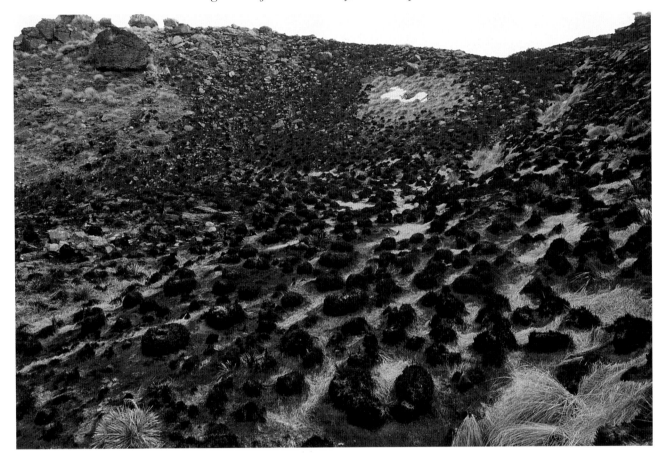

The main driver for such rapid change is the review of pastoral leasehold land tenure, a process that from the mid-1990s began to overshadow an earlier conservation thrust provided by the Protected Natural Areas Programme (PNAP).

Pastoral farming has dominated land use across the bulk of the high country since the 1850s. It brought modifications to soil and water regimes and also to the habitats for native flora and fauna. Vast areas of tussock grasslands and shrublands were burnt last century to increase 'carrying capacity' – the number of stock units capable of grazing a defined area. Tussock burning encouraged new growth and opened up land for oversowing with exotic grasses. With the advent of sheep runs marching shoulder-to-shoulder across every mountain range in the region, a strong pastoral farming ethic evolved, reinforced by land laws that allowed lessees the right to renew pastoral leases in perpetuity. Pastoral farming was seen to be occupying a wasteland, and adding substantial value to the land in an era when conservation was preoccupied with protecting forests, mountains and waterways.

Above: Newly burnt snow tussock grasslands on the slopes of the Old Man Range. Conservationists have long argued for stricter limits to be placed on tussock burning in Central Otago. Research indicates that burning of blocks of narrow-leaved snow tussock *Chionochloa rigida* too frequently will degrade the native grassland, especially when grazing follows burning within a few months. Even in the absence of grazing, *C. rigida* grassland at an altitude of 1,000m will take 25 years to recover to pre-burn stature. Grazing in the first two years after a burn retards full recovery. A code of practice is expected to give farmers guidance on how and when to burn. *Neville Peat*

Over time, however, attitudes and ethics change. From the early 1980s, a nature conservation ethic began pushing into the high country. In Central Otago at the time, little more than 1,000ha of tussock grassland was protected. Through the 1970s public awareness of conservation issues had been aroused by such issues as prospective lake-raising for power generation at Manapouri and Te Anau, beech utilisation on the West Coast and western Southland, and proposed heavy industry development on Aramoana saltmarsh. Yet conservation was hardly a household word when the first PNAP surveys probed the Old Man Range in

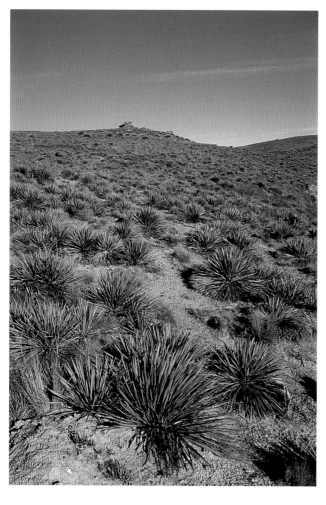

Extensive fields of golden spaniard, the speargrass *Aciphylla aurea*, have replaced snow tussock on the Bannockburn side of the Duffers Saddle, largely as a result of repeated burning of the tussock grassland.
Neville Peat

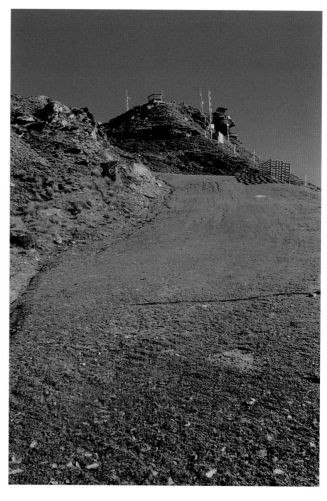

The scale of development and compromise to conservation is evident on Coronet Peak in this view to the summit from about 1,600m. Skifield operations exert pressure on natural values of these mountains with incremental developments annually. These ski-runs have replaced snowgrass slopes and are planted out with exotic grasses and herbs.
Brian Patrick

the early 1980s and recommended, as did successive surveys in other ecological districts, that an array of important habitats be protected. Farmers reacted defensively and angrily, claiming that conservation values had actually improved in their time and that they knew best how to protect natural features. Battle lines hardened. In 1987 the newly created Department of Conservation took over the PNA Programme from Lands and Survey and undertook a new round of surveys. On the one hand, these surveys served to harden the resistance of lessees and, on the other, they began to reveal a much fuller picture of Central's natural heritage. By the early 1990s, the Department of Conservation had secured a few special places, including the tops of the North Dunstan Mountains, Sutton Salt Lake and Flat Top Hill.

Then came the era of tenure review. Faced with low commodity prices, high debt loads in some cases and an outdated Land Act (1948) that curbed opportunities to diversify, lessees began queueing to do deals with the Department of Conservation through the auspices of the

Office of the Commissioner of Crown Lands. The long-winded 31-step process involved surrendering parts of the pastoral lease – mostly the higher land – for conservation purposes, in exchange for being able to freehold the best land for farming. Tens of thousands of hectares were gazetted for conservation management. On some range tops, Old Man and Lammerlaw/Lammermoor, for example, the newly protected blocks are destined to become conservation parks. In 1998, the tenure review process was finally given legal blessing through the passing of the Crown Pastoral Land Act. Although the Act streamlines the process somewhat, it also gives the Department of Conservation a clear role to advocate for conservation values, a role it did not formally have in the past.

What tenure review has failed to do to date, however, is ensure the protection of representative natural environments at mid-altitude or on valley floors, mainly because such areas are highly valued for farming. Land-use change is quickening in low-lying areas, placing pressure on the remaining native species and communities in areas such as

Land-use changes such as vineyard development impact heavily on conservation values in Central. Vineyards such as this one at Gibbston have replaced extensively grazed pastures. With these changes the last vestiges of natural flora and fauna are often extinguished on these sites, and yet rare and special plants or invertebrate animals may survive on adjacent, largely unmodified hillsides. *Brian Patrick*

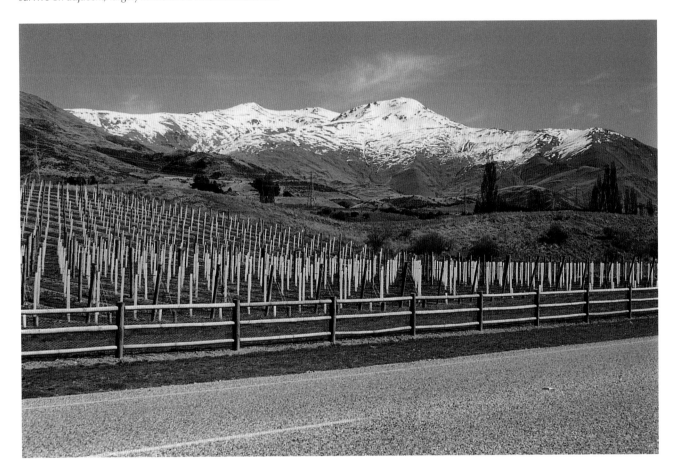

the Upper Clutha and Nevis Valleys. Meanwhile, new techniques of measuring biodiversity and ecosystem values are being developed to help the Department of Conservation identify and hopefully protect the most significant natural areas in the region at any altitude.

Although farming has clearly modified the basic nature of Central, it is not the only land use to have had an impact on native biota. The flooding of valleys for power development and irrigation has caused wholesale change in some areas. With the European settlement of Otago came myriad 'camp followers', some introduced for sport, some for commercial use, some for company. They included browsing animals such as deer, rabbits and goats. In a group of their own were the mustelids – in descending order of size, ferrets, stoats and weasels. Some domesticated animals went wild, notably cats and pigs. Exotic plants poured in, briar rose, thyme and European broom among them. Their introducers could hardly have imagined how these plants would spread and dominate in some areas.

Large tracts of briar, thyme and stonecrop clothe hill

Kawarau Water Conservation Order

In 1997, the Kawarau River and its tributaries in the Wakatipu Basin were officially recognised as having outstanding natural and scenic values. The recognition came in the form of the Kawarau Water Conservation Order, issued under the auspices of the Resource Management Act. In terms of the conservation order, the Kawarau and its tributaries (Dart, Rees, Caples, Greenstone and Lochy Rivers) gained an extra layer of protection from development or land-use changes. As far as the Nevis River is concerned, however, the order stopped short of prohibiting damming. It left the door ajar for hydro-electric development, although any power scheme would need to show respect for existing values. Seven years in the making, the water conservation order was supported by a range of organisations and individuals, including Fish and Game, angling clubs, canoe groups and adventure tourism operators.

The New Zealand falcon *Falco novaeseelandiae*, which was chosen as the species to adorn the $20 note, is the wildest bird in Central's skies. It hunts live prey, mainly small birds but also rabbits, lizards and large insects, and is a fierce defender of its nest site, which is usually an elevated rocky ledge fairly near water. Being at the top of the food chain, the falcon will reflect the health of its environment, and if numbers plummet, there could be a strong environmental reason for the decline. *Ian Southey*

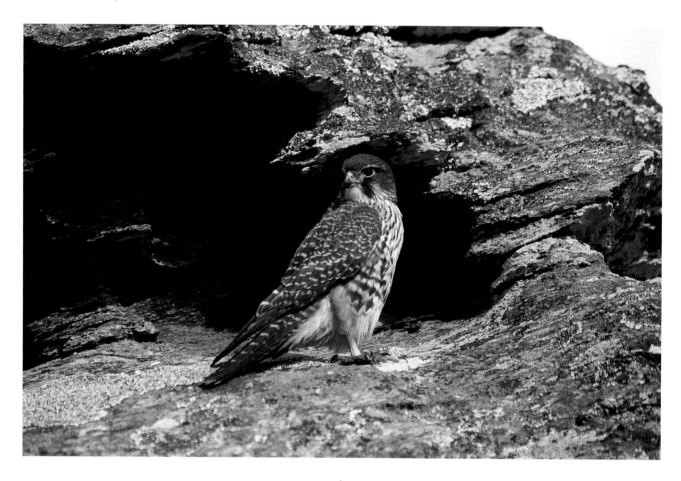

country or fill gullies in the dry core of Central. Whereas these exotic species may not pose an immediate and direct threat to conservation values, they will be hard to eliminate from areas earmarked for restoration.

It is testimony to the resilience of the native flora and fauna that a good deal of the biota has survived. No doubt the rigours of a cold dry climate have helped protect the natural elements.

Threatened Species

Given the special habitats and climate of Central Otago, the region not surprisingly has a diverse list of threatened species – lizards, fish, beetles, birds and plants – and an even longer list of species that are either endemic to Central or have a restricted distribution. There are no kiwi or kakapo in Central – high-profile conservation icons nationally – but the region does have some species whose future hangs in the balance, and a catalogue of less well-known species whose status can only be guessed at. As the Otago Conservation Management Strategy says, a good deal of research needs to be done to confirm which species are at risk beyond those already documented.

The native **fish**, the galaxiids in particular (see page 67), are an example of how much there is to learn and conserve. Until recent times, little was known about the distribution and diversity of the galaxiids in Central. Widespread surveys using electric fishing techniques have remapped galaxiid distribution, produced new species and catalogued the threats, which include land-use changes, modification of stream flows through, say, irrigation schemes, and, not the least, competition from brown trout. Life appears shaky for some of the rarer species.

Central also has some **lizards** that are at risk. Otago and grand skinks, listed in the highest category of threatened species, were once widely distributed but now occupy only about eight percent of their former range. In recognition of their status, the Department of Conservation has mounted a considerable effort to protect the scattered remnant populations. This involves habitat protection and protection from predators, chiefly cats and stoats.

Once common throughout Central Otago and other South Island areas east of the main divide, buff weka *Gallirallus australis hectori* is not now found in the wild in its original habitat. A healthy remnant population exists in the Chatham Islands, however, as a result of transfers of the species before their extinction on the South Island in the 1920s. In pre-European times buff weka were hunted by Maori, who regarded the bird as a valuable resource. This traditional interest has led Kai Tahu people into discussions with the Department of Conservation about the possibility of reintroducing buff weka into Central Otago. *Department of Conservation*

Among Central's native **birds**, New Zealand falcon, kea and mohua are species that need to be monitored. Falcons are raptors at the top of the food chain. They are not numerous compared to most native birds and are often confused with the Australasian harrier, a bigger bird. But having evolved in New Zealand far from the range of the cosmopolitan peregrine falcons, they excite considerable international interest. Eastern South Island falcons are characteristic of open rangelands and Central is a stronghold. The kea is also special, a clever mountain parrot and another New Zealand endemic, with an ancestry tracing back over two million years. Kea were branded pests and sheep killers last century. An estimated 150,000 of them were killed under a bounty scheme that lasted from 1890 to 1970. Today only about 5,000 kea are thought to remain in the mountains of the South Island. People and kea interact at skifields, tramping huts and other high country locations, where signs warn visitors not to feed kea and to take precautions against damage to cars and equipment. Mohua or yellowheads are the gentle songbirds of South Island

Hands-on discovery: This gecko, found on Roys Peak near Wanaka in early 1998, is thought to be a new species. The specimen was released after this photograph was taken. Conservation interest in Central's lizard community has quickened in recent years as a result of the identification of new species from genetic analyses.
Leigh Marshall

These pines in the Mt Aurum area will pose problems in the future as they spread seed. *Robin Thomas/DOC*

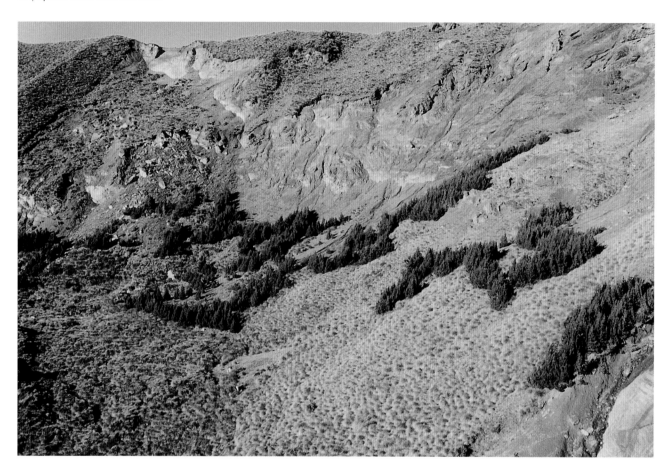

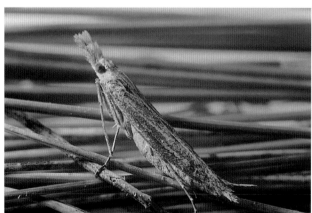

The flightless female of the moth *Orocrambus sophistes* epitomises the plight of many of the distinctive insects of Central. As its valley floor grassland habitat has shrunk, the species has disappeared from many areas including its type locality in the Ida Valley. It thrives only on Schoolhouse Flat in the Nevis Valley where a significant population of the plants *Carex muellerii* and *Festuca novaezelandiae* survive.
Brian Patrick

forests, once widespread but now found only in scattered remnant populations, mainly as a result of predation by stoats and rats. The Waikaia Bush population is vulnerable to extinction, although further east on the Blue Mountains mohua appear to be holding their own.

In the invertebrate world, conservation efforts are focussed largely on threatened **beetles** – the Cromwell and Alexandra chafers, and the carabid *Mecodema chiltoni* in the western mountains. Efforts are also being made to protect the large weta *Hemideina maori* on the Wanaka islands of Mou Waho and Mou Tapu, where it is vulnerable to predation by stoats, rats or mice. Stoats are thought capable of swimming to Mou Waho, where trapping and poisoning operations have been carried out in recent years. Two **grasshopper species** in the genus *Sigaus*, inhabiting the Earnscleugh Tailings, are the subject of scientific study and conservation efforts because of their rarity and limited distribution. Studies are also being carried out on two category A threatened **moth species** that have or had their last strongholds in the Queenstown area, *Xanthorhoe bulbulata*

Unwanted radiata pine trees are removed by Forest and Bird volunteers from the slopes above the Clyde dam in the Cromwell Gorge. *David McFarlane*

and *Asaphodes stinaria*. Results to date indicate the former species is extremely rare and may be extinct, while the latter has at least eight populations in western Otago and South Westland. The larval food plants of these two species are yet to be elucidated.

The use of lake islands as refuges for endangered species has developed in recent years. The Department of Conservation used Pigeon Island in Lake Wakatipu as a sanctuary for mohua. A few artificial islands were created at the upper end of the Dunstan reservoir for nesting by **waterfowl** such as black swan, grey teal and Australasian shoveler. Other birds, including black-fronted terns and black-backed gulls, have also taken up this new, safe nesting opportunity.

War against wildings

Wilding trees are introduced trees, mostly conifers, that spread randomly and persistently from forest plantations, shelter belts or amenity plantings. In Central they pose a major long-term threat to native grasslands, shrublands and

herbfields in certain parts of the high country. Wilding trees can also transform landscapes, reduce grazing potential and detract from outdoor recreation by blocking views and creating dense dark forests. The problem species in Central are mainly *Pinus radiata*, *P. contorta* (lodgepole pine), *P. nigra* (Corsican pine), *Psuedotsuga menziesii* (Douglas fir) and European larch (*Larix decidua*). Seed is dispersed by wind. In a gale it can fly for several kilometres, giving distant spread of a species. Spread can also occur on the fringe of plantations or fan out immediately downwind of individual trees. Some species will grow well above the natural treeline in Central.

The problem is being tackled on two fronts – control work and education. The control work involves chainsaw felling, hand-pulling if the seedlings are small, and poisoning. It is laborious work, undertaken sometimes in steep and difficult country. Control operations by the Department of Conservation in The Remarkables and Hector Mountains in recent years has involved the use of helicopters. The Department of Conservation is also

Prominent exotics: Yellow-flowered stonecrop *Sedum acre* and briar rose *Rosa rubiginosa* have invaded many dry hillsides in Central, including this area on the Knobby Range above the Roxburgh Gorge. The reddish areas are dominated by sheep sorrel *Rumex acetosella*. Grey cushions of *Raoulia australis* are also prominent. *John Douglas*

targeting other parts of the Wakatipu Basin, mainly Ben Lomond Scenic Reserve and Mt Aurum Recreation Reserve. In September 1997, the Royal Forest and Bird Protection Society joined the war against wildings. After staging a seminar of interested parties, Forest and Bird set up a project to systematically attack the worst areas with the cooperation of affected landowners. The Cromwell Gorge, Blue Mountains and Kakanui Mountains were among the areas where parties of volunteers were deployed to remove trees under expert supervision. By the end of the first year the project had destroyed 20,000 unwanted trees.

The second approach to dealing with the problem has to do with preventing spread. Studies undertaken by Forest Research scientists over many years have shown that the spread of unwanted trees can be limited if the plantings are carried out with appropriate site choice, species choice and plantation design.

The *Lagarosiphon* Story

A native of South Africa, the aquatic plant *Lagarosiphon major* has developed into a major weed of Lake Wanaka and the Upper Clutha. It was first recorded in the lake in 1973. Carrying drooping dark-green leaves on stems up to about 1m long, it forms dense underwater forests in water up to 6m deep. The stems are brittle and it transplants easily from broken-off pieces. As boat-owners know, *Lagarosiphon* chokes waterways and becames entangled in propellers. Moreover, it displaces native aquatic plants like the *Isoetes* community. Control work has been undertaken in Lake Wanaka for some years. With the spread of *Lagarosiphon* to the Dunstan Reservoir, efforts are being made to keep it in check there as well. Two other exotic weeds affect Lake Wanaka – Canadian pondweed *Elodea canadensis*, which is another oxygen weed, and water buttercup *Ranunculus trichophyllus*. *Lagarosiphon* is more aggressive than these two species.

Bibliography

Allen R.B. & McIntosh P.D. 1993 Saline Soils and Plant Communities and their Management, Patearoa, Central Otago. Landcare Research Ltd.

Allen R.B. & McIntosh P.D. 1994 Soils and Plant Communities and their Management, Pisa Flats, Central Otago. Landcare Research Ltd.

Allibone R.M. 1997 *Freshwater Fish of the Otago Region*. Otago Conservancy, Department of Conservation. Miscellaneous Report Series No. 36.

Anderson A. 1993 *When all the moa ovens grew cold*. Otago Heritage Books.

Barratt B.I.P. 1993 *Mecodema chiltoni* Broun An Assessment of the Priority for Conservation. AgResearch Ltd.

Barratt B.I.P. & Patrick B.H. 1992 Conservation of the Cromwell Chafer. *Proceedings of the New Zealand Entomological Society*. 4pp.

Brumley C.F., Stirling M.W. & Manning M.S. 1986 Old Man Ecological District. *A Survey for the Protected Natural Areas Programme*. Department of Conservation.

Clark G.R., Petchey P., McGlone M.S. & Bristowe P. 1996 Faunal and Floral Remains from Earnscleugh Cave, Central Otago, New Zealand. *Journal of the Royal Society of New Zealand* 26(3):363-380.

Comrie J. 1992 Dansey Ecological District. *A Survey for the Protected Natural Areas Programme*. Department of Conservation.

Department of Conservation, Otago Conservancy. 1998 *Otago Conservation Management Strategy*. Department of Conservation, Dunedin.

Dickinson K.J.M. 1988 Umbrella Ecological District. *A Survey for the Protected Natural Areas Programme*. Department of Conservation.

Dickinson K.J.M. 1989 Nokomai Ecological District. *A Survey for the Protected Natural Areas Programme*. Department of Conservation.

Dickinson K.J.M. & Mark A. F. & Barratt B.I.P. & Patrick B. H. 1998 Rapid Ecological Survey, Inventory and Implementation: A case study from Waikaia Ecological Region. *New Zealand. Journal of the Royal Society of New Zealand* 28(1):83-156.

Douglas B.J. 1985 *Manuherikia Group of Central Otago, New Zealand: stratigraphy, depositional systems, lignite resource assessment and exploration models*. Report to New Zealand Energy Research and Development Committee. 368pp.

Emerson B. 1994 Conservation Status of Chafer Beetles *Prodontria bicolorata* and *P. modesta*: Distribution and Ecological Observations. *New Zealand Entomologist* Vol. 17.

Emerson B.C., Wallis G.P. & Patrick B.H. 1997 Biogeographic Area Relationship in Southern New Zealand: Cladistic Analysis of Lepidoptera Distributions. *Journal of Biogeography* 24:89-99.

Enting B. & Molloy L. 1982 *The Ancient Islands*. Port Nicholson Press.

Fagan B. & Pillai D. 1992 Manorburn Ecological District. *A Survey for the Protected Natural Areas Programme*. Department of Conservation.

Fahey B.D. 1981 The Schist Tors of Central Otago. In *Man and his Environment*. University of Otago, Geography Department.

Garnier B.J. ed. 1948 *The Face of Otago*. Otago Branch, New Zealand Geographical Society/Otago Centennial Historical Committee.

Gill B. & Martinson P. 1991 *New Zealand's Extinct Birds*. Random Century.

Given D.R. 1981 *Rare & Endangered Plants of New Zealand*. Reed.

Grove P. 1992 Hawkdun Ecological District. *A Survey for the Protected Natural Areas Programme*. Department of Conservation.

Grove P. 1994 Maniototo Ecological District. *A Survey for the Protected Natural Areas Programme*. Department of Conservation

Grove P. 1995 Lindis, Pisa & Dunstan Ecological District. *A Survey for the Protected Natural Areas Programme*. Department of Conservation.

Heads M. 1998 Biodiversity in the New Zealand divaricating tree daisies: *Olearia* sect. Nov. (Compositae). *Biological Journal of the Linnean Society* 127:239-285.

Heather B. & Robertson H. 1996 *The Field Guide to the Birds of New Zealand*. Viking/Penguin.

Jamieson C.D. 1999 A new species of *Sigaus* from Alexandra, New Zealand (Orthoptera: Acrididae). *New Zealand Journal of Zoology* 26:43-48.

Johnson P.N. 1986 *Wildflowers of Central Otago*. John McIndoe.

Johnson P.N. & Brooke P. 1989 *Wetland Plants in New Zealand*. DSIR.

Johnson P.N. & Hewitt A.E. 1991 *Flat Top Hill, Central Otago: Report on Soils and Vegetation*. DSIR Land Resources.

Jolly V. H. & Brown J.M.A. 1975 *New Zealand Lakes*. Auckland University Press/Oxford University Press.

Kearsley G. & Fitzharris B. eds. 1990 *Southern Landscapes*. Geography Department, University of Otago.

Lister R.G. & Hargreaves R.P. eds. 1965 *Central Otago*. New Zealand Geographical Society.

Livingstone M.E. 1986 *Inventory of New Zealand Lakes, Part II: South Island*. National Water and Soil Conservation Authority, Ministry of Works and Development.

McGlone M.S., Mark A.F. & Bell D. 1995 Late Pleistocene and Holocene Vegetation History, Central Otago, South Island, New Zealand. *Journal of the Royal Society of New Zealand* 25(1):1-22.

McGlone M.S. & Moar N.T. 1998 Dryland Holocene Vegetation History, Central Otago and the Mackenzie Basin, South Island, New Zealand. *New Zealand Journal of Botany* 36:91-111.

McIntosh P., Beecroft G. & Patrick B.H. 1990 *Register of Sa-*

line soils in North and Central Otago. Volume 1. DSIR. 98pp.

Malcolm W.M. & Galloway D.J. 1997 *New Zealand Lichens, Checklist, Key and Glossary.* Museum of New Zealand. 192pp.

Mark A.F. & Adams N.M. 1973 revised 1995 *New Zealand Alpine Plants.* Reed/Godwit.

Mark A.F. & Bliss L.C. 1970 The High-Alpine Vegetation of Central Otago, New Zealand. *New Zealand Journal of Botany* 8(4):381-451.

Mark A.F., Johnson P.N., Dickinson K.J.M. & McGlone M.S. 1995 Southern Hemisphere Patterned Mires, with Emphasis on Southern New Zealand. *Journal of the Royal Society of New Zealand.* 25(1):23-54.

Mark A.F. & McSweeney G. 1987 Eyre-Cairnard Biological Treasure Trove. *Forest & Bird* 18(2).

Mason B. 1988 *Outdoor Recreation in Otago, Volume One: Central Otago's Block Mountains.* Federation Mountain Clubs of New Zealand.

Matthews M. & Patrick B.H. 1998 A New Diurnal Species of Heliothinae; *Australothes volatilis* endemic to New Zealand. *Journal of Natural History* 32:263-271.

Mildenhall D.C. & Pocknall D.T. 1989 *Miocene – Pleistocene Spores and Pollen from Central Otago, South Island, New Zealand.* DSIR.

Molnar R.E. & Pole M. 1997 *A Miocene crocodilian from New Zealand.* Alcheringa 21.

Mortimer N. 1993 *Geology of the Otago Schist and Adjacent Rocks.* Scale 1:500 000. Geological Map 7. Institute of Geological and Nuclear Sciences Ltd.

Mosley P.M. ed. 1992 *Waters of New Zealand.* New Zealand Hydrological Society.

Otago Catchment Board. 1956 *Shotover River Survey.* Bulletin No. 1 & 2. Dunedin. 72 + 64 pp.

Otago Catchment Board & Regional Water Board. 1985 *Water Resource Inventory for the Clutha, Kawarau and Hawea Rivers.* Otago Catchment Board, Dunedin.

Otago Regional Water Board. 1980 *Clutha Catchment Water Allocation Plan: A Land and Water Resource Inventory of the Clutha Catchment.* ORWB, Dunedin.

Patrick B.H. 1989 *Lepidoptera of Central Otago Saltpans.* Department of Conservation. 43pp.

Patrick B.H. 1991 Panbiogeography and the general naturalist with special reference to conservation implications. *New Zealand Journal of Zoology* 16(4):749-756.

Patrick B.H. 1994 *Valley Floor Lepidoptera of Central Otago.* Miscellaneous Series No.19. Department of Conservation.

Patrick B.H, Barratt B.I.P, Heads M. 1985 *Entomological Survey of the Blue Mountains.* New Zealand Forest Service, Invercargill. 32 pp.

Patrick B.H., Barratt B.I.P., Dugdale J.S., Roscoe D. & Ward J.B. 1996 *Rongahere Gorge Invertebrate Survey.* 32pp. Department of Conservation & Contact Energy Ltd.

Peat N. 1990 Saline-loving Plants of Central Otago. *Forest & Bird* 21(1):40-41.

Peat N. 1991 Protecting an Icon [The Remarkables]. *Forest & Bird* 22(2):36-42.

Peat N. 1993 The Myriad Fascinations of Flat Top Hill. *Forest & Bird* 268:20-22.

Pole M. 1992 Early Miocene Flora of the Manuherikia Group, New Zealand. 1. Ferns. *Journal of the Royal Society of New Zealand* 22(4):279-306.

Robertson B.T & Blair I.D. 1980 *The Resources of Lake Wanaka.* Guardians of Lake Wanaka/Tussock Grasslands and Mountain Lands Institute, Lincoln College.

Simpson G. & Thomson J. Scott. 1926 Results of a Brief Botanical Excursion to Rough Peaks Range. *New Zealand Journal of Science and Technology* 8(6): 372-378.

Walker S., Mark A.F. & Wilson J.B. 1995 Vegetation of Flat Top Hill: An Area of Semi-Arid Grassland/Shrubland Central Otago, New Zealand. *New Zealand Journal of Ecology* 19(2):175-194.

Whitaker A.H. 1987 A Survey of the Lizards of the Wanaka Area, Otago. *Otago 'Giant' Skink Survey No. 5.* New Zealand Wildlife Service, Wellington. 32pp.

Worthy T. H. 1998 Quaternary Fossil Faunas of Otago, South Island, New Zealand. *Journal of the Royal Society of New Zealand* 28(3):421-521.

Index

Foreigners wearing Otago colours – bright golden flowers of the California poppy are mixed with the purple-blue of Viper's bugloss on a roadside near Bannockburn. *Neville Peat*